Edited by Susan Lambert

Pattern And Design

Designs for the Decorative Arts 1480-1980

With an index to designers' drawings in the
Victoria and Albert Museum

VICTORIA AND ALBERT MUSEUM

An exhibition held at the
Victoria and Albert Museum
March 23-July 3, 1983

ISBN 0 905209 35 4

Designed by Leonard Lawrance
Printed and bound by Four Winds Press
Hampton, Middlesex.

Published by the
Victoria and Albert Museum
London SW7 2RL.
© Crown copyright 1983

Contents

Foreword

*T*his is the first exhibition in our new galleries
in the Henry Cole Wing and its theme was
chosen to demonstrate that the Department
remains an integral part of the V & A in spite
of its move. Indeed, from its foundation, the
Museum collected designs for the decorative arts.
At first they were lodged in the Art Library and
then, in 1909, transferred to the newly-established
Department of Engraving, Illustration and Design
which subsequently became, more simply but less
expressively, Prints and Drawings. Its holdings act
as an archive for the Museum's decorative arts
departments, and it is the relationship of designs
with Design in the broader sense that this
exhibition seeks to explore. Visitors will be
familiar with many of the exhibits and it is felt
that the exhibition can be enjoyed for the beauty of
the objects on show as much as for its didactic
content.

We hope also that this catalogue will serve a useful
purpose long after the exhibition closes. On the one
hand its illustrations provide a visual record of
designs and their varied relationships with finished
artifacts. On the other, the index of designers'
drawings in the Museum breaks new ground both
in making our collection more easily accessible and
– because of its vast extent – as a corpus of designers
in its own right.

The exhibition is a joint venture of several members of the Department under the watchful co-ordinating eye of Susan Lambert. The names of individual contributors are listed on p. xi. Colleagues in other departments – Ceramics, Far Eastern, Furniture & Woodwork, Library, Metalwork, Sculpture and Textiles – were most cooperative in letting us exhibit their objects and helping us to catalogue them. Elsewhere in the Museum we are grateful to John Physick and Michael Darby for advice and, beyond its walls, our thanks must be expressed to Vanessa Brand and Duncan Simpson of the Historic Buildings Division of the G.L.C. for advice and to Lance Day and David Bryden of the Science Museum for a generous loan (1.11.b) and for help in cataloguing it. The photographs are the work of Sally Chappell and Geoffrey Shakerley and the catalogue was typed with her usual accuracy and despatch by Stella Ruff. As always we are much indebted to the Publications Officer, Nicky Bird. Finally, I should like to offer my warmest thanks to numerous colleagues in the Department of the Environment who worked on the conversion of the Henry Cole Wing and without whom there would have been no hall in which to hold the exhibition.

C.M. Kauffmann
Keeper, Department of Prints, Drawings &.Photographs
and Paintings

Introduction

'In German the term Ornament would serve
quite well, and it will be seen that Victorian critics
transferred this usage to England, but to most
speakers of English, 'ornament' conveys some
knick-knack on the mantel-piece, and to the
musician a technical term for certain flourishes.
The word 'design' tends to relate to technology and
the term 'decoration' rather begs the question
whether the practice with which I deal is simply one
of adornment. There remains that jack-of-all-
trades, the term 'pattern', which I shall use quite
frequently though not with very good conscience. For
the word is derived from Latin pater (via patron),
and was used for any example or model and then also
for a matrix, mould or stencil. It has also become a
jargon term for a type of precedent and has therefore
lost any precise connotation it may have once had.'
E.H. Gombrich 'The sense of order, a study in the psychology of
decorative art', 1979.

*W*e were attracted to the term 'pattern' as part
of the title of this exhibition precisely because of its
ambiguity. 'Patterns' in all the senses described
above, if the terms 'matrix' and 'stencil' are
stretched to include the engraver's plate, play a
major part in the exhibition. We chose the word
'design' also because of its all-embracing character,
from the modern sense linked to factory production
to the Italian sense of 'disegno': the process of
giving material and visible form to the conception of
the artist. During the Renaissance this process of
planning on paper (or in other materials) was so
inextricably linked to the completed work in its
intended medium that the term for drawing and
design was the same.
Using grand words with broad generalisations like
that, however, might lead people to expect a history

*of pattern and design, good and bad, covering five
centuries. Of course our intentions are far narrower,
with prints and drawings, although shown in
apposition to objects from most other departments in
the Museum, as the principal exhibits.*

*What is 'good' and 'bad' design has been a subject
for discussion and changes of opinion since antiquity.
No standards have remained unquestioned for long.
Even the 'absolute' canon of classical sculpture has
been subject to revision.[1] The Apollo Belvedere
(see cat. no. 2.3 pl.3), considered until the
18th century the greatest sculpture in the world, a
peerless example of the Attic genius, was described
by French artists studying in Rome late in the 18th
century as having the appearance of a 'scraped turnip'.
It is now believed to be a Roman copy after a lost
original. The Borghese Dancers (see cat.
no. 2.8.f), bought by Napoleon in 1807 and
displayed in the Louvre by 1820, still grace
moulded window boxes although the relief itself has
been consigned to the reserve collection of the Louvre
and is considered a neo-Attic work of indifferent
quality.*

*Vitruvius, writing at about the time of Christ and
providing the only manual of building practice to
survive from antiquity, was scathing about the wall
paintings in Roman palaces and villas. Of them he
wrote 'reeds are substituted for columns, fluted
appendages with curly leaves and volutes take the
place of pediments, candelabra support represent-
ations of shrines, and on top of their roofs grow
slender stalks and volutes, with human figures
senselessly seated upon them'[2] (see cat. no. 1.9.a).
Yet like the monumental architecture, the influence
of these ancient Roman paintings has pervaded
design since they were re-discovered late in the 15th
century. Forms deriving from them are now part of
the common culture and have often been used by crafts-*

men and designers with no knowledge of the original source for their inspiration.

Artists and theorists have struggled through centuries to devise the formulae of good design. The part, for example, that the study of nature should play has been increasingly discussed, the debate reaching a peak in the 19th century. Should nature's underlying laws be followed or should her outward manifestations be copied? The painter, Richard Redgrave, who was botanical lecturer and teacher in the Government School of Design from 1847 and its headmaster from 1848, discussed the subject in connection with the 'differences between the ornamentist and the artist' in A catalogue of the articles of ornamental art selected from the exhibition of industry of all nations in 1851 and purchased by the Government (1852). He claimed 'Art has its childhood in a careful imitation of nature, and grows into an abstract imitation or generalization of nature's highest beauties and rarest excellencies ... nature, thus selected, becomes the vehicle for impressing men with the thoughts, the passions and the feelings which fill the imaginative mind of the artist ... In considering the scope of the ornamentist, it will be evident that ... his effort is to give the most characteristic embodiment of those natural objects ... rather than to imitate; indeed he departs more and more from imitation as he diverges from the path of the artist to occupy his own separate province as an ornamentist.'

The exhibition, however, is only concerned with this and other well-rehearsed arguments on the principles of good design so far as they are raised by the exhibits themselves. No aesthetic judgement, however tentative, is offered by inclusion of any object, be it a piece of paper, a sculpture, a piece of furniture, a candlestick, a mug or a silk petticoat,

although on the whole such objects have entered the Museum with the imprimatur of some period's taste. The exhibition has two basic aims. The first is to show the varied roles that prints and drawings, whether intended as ends in themselves or as in some way preliminary to a particular object or ornament, play in the creation of artifacts. The second is to indicate how the study of works on paper, partly because of the sheer number in which they survive, in connection with the decorative arts adds not only to our understanding of an individual work but can also deepen our knowledge of the culture in which an object was made. To take an extreme case, it was through the prints and drawings produced on the excavation of Pompeii (see cat. no. 1.9.a) that people in the 18th century obtained more vivid knowledge of Roman civilisation than was available even in the first-hand written accounts of the disaster. Moreover, it is through these works on paper and their influence on the decorative arts throughout Europe that we can form an impression of the tremendous imaginative impact the excavations made on certain areas of civilisation.

The exhibition is divided into four sections. The first looks at the variety of drawn and printed source material used by craftsmen and designers; the second demonstrates how the same source material has been adapted by subtle changes to fit the ethos and technology of different styles and periods; and the third considers the sort of information, not available from the artifacts themselves, that can be gleaned from prints and drawings. The fourth section, more of an appendix to the exhibition, consists of drawn copies of Museum objects made by designers in different fields which have, through entering the collections, themselves become available to design students as

patterns. *The three main sections consist of groups of varying numbers of prints and drawings and, in some cases, artifacts selected to show as wide a cross-section of design as possible and presented to make a particular point. There is nothing exclusive about these groups and many of the objects could have been used in different contexts within the exhibition. Any object could tell a different story, and perhaps in future exhibitions some of them will.*

The intention is to provide an illuminating starting-point for the visitor to a large collection of drawn and printed designs in a big decorative arts museum. It is hoped that the exhibition will whet appetites and help the adrenalin to flow rather than annoy and frustrate by the lack of substance with which trains of thought are followed up. Every visitor, even those who had different expectations aroused by the title, should find something of interest and a stimulus to explore further the wealth of designs housed in the Department. All of them can be seen on request in the Print Room and everyone is welcome.

SL

[1] See F. Haskell and N. Penny, *Taste and the antique, the lure of classical sculpture 1500-1900,* 1981

[2] Quoted from P. Ward-Jackson, *Some main streams and tributaries in European ornament,* Victoria and Albert Museum Bulletin Reprints 3, 1969, p.9

Catalogue

Contributors' entries are signed with the initials of the authors:

HB	Harold Barkley
JH	Jean Hamilton
SL	Susan Lambert
MS	Michael Snodin
MT	Margaret Timmers

Charles Newton helped compile the 'Index to designers' drawings in the Victoria & Albert Museum'.

Books referred to frequently in the text are abbreviated as follows:

Bartsch	A. Bartsch, *Le peintre graveur*, Vienna, 1803-21.
Guilmard	D. Guilmard, *Les maîtres ornemanistes*, Paris, 1880-81.
B.N. Fonds	Bibliothèque Nationale, *Inventaire du fonds Français*, Paris, 1932-67.
Berlin	*Katalog der Ornamentstich-Sammlung, der staatlichen Kunstbibliothek Berlin*, Berlin and Leipzig, 1936-9.
Schéle	S. Schéle, *Cornelis Bos; a study of the origins of the Netherlands grotesque*, Uppsala, 1965.
Baudi de Vesme	A. Baudi di Vesme and P.D. Massar, *Stefano della Bella*, New York, 1971.

■ *Indicates a reproduction in colour also*

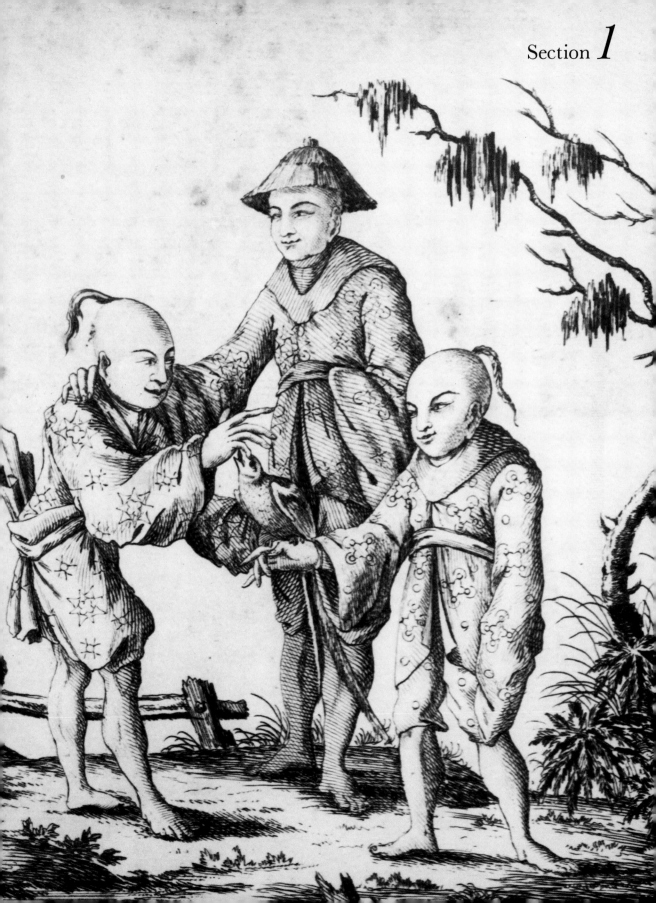

Section 1: Drawn and printed source material used by craftsmen and designers

*I*deas relating to the design of hand and machine made articles have been transmitted over the years in many different ways including through the movement of the artifacts themselves, through easily transported casts and models and, of course, through verbal explanations. Nevertheless, designs (in the widest sense) on paper have been of the greatest influence. This section shows a varied selection of these designs in some cases with objects for which they appear to have been used as direct sources of inspiration.

Although model books were used throughout the Middle Ages, the existence of paper as a relatively cheap commodity was essential for the rapid transmission of ideas in this way. It is recorded in Italian studios around 1300 but it did not become plentiful until the 15th century. Almost equally important was the ability to reproduce drawn designs in greater numbers and more accurately than was feasible by hand. The first prints on paper, made towards the end of the 14th century, were woodcuts. It is thought, however, that it was through the adaptation of the goldsmith's craft of decorative engraving on their wares to the engraving of metal plates to hold ink for printing on paper, in the second quarter of the 15th century, that the first prints intended to be used as patterns to copy were made (cat. no. 1.1.a). Although produced by goldsmiths for goldsmiths, they would have been equally useful to craftsmen in other fields, for example wood carvers, leather workers, wrought iron founders and lacemakers. Moreover, while these single sheets may at first have been circulated little beyond goldsmiths' workshops, similar arrangements of motifs appeared on decorative title-pages to books on every subject and would through this means have reached a much wider public.[3]

Once printed decorations and images were produced in great numbers and engravers put their names to them, it is impossible to discern the specific impulse behind the production of a certain engraving. According to tradition, Marcantonio Raimondi's prints after Raphael were made to spread the latter's fame. Nevertheless whatever the intention of the individual engraver, the result was that images, whether decorative or figurative, were carried from one end of the continent to the other and provided craftsmen and designers with eagerly sought after source material (cat. nos. 1.2.a; 1.3, a, c, d; 1.4.a–c, e). Such was the demand for these images that many of them were re-engraved many times (cat. no. 1.6).

Even the early goldsmiths' decorative engravings may have been intended to advertise their wares. As designs for artifacts were published increasingly in book form, the concept of the printed pattern book evolved. It took two distinct forms: that of a book of patterns to provide craftsmen with models to follow (cat. no. 1.7.a) and that of books of patterns intended to advertise the sale of the products reproduced. Sometimes, as was the case with Thomas Chippendale's 'The gentleman and cabinet-maker's director' (see cat. no. 3.3.b), first published in 1754, the book was intended to have this dual function but at other times designs which appear to show the influence of a particular source, were pirated (see cat. no. 1.8).

There is also no clear dividing line between pattern books and volumes of designs produced for the connoisseur (see cat. no. 1.9.a & b). Through the 18th and 19th centuries a gradual movement towards the compilation of compendiums of design intended to feed the needs of the scholar rather than those of the craftsmen or designer can be glimpsed. Even the intellectualising historicism of

[3] S. Jervis makes this point in the introduction to *Printed furniture designs before 1650*, 1974.

Owen Jones's 'Grammar of ornament' (cat. no. 1.9.c), intended for the design student, reflects this trend. There is no doubt that pattern books have come, in general, to be of more interest to the student of the decorative arts than to the practising designer.

As the designer has become more distinct in concept (if not in practice) from the craftsman, standard models have inevitably had less appeal. Sources of inspiration have become more dependent upon the designer's personality. William Morris must have been attracted to Gerrard's Herball, *first issued at the end of the 16th century, partly because it was produced in a tradition he wished to emulate in the books he published (cat. no. 1.10). Festival of Britain designers were inspired by patterns discovered through contemporary scientific research (cat. no. 1.11). Growth of the design profession has led the net for inspiration to be cast wider.*

Since the late 19th century photography has made it possible to print visual images on paper with even greater speed. No one is unaffected by the resulting mass of printed matter which assails us daily and images on paper, whether they are, for example, in magazines, in catalogues or on posters, remain the most powerful vehicle in the communication of ideas about design.

Schongauer's image of the crozier has been selected to represent early goldsmiths' engravings. These versions provide an example of the ways in which the use and status of a single image can change with the passing of time.

1.1.a Martin Schongauer (c.1430-1491) and an anonymous artist

A crozier. The part below the crook is a drawn 19th century copy made to deceive, on another piece of paper joined almost invisibly to the printed sheet. c.1475.

Engraving and pen and ink. 10.5 x 9.4 cm (the print, irregularly cut) 14001 (purchased in 1856 from 'Evans' for 4 guineas)

Literature: Bartsch no.106; M. Lehrs, *Geschichte und Kritischer Katalog des Deutschen, Niederländischen und Französischen Kupfertstichs im XV. Jahrhundert*, 1925, 5, 105.

The making of prints (engravings) from engraved metal plates is believed to have derived from the decorative methods of goldsmiths. The goldsmithing origins of the early engravers show not only in their tight decorative technique but also in their subjects, which included almost from the beginning decorative foliage and representations of whole metal objects, presumably intended for use by their fellow goldsmiths. Martin Schongauer was the first German engraver who is known to have been more of a painter than a goldsmith. His father, however, was a goldsmith, and his prints of foliage and metalwork show a good understanding of that medium. The simple and direct treatment of this crozier (unlike his very complex later print of a censer) suggests its use as a goldsmith's model, as does the close clipping of the image, a characteristic of such engravings when found in

surviving craftsmens' scrapbooks. Unfortunately no croziers to this design have been recorded, but the design of the stem was adapted for the decoration of a manuscript of 1490-91.

The revival of interest in early German prints had begun by the 18th century and by 1856, when the crozier design was bought by the Art Library for the use of design students, such prints were also sufficiently valuable in their own right to be faked. The faker has cleverly avoided copying the signature which would have invited inspection, but his line-work differs in many ways from the original.

1.1.b After Martin Schongauer (c.1430-1491)

A crozier. From G. Duplessis, *Oeuvre de Martin Schongauer ... par Amand Durand*, 1881, pl.107.

Signed *MS*. Stamped on the back with Amand Durand's mark.
Heliogravure. 28.1 x 11 cm
E.2315-1930

The detection of such fakes of rare plates such as that shown as cat. no. 1.1.a was made possible by the introduction of photography and of heliogravure, a method of producing etched copies photographically. Amand Durand's output of heliogravures of rare prints, which ran to over 1000 plates, was intended for the connoisseur. Yet in spite of the photographic accuracy of this reproduction of the crozier, the print is entirely characteristic of etchings of the 1880s in ink, paper and tone and could never be confused with Schongauer's original.

MS

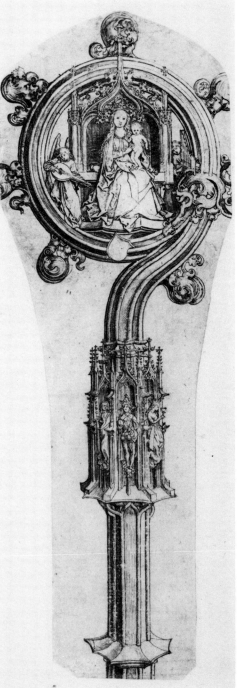

1.1.a

1.2

The engravings of Marcantonio Raimondi were widely circulated at the time they were made and the scenes they depict were adapted to decorate many different sorts of wares (see cat. no. 1.3.a). Maiolica pieces were among those frequently painted with designs based on his popular subjects. Exhibited are a print attributed to Raimondi and a maiolica dish decorated with a scene adapted from it. The scene has been skilfully compressed and modified to suit the size and shape of the ceramic dish.

1.2.a Attributed to Marcantonio Raimondi (c.1480-c.1534)

Helen carried off by the Trojan warriors: in the left foreground, six Trojans in a boat, two of them struggling to pull Helen aboard; a Greek on shore endeavours to restrain Helen, gripping hold of her drapery; in the middle distance, troops from further ships advance to land, and are then engaged in combat; a large building occupies the background on the right.

Engraving. Cut to 29 x 42 cm
Dyce 1032

Literature: Bartsch no. 209, 1st state; H. Delaborde, *Marc-Antoine Raimondi,* Paris, 1888, pp.291-2; A. De Witt, *Marcantonio Raimondi incisioni,* Florence, 1968, p.10, the engraving by Marco Dente repr. pl.72.

The Department has another impression of the first state, Dyce 1033, and two impressions of the second state, Dyce 1034 and 1035.

Bartsch has no hesitation in attributing the engraving to the hand of Raimondi, although a later cataloguer of his work, Henri Delaborde, casts some doubt on the attribution on stylistic grounds. The subject of the engraving was thought to be after Raphael, and the 3rd state of the print bears the inscription *Rafael Vrbi. inuen.*, but no specific work by that artist has yet been identified as the source. Delaborde suggests that the name of Giulio Romano rather than Raphael as the author of the original. A copy of the print, which varies from it in detail, was engraved by Marco Dente da Ravenna (died 1527).

1.2.b Maiolica dish, painted by The Master of the Milan Marsyas, Urbino, c.1530.

Showing the Rape of Helen adapted from the print of the same subject attributed to Marcantonio Raimondi. From a tree is hung a shield of arms (Azure a griffin sergeant or) flanked by the initials G.F. On the boat is the name PAGANVCCI. On the back, yellow concentric circles.

Diameter 26.5 cm
Bequeathed by George Salting
Department of Ceramics, C.2232-1910

Literature: Burlington Fine Arts Club, *Catalogue of specimens of Hispano-Moresque and majolica pottery exhibited in 1887,* 1887, no.260; C.D.E. Fortnum, *Maiolica,* Oxford, 1897, pp.260, 267; B. Rackham, *Victoria and Albert Museum. Guide to Italian maiolica,* 1933, p.63; J.V.G. Mallet, *Xanto: i suoi compagni e seguaci* (in publication), a paper first read to the Seminar at Rovigo in 1980.

The image on the dish differs from the engraving in that the composition is compressed to show only the six Trojans in the boat trying to abduct Helen, and the two Greeks on shore, one holding Helen back and the other counter-attacking with drawn sword. The background is provided by a

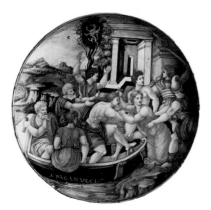

■ 1.2.b

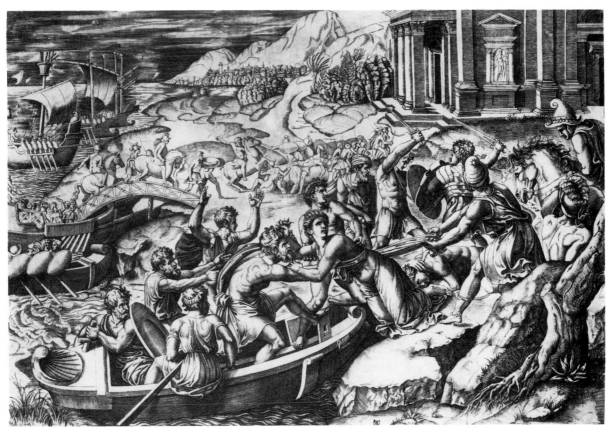

l.2.a

modified version of the landscape and large building depicted in the print.

The dish was formerly described by Bernard Rackham as having been painted by Francesco Xanto Avelli da Rovigo, but has since been re-attributed by John Mallet. The arms depicted are recorded for Fabri (Province of Speyer), to a member of which family the initials presumably relate.

MT

1.3

Limoges had long been celebrated for its enamel work and in the medieval period had produced fine examples in the champlevé process, (i.e. with the enamel held in hollows gouged out of the copper support). When the art was revived there in the late 15th century its achievements were to be, however, in the field of painted enamels. This group hints at the variety of the provenance of the sources used by Limoges enamellers during the 16th century and at the freedom with which they felt able to adapt the scenes and radically alter their scale.

1.3.a Marcantonio Raimondi (c.1480-c.1534)

The Virgin by the palm-tree. The Virgin seated with the Holy Child on her knee, with St Elizabeth and the Infant St John the Baptist, in a landscape with a palm-tree and a shed. After Raphael (Raffaello Sanzio) (1483-1520)

Engraving. 24.7 x 17.6 cm
Dyce 1021

Literature: Bartsch no.62.

The group of figures is a variation on the similar group in Raphael's 'Madonna of Divine Love' of c.1518 in the Museo Nazionale di Capodimonte, Naples. A palm-tree is used in the composition of his 'Holy Family with the palm-tree' of c.1505-07 in the Ellesmere Collection (now on loan to the National Gallery of Scotland, Edinburgh).

P. Kristeller, *Jahrbuch der Königlich Preussischen Kunstsammlungen*, 28, 1907, p.220, considered that Marcantonio's print represented a preliminary design for the Naples picture and H.P. Mitchell advanced the view that the design may have existed in another

otherwise unrecorded variant which is reflected in the enamel by the Master MP (cat. no. 1.3.b). It seems improbable, however, that the enameller would have had direct access to such a source.

1.3.b Plaquette in *grisaille* Limoges enamel from the Pénicaud Workshop attributed to the Master MP (worked mid-16th century). c.1540.

Showing the Virgin seated with the Holy Child on her knee, with St Elizabeth and the Infant St John the Baptist shown against an architectural background.

Impressed on the reverse twice with the stamp of the Pénicaud Workshop.
6.6 x 7.3 cm
Department of Ceramics, 4247-1857

Exhibited: Special Loan Exhibition of Enamels on Metal, 1874, no. 626, lent by the South Kensington Museum (now the Victoria and Albert Museum)

Literature: H.P. Mitchell, 'Two little masters of Limoges enamelling', *Burlington Magazine*, 1918, 32, pp.190–198.

The design source for the composition appears to have been the engraving by Marcantonio Raimondi, after Raphael, entitled 'The Virgin by the palm-tree'. However, it is not the complete source, for the landscape background, the shed and the palm-tree itself are omitted by the enameller in favour of an architectural setting. Although the composition of the group of figures in the foreground of the plaquette corresponds fairly closely to that of the group in the engraving there is a major compositional variation in the playful addition of the lamb shown clinging to the Baptist's back. This addition and the alteration of the background may indicate either a degree of eclecticism

on the part of the enameller (somewhat unusual in one who copied faithfully in another enamel Marcantonio's 'Martyrdom of St Lawrence') or another design source as yet unidentified.

1.3.c & d René Boyvin (c.1525-c.1580 or 1598)

Two plates from a series of twenty-six plates after designs by Léonard Thiry (c.1500-c.1550) entitled *Hystoria Iasonis Thessaliae Principis de Colchica velleris aurei expeditione ...*, published by Jean de Mauregard, Paris, 1563.

Each signed with the engraver's monogram *RB*.

Engravings. E.2020-1908
15.8 x 23.1 cm; 26595.b 16 x 23 cm

Plate 4: Phrixus, son of Athamas and cousin to Jason, greeted by King Aeetes on his arrival in Colchis after crossing the sea on the back of the Golden Ram; the ram is about to be sacrificed at an altar and its Golden Fleece removed.
E.2020-1908

Plate 17: Jason and Medea disembarking with the Argonauts on their return to Iolcus and being greeted by King Pelias, the uncle of Jason who originally commanded the Argonauts to secure the Golden Fleece.
26595.b

Literature: A.P.F. Robert-Dumesnil, *Le peintre-graveur français*, Paris, 1850, 8, nos.42 and 55.

These images were used as sources for the decoration on the exhibited casket.

It is possible that the engravings may have appeared singly before the collected editions of 1563 were published by J. de Mauregard. Besides the Latin edition there is another of the same year in which the plates are

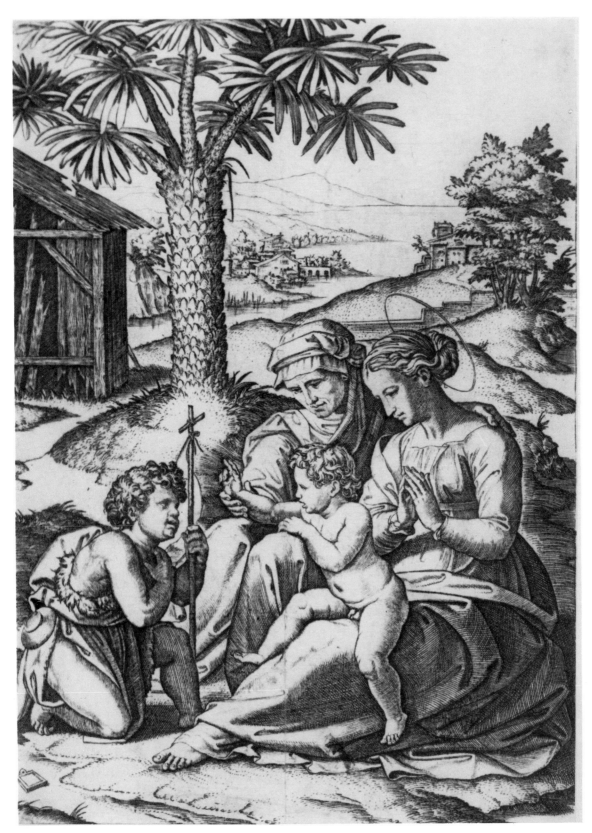

1.3.a

9

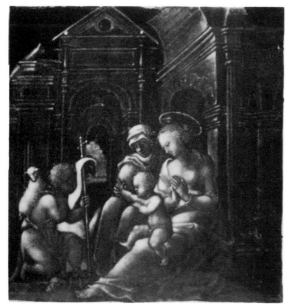

1.3.b

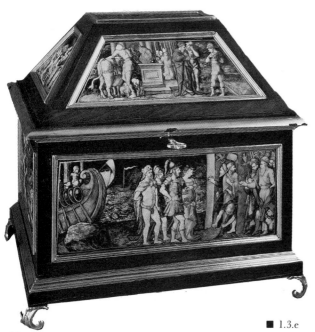

■ 1.3.e

numbered and bear verse captions in French printed in the lower margins from separate plates.

1.3.e Plaques, nine in Limoges enamel, forming a casket, by Léonard Limosin (c.1505-1575/77). c.1570. Eight with scenes from the Legend of the Golden Fleece after engravings by René Boyvin published 1563; all set in a modern wooden frame.

H. 30.8 cm; W. 23.8 cm; L. 33.3 cm
Department of Ceramics, 482-1873

Provenance: John Webb Collection

Exhibition: *Special loan exhibition of enamels on metal,* 1874, no. 564, lent by the South Kensington Museum.

The work of Léonard Limosin is characteristic of the fully-developed Renaissance style of Limoges painted enamels. Limosin was a leading exponent of that art and after his introduction to the court of François I in the 1530s he became part of the circle of artists which constituted the School of Fontainebleau. In this late example of his work we find Limosin using pictorial sources deriving entirely from that school. He takes his images (with some modifications dictated by the exigencies of the space available to him) direct from René Boyvin's engravings of 1563 (see cat. no. 1.3.c & d), after designs by Léonard Thiry made prior to 1550. He omits, however, the characteristic elaborate borders of strap-work and human figures derived from the painted and stuccoed decoration carried out for François I by Rosso Fiorentino in the great Gallery of the Palace of Fontainebleau constructed between 1533 and 1535.

The subjects chosen for this series of plaques are a partly sequential selection from the set of twenty-six subjects in the Fleece legend depicted

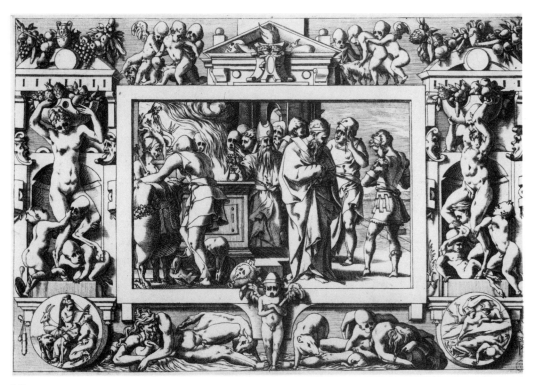

1.3.c

by Boyvin. The eight subjects shown
are: the Flight of Phrixus to Colchis on
the Golden Ram, with the death of
Helle (pl.3); the arrival of Phrixus in
Colchis (pl.4); Jason subduing the
bulls of Mars (pl.9); Jason seizing the
Golden Fleece (pl.13); Medea and
Jason embarking for flight (pl.14); the
murder by Medea of her brother
Absyrtos (pl.15); Jason, Medea and
the Argonauts disembarking at Iolcus
and being greeted by King Pelias
(pl.17); and the conjuration by Medea
of a chariot drawn by winged dragons
(pl.18).

HB

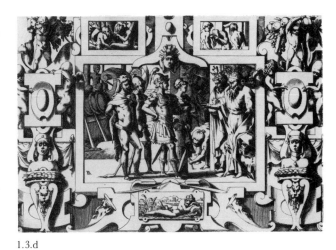

1.3.d

1.4.a

1.4.b

Cornelis Bos engraved designs of an ornamental and figurative nature of his own invention and reproduced the designs of others. At one stage he also acted as a print dealer and bookseller handling the abbreviated 1539 Flemish edition and the full 1542 German edition of Vitruvius. He was born and died in the Netherlands but his movements during his life are surrounded with controversy. It is likely that he visited Paris and Fontainebleau and certainly Rome, the latter probably more than once. This selection of his prints, shown with a spinet and a table, demonstrates how decorative motifs were disseminated throughout Europe through his engravings.

1.4.a Cornelis Bos (1506-1556)

Panel of grotesque ornament: in the centre, a mask crowned with leaves; on each side a bird resembling a crane with its head turned inwards. From a set of eight.

Signed and dated *CB 1548*.
Engraving. Cut to 4 x 5 cm
23090.23

Literature: Guilmard p.476, no.5; Berlin no.207.3; Schéle no.154.

This is a direct copy of a detail in the Vatican Loggia. It appears also at the top of an 18th century etching after Raphael's decorations (cat. no.1.9.b).

1.4.b Cornelis Bos (1506-1556)

Panel of grotesque ornament: a satyr seated in strapwork, holding in each hand a spray of foliage. From a set of eight.

Signed and dated *CB 1548*.
Engraving. Cut to 4.2 x 5.7 cm
23090.22

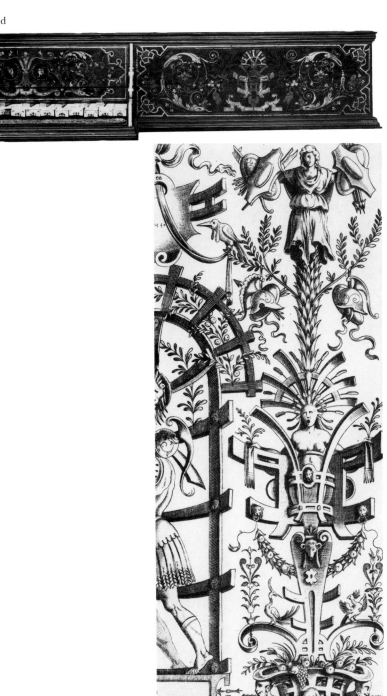

Literature: Guilmard p.476, no.5;
Berlin no.207.3; S. Schéle,
'Drottninggravarna i Uppsala
domkyrka', *Konsthistorisk Tidskrift*,
1958, pp.83-107, relevant section of
monument repr. p.98; Schéle no.253.

It has been established that Bos was in
Rome from 1548 to 1550 when he
made these engravings influenced by
the decorations of the Loggia at the
Vatican, partly on the grounds that
neither drawings nor prints of the
subjects were in circulation at that
date. The satyr seated in strapwork
appeared only a few years later, with
other designs based on engravings by
Bos, on a monument to the second
queen (died 1551) of Gustavus Vasa of
Sweden attributed to the school of the
Utrecht sculptor, Colyns de Nole.
Thus a design in paper form, inspired
by a painted Italian grotesque, had
travelled from one end of the
continent to the other to be translated
into stone.

1.4.c Cornelis Bos (1506-1556)

Panel of grotesque ornament: the right
part of a larger design; in the centre
half the figure of a helmeted warrior,
cut by the edge of the plate; on the
right, a woman with open mouth
fastened by straps to a cartouche.

Signed and dated *CB 1500*.
Engraving. Cut to 30.1 x 10.4 cm
27723.2

Literature: Guilmard p.476, no.5;
Berlin no.208.5; Schéle no.126.

The pattern of the cartouche to which
a woman is strapped is typical of the
decoration in the Gallery of François I
at Fontainebleau. The trellis to the
left, the helmeted warrior and the
trophies at the top have a Roman
flavour. Nevertheless the print as a
whole is of a kind to have had little

appeal for the Italian print market and is generally believed to have been made after Bos's final return home to the Netherlands in 1550.

1.4.d Spinet, Italian. 1568.

The case inscribed and dated *Marci Iadrae MDLXVIII*. The underside of the sound board inscribed and dated *A laude é gloría sia dela santíssíma trínita é dela gloríosa é sempre vergíne maria francísí brixiensis fecit 1569*.

Cypress wood with painted and gilt decoration. H. 17.5 cm; W. 47 cm; L. 148.5 cm.
Department of Furniture and Woodwork, 155-1869

R. Russell in his *Catalogue of musical instruments*, 1, no.4 gives a detailed study of the spinet, suggesting that Francesco of Brescia may have been its maker and Marco Jadra a dealer in such instruments. Its relevance here lies in its painted decoration which includes two figures similar to that of the woman strapped to a cartouche in the engraving by Bos (cat. no. 1.4.c). If this engraving was made in the Netherlands in 1550, the influence in this example has travelled in the reverse direction from that in cat. no. 1.4.b. An image conceived in the Netherlands is incorporated in painted decoration in Italy some eighteen years later.

1.4.e Cornelis Bos (1506-1556)

Panel of grotesque ornament: a fantastic car drawn backwards through the waves by satyrs; on the car a female nude is seated under a trellis, playing a lute, possibly Euterpe; above, nude figures playing a hurdy-gurdy and a trumpet. From a set of eight of which two are dated 1550.

Engraving. Cut to 15.6 x 26.1 cm
26467
Literature: cf. Guilmard p.476 no.5; Berlin no.208.2; Schéle no.118.

1.4.f Console table, French. Mid-18th century.
With waved outline and cabriole legs, decorated with a fantastic composition in Boulle marquetry of brass on tortoise-shell. Mounted in ormulu with masks and acanthus foliage.

H. 78.7 cm; L. 129.5 cm; D. 50.8 cm
Department of Furniture and Woodwork, 1021-1882

There is some doubt about the relationship between the top of this table and its base. *Connaissance des Arts,* 2, 1958, p.39 reproduces a table with a top with the same fantastic composition in reverse and with a base more in keeping with the piece's general style. The table is shown here because the decoration of its top, consisting of a fantastic car, incorporates details such as the figures playing the hurdy-gurdy and the trumpet from the exhibited engraving by Bos (cat. no. 1.4.e) and other motifs such as the bulls, the satyr beside them and the satyr at the front of the car from another engraving in this series of fantastic cars (pl.1.). Made two centuries after the prints, the table gives an indication of how long such prints remained current as sources of inspiration.

SL

1.4.e

Plate 1 Cornelis Bos (1506-1556). Panel of grotesque ornament; a fantastic car pulled by two bulls. Engraving from the same set as cat. no. 1.4.e

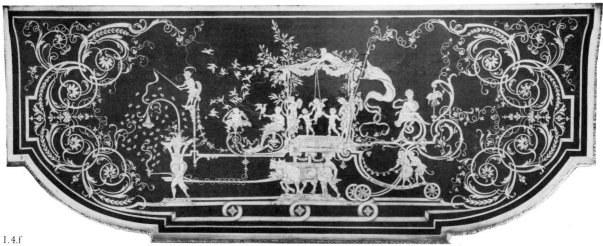

1.4.f

1.5

A mid-16th century volume of designs is shown with a contemporary replica of one of the drawings suggesting the importance attached to spreading designs beyond a single workshop.

1.5.a Filippo Orso (Orsoni) (active 1554)

Album containing 2 title-pages and 304 pages of designs for armour, weapons, sword hilts, horses' bits etc, bound in boards, the back missing.

Inscribed variously throughout.
E.1730 dated *1554*.
Pen and ink, or pen and ink and wash, with some yellow watercolour.
Size of pages 41.9 x 28 cm
E.1725-2031—1929

Literature: J. Mann, 'The lost armoury of the Gonzagas', *Archaeological Journal*, 1938, 95, pp.239–236; J.F. Hayward, 'Mannerist sword hilt designs' *Livruskammaren* (Journal of the Royal Armoury, Stockholm), 1959, 8, pp.79–109; P. Ward-Jackson, *Italian drawings*, Victoria and Albert Museum, 1979, 1, no.212; D. Chambers and J. Martineau ed., *Splendours of the Gonzaga*, exhibition catalogue, V&A Museum, 1981, no.72.

The volume is open showing a sword hilt in gold and silver, E.1798–1929.

Very little is known about Orso. The first title-page of the volume implies that he was a painter not an armourer but similarities have been noticed between his designs and those believed to have been carried out by the Mantuan court armourer, Caremelo Modrone.

The interest of the volume in this context is the evidence that suggests that Orso intended to have the designs engraved to provide patterns for circulation but, unable to afford the engraver's fee, was reproducing them by copying by hand. The style and lay-out of the two title-pages with their bandwork cartouche and escutcheons are similar to engraved title-pages of the period. Two other copies of the album are known: one is in a private collection in Co. Limerick with 150 drawings of horse caparisons and bits, with few exceptions, the same as in this volume and another, even more similar, is in the Library at Wolfenbüttel. Some of the drawings are inscribed with descriptions of the function of the objects shown and others with comments on the merits of their design. While some of the designs show an impractical degree of fantasy, others might well have been made for use.

1.5.b Filippo Orso (Orsoni) (active 1554)

Design for a sword hilt.

Pen and ink, with brown and yellow wash. 22.2 x 22.2 cm
1088

Literature: P. Ward-Jackson, *Italian drawings*, Victoria and Albert Museum, 1979, 1, no.213.

The existence of this drawing adds further weight to the argument that Orso was reproducing his designs by hand.

It was acquired as an example for students at the School of Design and became part of the Museum's collection in 1864 (see Section 4).

SL

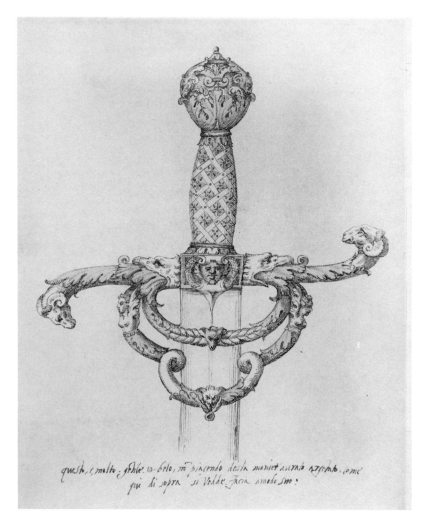

*questo, e molto gentile, e bello, me piacendo de la manica ausata argento, come
piu di sopra si vedde faccia amodo suo:*

From 1.5.a

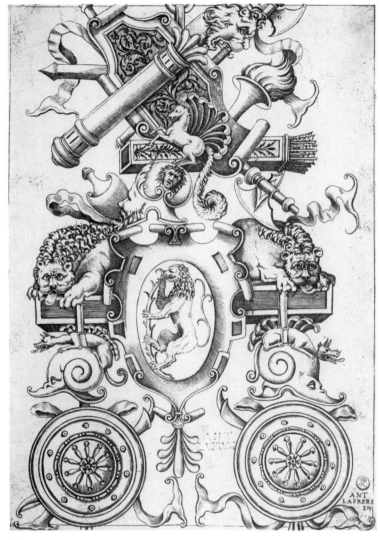

1.6.a

Early 16th century Roman prints showing vases, trophies and other Roman antiquities were almost the first of their kind. Although crude and often inaccurate to the point of being fanciful, they were to play a substantial part as models until and after the onset of neo-classicism. The prints shown here, all Roman and showing the same trophy, cover a span of 220 years. They give some idea of the great numbers in which such prints were reissued and copied.

1.6.a Anonymous, after Enea Vico (1523-1567)

A trophy. pl. 10 from a set of 16 published by Antonio Lafreri. 1553.

Lettered *Ant Lafreri* twice, once erased. Numbered *10*.
Engraving. 22.9 x 16.4 cm
20302.10

Literature: Bartsch no. 443.

1.6.b Anonymous, after Enea Vico (1523-1567)

A trophy. The plate as cat. no. 1.6.a, but re-issued by Petrus de Nobilibus, 1586.

Lettered and numbered as cat. no. a, but additionally *Petri de Nobilibus Formis*.
Engraving. 22.9 x 16.4 cm
29522.A.6

1.6.c Anonymous, after Enea Vico (1523-1567)

A trophy. A contemporary reversed copy of cat. no. 1.6.a, first issued by Antonio Salamanca (c.1500-1562), which was subsequently reissued by Horatius Pacificus and (this print) by Giovanni Battista de Rossi.

Lettered *Giob. de Rossi in P. Navona
Horatius Pacificus Formis Ant. Sal. Exc.*
Numbered *1*.
Engraving. 23.1 x 15.2 cm
20303.2

1.6.d Anonymous, after Enea Vico (1523-1567)

A trophy. A re-issue of cat. no. 1.6.c, as the first page of Carlo Losi's edition of the set, 1773.

Lettered *Presso Carlo Losi in Rom. 1773. Ant. Sal. Exc.* Numbered *1*.
Engraving. 23.1 x 15.2 cm
24496.1

1.6.e Anonymous, 16th century (?) after Enea Vico (1523-1567)

A trophy. A reversed copy of cat. no. 1.6.c.

Engraving. 22.3 x 15.5 cm
E.389-1911

The Museum's collection of examples of Vico's trophies represents 14 sets, including reissues, and consists of 3 sets of the original plates, 4 sets of true copies and 7 sets of reversed copies. These include 2 sets of French prints. Reversed copies are easier to produce as they remove the need to engrave the image in reverse. The true copy shown here (cat. no. 1.6.e) is a reversed copy of a reversed copy.

It may be wondered how such crude prints could find a market as late as 1773, 28 years after Piranesi had begun producing his great series of etchings of Roman antiquities. Their publication presumably represents a typical example of the opportunism of print publishers at a period when any Classical image had a sale.

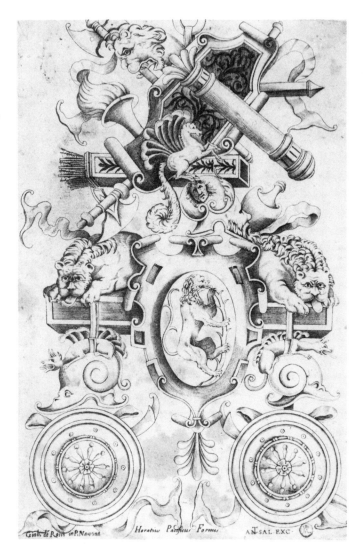

1.6.c

Carlo Losi had not only the copper plates for the original set but also those of Salamanca's reversed copies. His enlarged set of 25 plates was made up from both sets and of course included eight duplicates; whether his purchasers noticed is not recorded.

MS

19

1.7

This group shows a mid-18th century volume of designs 'Calculated to Improve the present Taste' with a textile firm's slightly later pattern book showing the influence of such publications and a textile produced by the firm including elements from the pattern book and from the volume of designs.

1.7.a Matthew Darly (worked c.1750-1778)

A New Book of Chinese Designs Calculated to Improve the present Taste, consisting of Figures, Buildings, & Furniture, Landskips, Birds, Beasts, Flow [sic]rs and Ornaments, &c. By Messrs Edwards And Darly. Published according to Act of Parliament, & Sold by the Authors, the first House on the right hand in Northumberland Court, in the Strand, & by the Print & Booksellers in Town & Country. MDCCLIV. Full bound in leather, gold tooled, lettered on the spine *Chinese Designs.*

Lettered on the title-page with title etc. and *J. Champion Scr. Edwards & Darly sculp.* With index to plates. Lettered on the plates *Edwards & Darly Invt. Sculp. According to Act 1754* etc.
Engravings. Size of volume 27.8 x 22.5 cm
E.6502-6617—1905

The book is open at Plate 22 which is likely to have formed the basis for the similar group of a man and two children in the 'Pagoda' cotton (cat. no. 1.7.c).

Matthew Darly was a manufacturer of paper-hangings, an engraver and designer, who engraved many of the plates in Chippendale's *Director*, and also published ornamental borders for 'print rooms'. In 1754, the same year

as the publication of *A new book of Chinese designs*, he drew and engraved microscopic slide magnifications, which appeared as a plate in the *Gentleman's Magazine* (see cat. no. 1.11.a). He was in addition a well known caricaturist. He specialized in paper-hangings in the 'chinese taste'. This volume, and other works including J.A. Fraisse's *Le livre de dessins Chinoises ...* (1735), Sir William Chambers' *Designs for Chinese buildings, furniture, dresses, etc* (1757), and Paul Decker's *Chinese architecture civil and ornamental* (1759) were among the sources of pattern in the oriental style widely adapted to architecture, furniture, textiles and wallpaper during the 18th century.

1.7.b Foster & Co., Bromley Hall

Volume containing impressions (233 pieces) pasted in, of 144 copperplate designs for printing on textiles, some of the impressions being large sheets cut into two parts and pasted on facing pages. The designs are in two groups, the first mainly of flowers and foliage (120) from a series numbered by the manufacturer P.1 to P.185; the second (24) with figures, birds and animals amid floral decoration, is unnumbered but inscribed in ink with brief titles. Pasted inside the front cover is a sheet of paper watermarked 1801, inscribed in ink with an incomplete list of pattern numbers and titles of designs. Full bound in calf, with two bronze clasps. English, c.1760-1800.

Inscribed in ink throughout the volume with numbers, titles, notes etc. Lettered on labels on the front and back covers *Foster's Bromley.*
Engravings. Size of volume 55.9 x 35.6 cm
Given by the Calico Printers' Association Ltd
E.458 (1-223) — 1955

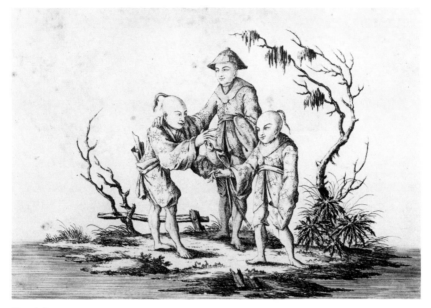

From 1.7.a

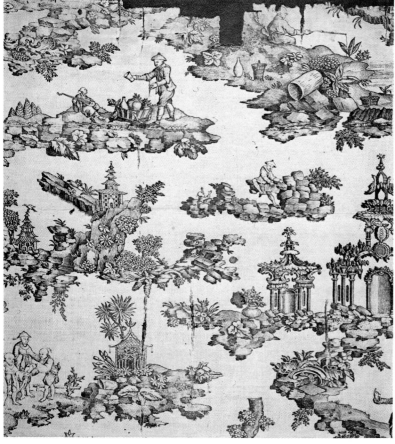

Literature: *Loan exhibition of English chintz,* Victoria and Albert Museum, 1960, p.22.

The volume, which constitutes the pattern-book of Foster & Co., is open at two plates (E.458.182, 183) which show three elements in the design of the 'Pagoda' cotton (cat. no. 1.7.c): a pavilion, a tree trunk under which is a fisherman, and a merchant conversing with a musician.

The Bromley Hall factory on the right bank of the River Lea in Poplar, Middlesex, was probably the largest of the early print works. It is first mentioned in the 1740s and was operated successively by members of the Ollive family (dyers and calico printers since the late 17th century), Joseph Talwin, and the Foster family, under the name of Ollive and Talwin (1763-1783), Talwin and Foster (1785-1790) and Foster and Co (1790-1823). The Ollives, Talwins and Fosters were all Quakers and probably interrelated.

1.7.c Plate-printed cotton entitled 'Pagoda'. Printed at Bromley Hall, c.1774-1780.

78.8 x 71.1 cm
Given by Mrs Cora Ginsburg
Department of Textiles and Dress
T.233-1870

Literature: F.M. Montgomery, *Printed textiles English and American cottons and linens 1700-1850,* New York, 1970, repr. p.266; *Loan exhibition of English chintz,* Victoria and Albert Museum, 1960, no.90; B. Morris, 'English printed textiles, pt. 2: copperplate', *Antiques,* 1957, 71, pp.360-363.

Other pieces of 'Pagoda' are in the Boston Museum of Fine Arts, Musée de L'Impression sur Etoffes,

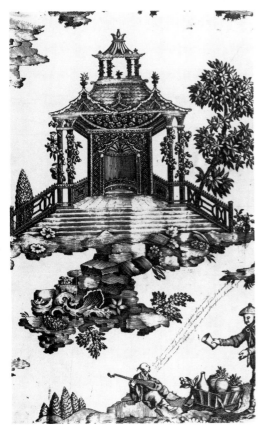

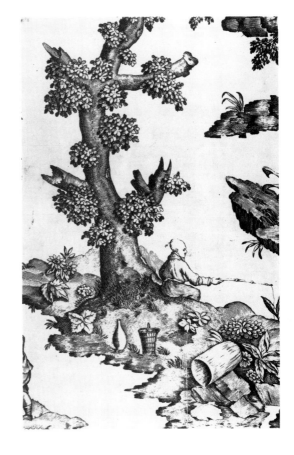

From 1.7.b

Mulhouse, and Henry Francis Du
Pont Winterthur Museum, U.S.A.

Three elements of the design are
shown in the plates from the Bromley
Hall Pattern Book (cat. no. 1.6.b) and
a third derived from plate 22 of
Darly's and Edwards' *A new book of
Chinese designs* (cat. no. 1.7.a). The
remaining sections of the design are
rather less closely related to the plates
in the book, but the figure of the
merchant appears in plate 29, the
fisherman in plate 45, and the temple
on a rock in plate 94.

JH

1.8

Pattern books, defined as collections of engraved designs for particular or general application, have existed since the 16th century. The development towards the more modern type of illustrated trade catalogue, also called a pattern book, can be seen in Thomas Chippendale's 'The gentleman and cabinet-maker's director' first published in 1754, which was both a source of designs for others and an advertisement for the author's cabinet-making business. The true illustrated trade catalogue does not seem to have emerged until the 1770s and was particularly associated with the west-Midlands metal trades and the fused-plate (Sheffield plate) manufacturers of Sheffield. The frequent foreign inscriptions on surviving examples seem to show that they were often intended to promote sales abroad: one such 18th century catalogue in the Museum was purchased in 1858 in a market in Turin. Precautions, such as the removal of the title-page, were taken by middle-men to protect their source of supply but nothing could be done to prevent the designs being imitated. Here, two versions of a trade catalogue are shown with a candlestick, close in design to the one illustrated, made by one of the firm's competitors.

1.8.a Anonymous, for Matthew Boulton (1728-1809)

Pattern book of designs for silver and Sheffield plate. 25 whole plates and 121 plates pasted onto 18 leaves. In a late-19th century buckram binding. c.1785.

Some plates lettered *Square Foot* etc. The images numbered in ink from *101* to *348* in an incomplete sequence. Some inscribed in ink with notes. Engravings. Size of volume

22.5 x 35.5 cm
Given by John Wateridge
E.2060-1952

The famous Birmingham manufacturer Matthew Boulton began his marketing experience in 1759 in the 'toy' trade of buttons, chains and other trinkets, in which he built up a network of correspondents 'in almost every mercantile town in Europe' and maintained a number of travelling agents. Although working outside Sheffield he was from the mid-1760s onwards the largest single manufacturer of Sheffield plate. He is known to have produced two engraved catalogues for silver or plate. The first, made in the 1770s, contained small images well adapted to being cut up and sent individually to correspondents rather like the small drawings which were sent to special customers. At a later date, perhaps in the 1780s, he published another catalogue probably for plate alone, containing full-size images like the ones produced by his Sheffield competitors. It is probably this one which was described in 1803 as the 'Book of Engravings ... of plated wares such as he generally sends abroad for Correspondents to order from'. This example is a later amalgamation of the two catalogues. That its donor, John Wateridge (cat. no. 4.6), was a designer in metal who acquired the volume in 1910 indicates how long such patterns remained useful sources of design.

1.8.b Anonymous, for Matthew Boulton (1728-1809)

Volume of designs for silver and Sheffield Plate, made up from a pattern book. 29 plates pasted onto 29 leaves in a modern paper and vellum binding bearing two labels, one inscribed 'Argenterie Anglaise'. c.1785.

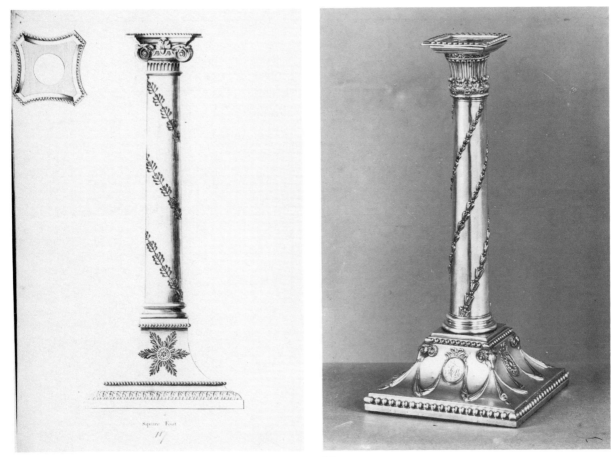

From 1.8.a

1.8.c

Most lettered with titles and inscribed in ink with serial numbers from *5288* to *5944* in an incomplete sequence.

Engravings, cut. Size of volume 25.6 x 38 cm
E.1224-1252—1979

A recent rebinding of the second catalogue described above.

1.8.c Candlestick, English. c.1780

Sheffield plate. 28.7 x 12.7 cm
Department of Metalwork, M.110A-1912

Although not by Boulton, the candlestick demonstrates the close similarity between many of Boulton's products and those of his competitors.

MS

25

1.9

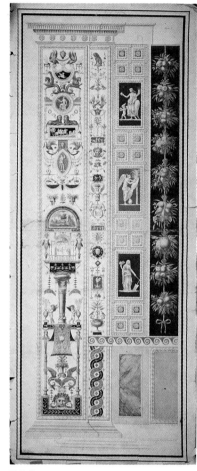

Wall paintings cannot easily be transported, yet the Pompeian-type wall decorations were central to the Western decorative repertoire. This group shows how the style was transmitted through works on paper, each period producing versions transformed by current opinion and, therefore, subtly different from the original and in keeping with their own time.

1.9.a Angelo Campanella (1746-1811) and Pietro Vitali (1755-1810) after drawings by Anton Raphael Mengs (1728-1779) and Anton von Maron (1733-1808)

Plates (2) from a set of 11 entitled *Die Antiken Wand- und Deckengemälde des Landhauses Negroni, welche Villa zwischen dem Weinhügel und dem Esquilinium im Jahre 1777 entdeckt und ausgegraben wurde ...*, Rome, 1778-1793.

Etchings, coloured by hand. Each cut, E.526 48.5 x 60.5 cm; E.520 50.4 x 63.5 cm
E.520, 526—1890

These plates reproduce frescoes at the Villa Negroni, Rome, unearthed in 1777. They show decorations similar, although less dotted with whimsical features than some, to the kind that inspired Raphael (see cat. no. 1.9.b) and other artists early in the 16th century.

As fervour surrounding such archaeological digging increased with the beginning of the excavation of Pompeii and Herculaneum in 1748, such sumptuous publications recording the findings were issued in several languages. The forms they depicted were by no means always accurate but they had an enormous influence on contemporary design. The volumes, however, were intended as much for the connoisseur. That this

was particularly so in the case of the exhibited prints is shown by comparing them with uncoloured versions. An editing has taken place during the hand-colouring, with the result that the subjects are considerably falsified by the veiling of all genitalia beneath skilfully painted draperies executed in body-colour.

1.9.b Giovanni Ottaviani (1735-1808) after drawings by G. Savorelli and P. Camporesi, after Raphael (Raffaello Sanzio) (1483-1520)

Pl.1 from the set entitled *Loggie di Rafaele nel Vaticano*, Rome, 1772-77.

Lettered *Cai. Savorelli Pict., et Pet. Camporesi Arch. delin. Joann. Ottaviani sculp. cum privilegio SS. D.N. Clementis XIII* and with a scale. Numbered *Num.1.*
Etching, coloured by hand. Cut to 107.5 x 40.5 cm
E.335-1887

The excavation of private dwellings around Rome at the end of the 15th century delighted scholars and artists alike. The light fanciful nature of the decorations consisting of an abundance of decorative motifs arranged symmetrically and in compartments but otherwise with little relation to one another (see cat. no. 1.9.a) surprised a generation who knew only of the monumental public style of Roman architecture.
A number of artists were inspired by the decorations but Raphael was the first to transform them into a system of decoration which has become known as the 'grotesque', the term stemming from the style's below-ground, grotto-like source.

Raphael's work in this style 'set out to create ... [an] interior which should accurately reflect all that the most

■ 1.9.a

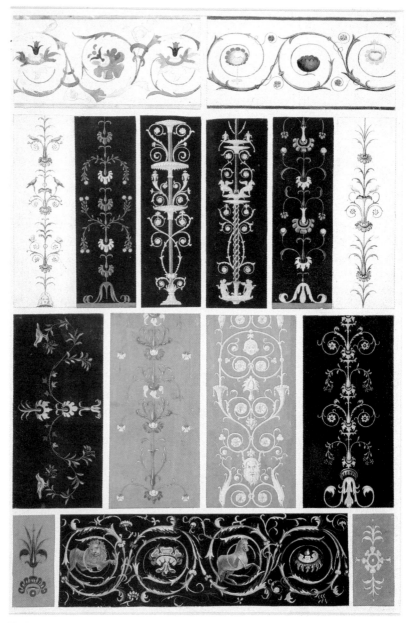

■1.9. c

recent discoveries had taught him and his contemporaries about Roman decorative art as applied to private apartments, and he came so close to success that for the next three hundred years his Loggia was studied by architects and decorators as reverently as the ancient ruins themselves. Even in the archaeological revival during the second half of the eighteenth century, the works of architects like Robert Adam proclaimed that they had learnt as much from Raphael as from Fabullus, the decorator of Nero's Golden Palace'.[4]

Artists and designers of every kind studied Raphael's Loggia when they visited Rome and prints of details were in circulation. The engraving (cat. no. 1.4.b) by the Flemish artist, Cornelis Bos, shows a small 16th century example. This 18th century series was, however, among the first to show the Loggia so extensively with overall views and scaled details. The lavishness of the publication shows Raphael's decorations being presented in a way indistinguishable from the Roman murals that were their prototype. The overworked faded appearance of the etched line under the hand colouring of this example is an indication of the large number of impressions printed and published.

[4] P. Ward-Jackson, *Some main streams and tributaries in European ornament*, Victoria and Albert Museum Bulletin Reprints 3, 1969, p.9; see also N. Dacos, *Le découverte de la Domus Aurea et la formation des grotesques à la Renaissance*, 1969

1.9.c Charles Aubert or Albert Henry Warren (1830-1911) or Mr Stubbs, students of Owen Jones (1809-1874)

Drawings (15 affixed to one sheet, arranged for publication) for pl.24 'Pompeian No.2' for Owen Jones, *The grammar of ornament*, London, 1856.

Watercolour and gouache. Overall size 44.5 x 29 cm
1597
The grammar of ornament consists of 100 lithographic plates, produced by Day and Son, illustrating twenty chapters which discuss ornament produced by various cultures and epochs, while the final chapter looks at 'Leaves and flowers from nature'. In the introduction Owen Jones states that his aim was to establish:

'First. That whenever any style of ornament commands universal admiration, it will always be found to be in accordance with the laws which regulate the distribution of form in nature.
Secondly. That however varied the manifestations in accordance with these laws, the leading ideas on which they are based are few.
Thirdly. That the modifications and developments which have taken place from one style to another have been caused by a sudden throwing off of some fixed trammel, which set thought free for a time, till the new idea, like the old, became again fixed, to give birth in its turn to fresh inventions.
Lastly. I have endeavoured to show ... that the future progress of Ornamental Art may be best secured by engrafting on the experience of the past the knowledge we may obtain by a return to Nature for fresh inspiration. To attempt to build up theories of art, or to form a style independently of the past would be an act of extreme folly. It would be at once to reject the experiences and accumulated knowledge of thousands of years. On the contrary, we should regard as our inheritance all the successful labours of the past, not blindly following them, but employing them simply as guides to find the true path.'

Of this particular Pompeian plate he wrote: 'The ornaments for the pilasters and friezes ... after the Roman type, are shaded to give rotundity, but not sufficiently so to detach them from the ground. In this the Pompeian artists showed a

judgment in not exceeding that limit of the treatment of the ornament in the round, altogether lost sight of in subsequent times. We have the acanthus-leaf scroll forming the ground work, on which are engrafted representations of leaves and flowers interlaced with animals, precisely similar to the remains found in the Roman baths, and which, in the time of Raphael became the foundation of Italian ornament.'

Jones's comments have the same flavour as those in *The catalogue of the Museum of Ornamental Art, at Marlborough House* (see cat. no. 4.1) and so it is no surprise to find that he was among those who made the selection of objects from the Great Exhibition of 1851 which formed the foundation of the Victoria and Albert Museum's collections.

SL

The focal point for this group is William Morris's design of 1874 for a wallpaper entitled 'Willow'. One of his sources of inspiration for this pattern may well have been a book illustration of the osier or water willow in Gerard's Herball, *of which a 1633 edition is shown. Morris obviously studied with delight the delicate tracery of willow, and it appears not only in his design of that name, but also, for example, in his 'Tulip and Willow' chintz of 1873, and as a background to his 'Powdered' wallpaper of 1874. His designs themselves became source material, and a printed cotton entitled 'Willow', 'Scroll' or 'Little Scroll' was produced by his own firm Morris & Co in c.1895, although not under his direct guidance: its alternative titles are clues that its true derivation was not the main 'Willow' paper, but the background of the 'Powdered' paper. The last item in the group, a wallpaper produced by Osborne & Little in c.1975, was adapted from the above-mentioned printed cotton, but possibly also influenced by the original 'Willow' paper. Although based on a Victorian design, it is essentially modern in idiom.*

1.10.a John Gerard, *The Herball; or Generall Historie of Plantes. Gathered by John Gerard* [etc]. Very much enlarged and amended by Thomas Johnson. Engraved title-plate by J. Payne and cuts. Published London, by A. Islip, J. Norton and R. Whitakers. 1633.

Folio 35 x 23 cm
National Art Library, 26.ix.1854

Literature: W. Blunt, *The art of botanical illustration*, 1950, p.72; V. Kaden, *The illustration of plants and Gardens 1500-1850*, 1982, p.4.

30

Open at page 1389 to show the illustration entitled 'The Oziar or Water Willow'.

The first edition of Gerard's *Herball* was published in 1597 and contained only 16 original wood-cut illustrations, the remainder deriving from other earlier works; it was not uncommon for the same blocks to pass from one printer to another for use in various publications. Johnson's scholarly edition of 1633 was illustrated by 2677 cuts from blocks held by the printer Christophe Plantin of Antwerp.

In his patterns adapted from nature, William Morris drew not only upon his powers of direct observation, but also upon sources of plant imagery provided by 16th and 17th century herbals, which helped to clarify his perception of shape and form. Gerard's *Herball* was a boyhood favourite, and his own copy of the 1633 edition is now housed at the William Morris Gallery, Walthamstow (museum number K.776). His daughter, May Morris, remarked that 'The pupil never forgot his [W.M's] insistence on observing closely all detail of serrated edge and variation of line and attachments to stem, etc, nor the interest his talk on flowers and looking through old Gerarde with him, gave to such study'. (May Morris, *William Morris artist writer socialist*, Oxford, 1936, I, p.36).

1.10.b Wallpaper, entitled 'Willow', designed by William Morris (1834-1896). 1874.

Inscribed on the back in ink *Willow 70* and *5/-*.
Colour wood-block, printed in green. 68.4 x 49.4 cm
Given by Morris & Co.
E.493-1919

Literature: P. Floud, 'Dating Morris patterns', *Architectural Review*, July 1959, pp.15-20; P. Floud, 'The wallpaper designs of William Morris', *Penrose's Annual*, 1960, 54, pp.41-5; F. Clark, *William Morris wallpapers and chintzes*, 1974; C.C. Oman and J. Hamilton, *Wallpapers a history and illustrated catalogue of the collection in the Victoria and Albert Museum*, 1982, no.1065.

This design and that described in cat.no.1.10.c are from volume 1 of two wallpaper pattern books containing original printed samples (25 and 27 on 168 sheets, including different colour-ways) collected together by William Morris. The numbers inscribed after the titles of the patterns are taken from Morris & Co.'s log books.

'Willow' is characteristic of the group of nine wallpapers which Morris designed during the period 1872-1876, exhibiting an apparently spontaneous naturalism in which the intricate curves and interlacings of the foliage

■ 1.10.b

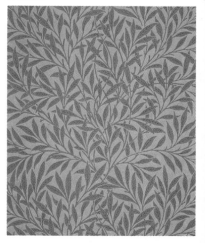

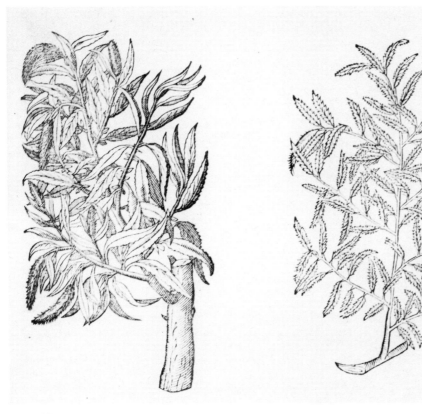

From 1.10.a

31

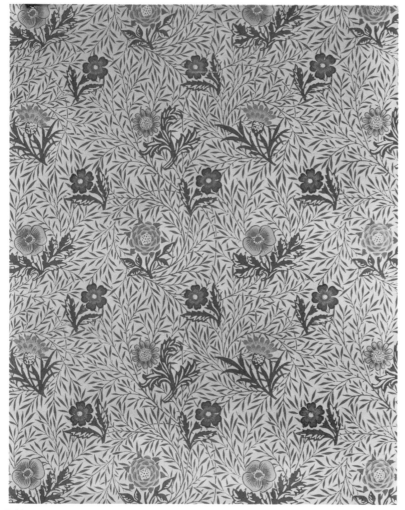

1.10.c

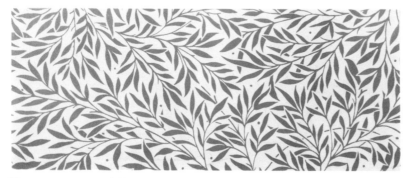

mirror the conformations of natural growth. This disguises the skill with which Morris imposes on the design a complex repeating pattern, as he seeks 'to mask the construction of our patterns enough to prevent people from counting repeats, while we lull their curiosity to trace it out'. (W. M., *Some hints on pattern-designing*, 1881).

1.10.c Wallpaper, entitled 'Powdered', designed by William Morris (1834-1896). 1874.

Inscribed in ink on the back *Powdered 234* and *6/-*.
Colour wood-block. 68 x 53.2 cm
Given by Morris & Co
E.487-1919

Literature: As for cat.no.1.10.b.

The background of this paper is provided by a pattern of intertwining willow similar to the main design in the paper of that title, although on a reduced scale. A certain naïveté in the delineation and placing of the flower motifs makes the repeat more obvious in this instance.

1.10.d Printed cotton fabric entitled 'Scroll', 'Little Scroll' or 'Willow'. Printed by Morris & Co, Merton Abbey. c.1895.

Block-print in red on white. 59.7 x 96.5 cm
Given by Mrs Gubbins
Department of Textiles, T.209-1953

Literature: L. Parry, *William Morris Textiles*, 1983, no. 85.

The design on this fabric is adapted from the background pattern of 'Powdered' wallpaper designed by Morris in 1874. An original block is in the William Morris Gallery, Walthamstow. This example is a surface print from such a block, but

1.10.e

the main print run, Pattern No.9419, was indigo discharged i.e. printed by a dyeing method in which the pattern was bleached out of an indigo-dyed background.

The design differs from Morris's 'Willow' paper of 1874 (and the woven textile after it), although there are obvious similarities between 'Willow' and the leafy-patterned background of the 'Powdered' paper.

1.10.e Wallpaper produced by Osborne & Little Ltd for Liberty & Co, c.1975. Adapted from the printed cotton fabric entitled 'Scroll', 'Little Scroll' or 'Willow' printed by Morris & Co. c.1895.

Screenprint in green. 17.5 x 36 cm
E.180-1978

Literature: 'Brothers-in-law-in-wallpapers Peter Osborne & Anthony Little', *House and Garden*, Dec 1972/Jan 1973, p.62; C.C. Oman and J. Hamilton, *op.cit.*, no.534.

The wallpaper was also produced in another four colourways. It was issued to coincide with the exhibition *Liberty's 1875-1975*, held at the Victoria and Albert Museum, July – October 1975.

Peter Osborne and Anthony Little, who set up their wallpaper firm in 1968, have, from 1973 onwards, included adaptations of High and Late Victorian patterns among their ranges of original designs. The *fons et origo* of their 'Victorian' repertoire has frequently been the study of items in the collections of the V & A Museum, in this case T.209-1953 in the Department of Textiles, with possible reference also to the 'Willow' wallpapers E.488-493-1919 in the Department of Prints, Drawings & Photographs.

1.10.d

1.11

From 1.11.c

This group provides examples of designers finding inspiration outside fields normally associated with them, in this case in scientific research.

1.11.a Matthew Darly (worked c.1750-1778)

Illustration to 'Microscopical objects; with Remarks' in *The Gentleman's Magazine and Historical Chronicle*, vol.24, London, 1774.

Etching. 19 x 25 cm
National Art Library

It seems probable that the Greeks and Romans cut their designs on gems with the use of magnifying glasses, but the first real evidence of the use of a magnifying glass is shown in the engravings of Georg Höfnagel's miniatures of 'all animated nature', made for the Emperor Rudolf II in the 1590s. In 1665 Robert Hooke published *Micrographia*, in which he described the point of a needle under the microscope as being 'not round, nor flat, but irregular and uneven' and stated that 'in the works of Nature, the deepest Discoveries show us the Greatest Excellencies'. The optics of his compound microscope remained the basic optical system for English microscopes for one hundred years.

Illustrations like the one exhibited appeared occasionally in such publications of general interest and made the reading public of the 18th century familiar with a new world of form and pattern in nature. Its engraver, Darly, also issued ornamental designs 'to improve design in the decorative arts' (see cat. no.1.7.a).

1.11.b Anonymous, English

Hand bill advertising an exhibition of objects under the microscope, held by Philip Carpenter, optician, 24 Regent Street, London, 1827.

Etching. 27.6 x 20 cm
Lent by the Science Museum, 1934-124

Microscopes had long been in common use by the beginning of the 19th century, and during the second quarter of the century several exhibitions were held in show rooms in London, advertising in superlative terms the wonders of nature to be seen with a new variety of instruments produced by the opticians. In 1827 P. Carpenter, Optician, held an exhibition at 24 Regent Street in which twelve microscopes were at the service of the visitor to operate himself. The objects under view were exotic insects, mites and aquatic animalcula but the exhibition received a glowing 'write up' in such unscientific publications as the *Theatre Observer* for 11 August 1827.

Carpenter was also originally the sole maker of the kaleidoscope, invented by Sir David Brewster in 1818. With its fragments of coloured glass, the kaleidoscope produced abstract symmetric patterns analogous to the geometric structures of crystals revealed by the microscope.

The magnification of both living and inanimate objects could have provided a new dimension to the pattern and design of the visible world of nature, and a new field was opened up, not only to the general public as a source of entertainment, but also, it seems probable, to the professional designer for whom it provided fresh inspiration.

1.11.c Anonymous, English

Volume containing designs (1161) for textiles: floral and small abstract

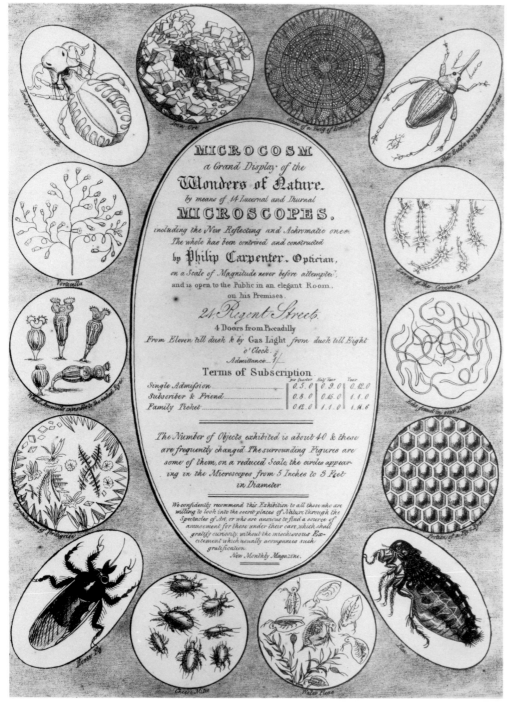

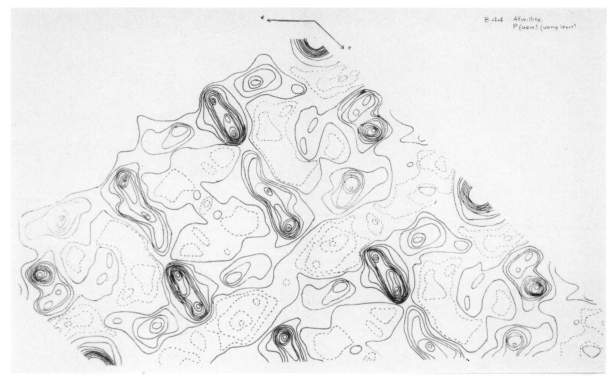

8.44 Afwillite.
P (uvw) (using levor)

1.11.d

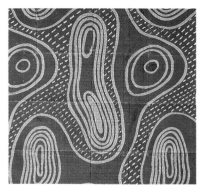

■ 1.11.e

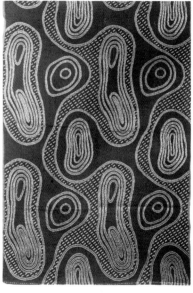

1.11.f

patterns. English, late 18th century to mid-19th century.

Pen and ink, watercolour, gouache, wood block, etc, on various papers.
In volume 40 x 28 cm
8899A

The volume is open showing, among others, an early 19th century design with a vermiform pattern (8899A.468), possibly inspired by a slide magnification of paste worms such as that shown as fig. 7 in Darly's etching (cat. no. 1.11.a) and to the right of the handbill for Philip Carpenter's exhibition (cat. no. 1.11.b).

The patterns and 556 fabric samples were purchased by the Museum in 1882. Nothing is known of their provenance. The patterns include others which are similar to magnified structures but they are as likely to have evolved as a result of the kind of patterning machines in use as through any consciousness of scientific research.

JH

1.11.d Dr. Helen Megaw (born 1907)

Diagram of the crystal structure of afwillite, showing by contours the interatomic distances in the structure.

Inscribed *8.44 Afwillite P (uow) (using lever).*
Dye-line. 27.4 x 45.3 cm
The Festival of Britain archive in the Contemporary Archive of the National Art Library

Literature: H. Megaw, 'The investigation of crystal structure', *Architectural Review,* 1951, 109, pp.236-9.

At the end of the 1940s, a new source of inspiration for decorative patterning was provided by studies in X-ray crystallography. The theory that every crystal structure was composed of a regular repetition of identical units had already been surmised by 17th and 18th century scientists such as Robert Hooke (Newton's contemporary) and René Just Haüy. This was confirmed when X-rays were first applied to the study of crystals by von Laue in Germany in 1912, and then in England by W.H. and W.L. Bagge. Scientists were now able to explore in detail the particular arrangement of atoms within various forms of matter. It was the diagrams in which they charted and recorded the infinitely varied patterns of nature that prompted one crystallographer, Dr Helen Megaw of Girton College, Cambridge, to perceive that such diagrams could be used as a basis for textile design.

The idea was taken up and developed by Mark Hartland Thomas who, as head of the Council of Industrial Design's Industrial Division, was given the main responsibility both for selecting exhibits for the Festival of Britain in 1951, and for stimulating fresh design ideas within the exhibiting industries. He wrote at the time that 'these crystal structure diagrams had the discipline of exact repetitive symmetry: they were above all very pretty and were full of rich variety yet with a remarkable family likeness; they were essentially modern because the technique that constructed them was quite recent, and yet like all successful decoration of the past, they derived from nature – although it was nature at a submicroscopic level not previously revealed'. He set up a Festival Pattern Group, to which Dr Megaw was appointed scientific advisor, and commissioned chosen manufacturers from a range of industries, including

textiles, cutlery, ceramics, plastics, paper and glass to produce a range of designs based on the crystal structure of matter as varied as haemoglobin, nylon, afwillite, sugar and china clay.

1.11.e Marianne Straub (born 1909)

Full-size working drawing for a furnishing fabric entitled 'Surrey', manufactured by Warner & Sons Ltd., 1951.

Inscribed in pencil on the back *8.44*. Body-colour, squared in pencil for transfer. 89 x 100.4 cm
E.567-1980

The design for 'Surrey', was based on the crystal structure of afwillite and the number inscribed on the back refers to the crystallographer's original diagram.

1.11.f Jacquard-woven fabric of worsted, nylon and cotton entitled 'Surrey', designed by Marianne Straub and manufactured by Warner & Sons Ltd. British, 1951.

66 x 76.2 cm

Given by Warner & Sons Ltd Department of Textiles and Dress, Circ. 306A-1951

Warner & Sons Ltd was one of the firms chosen to represent the textile industry within the Festival Pattern Group.

1.11.g 'The Souvenir Book of Crystal Designs', London, 1951, a re-print, with additions, from Mark Hartland Thomas's article 'Festival Pattern Group' in *Design,* May-June 1951, 29-30, pp.12-24.

The Festival of Britain archive in the Contemporary Archive of the National Art Library, L.4676-1977

Open showing a photograph of 'Surrey' and other textiles on display in the foyer of the South Bank's Regatta Restaurant.

The textile was displayed in the South Bank's Regatta Restaurant, which was designed by Misha Black and Alexander Gibson and chosen as the showcase for the Group's project.

MT

From 1.11.g

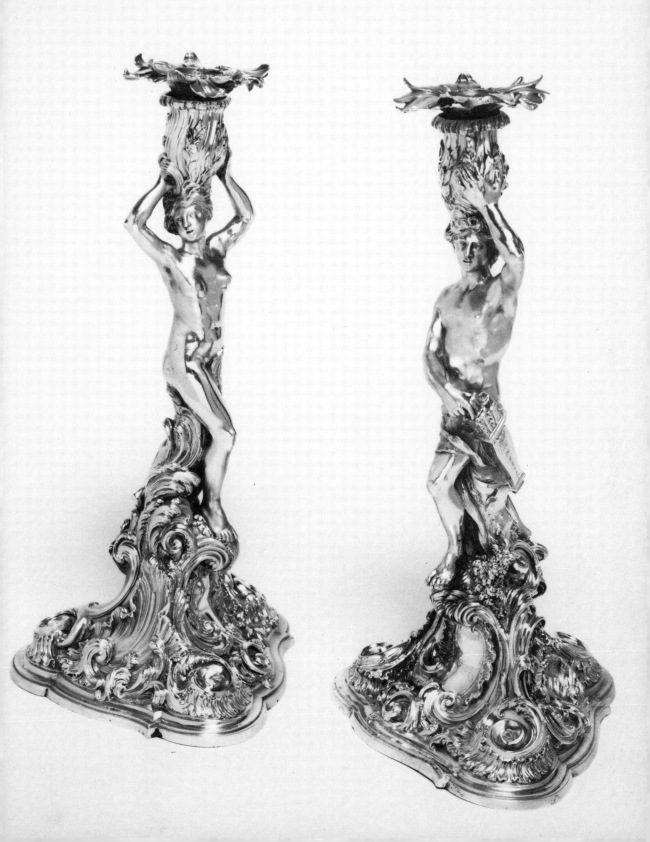

Section 2: The adaptation of designs to different materials and styles

*T*he question of nature's role in design has been alluded to in the introduction. Other ingredients of 'good' design to be recommended increasingly since the industrial revolution and of deep concern to the founders of design education·are the suitability of form for its function and the judicious use of materials. C. Percier and P.F.L. Fontaine (see cat. no. 2.7) drew attention to both at the beginning of the 19th century. They claimed '... the true model for each object, each piece of furniture, each implement is what is shown by the use to which it is to be put' and denigrated debasing falsifications that they felt the skills of industry had introduced: 'Plaster takes the place of marble, paper plays the part of painting, moulds imitate the work of chisels, glass substitutes for precious stones, plating replaces solid metals, varnish fakes porphyry'.[5] Similar ideas were given prominence as 'General principles of decorative art' when this Museum was founded. 'The true office of ornament is the decoration of utility. Ornament, therefore, ought always to be secondary to utility. Ornament should arise out of, and be subservient to construction. Ornament requires a specific adaptation to the material in which it is to be wrought, or to which it is to be applied; from this cause the ornament of one fabric or material is rarely suitable to another without proper adaptation.'[6] Later Johannes Itten in his preliminary course at the Bauhaus went even

[5] Translated from the preface to *Recueil de décorations intérieurs, comprenant tout ce qui a rapport à l'ameublement ...*, 1812.

[6] Department of Science and Art, *A catalogue of ornamental art, at Marlborough House ...*, 1853, p.6.

further. He acquainted his students with different materials on the premise that a thorough knowledge of them was essential to the discovery of the true form of each material.

Nevertheless, during the five centuries represented in this exhibition, the same forms appear frequently in a variety of materials on or as artifacts with differing functions. Shapes and materials are seen to be used according to current conventions rather than because of the existence of any discernable inherently correct way of handling them.

Accordingly this section demonstrates that what is considered fitting use of form or material changes with fashion. The first group in it suggests the variety of ways in which decorative prints designed by one artist have been adapted to different uses over two and a half centuries. The other groups have an artifact or a design and, in one case, a firm's ledger as focal points. The prints and drawings shown with them either trace the history of their design to sources which were probably unknown to the creator of the object or suggest how a design has been adapted to cater for fashionable demand. The groups emphasize that basically the same shapes or decorative motifs have different elements exaggerated or neglected in keeping with the taste of a period. Through the neutral support of paper, flat but capable of giving the illusion of three dimensions, the mutation of style is more easily studied than from the artifacts themselves.

2.1

Stefano della Bella was born in Florence and published his first etching in 1617. He was initially inspired by the manner and example of Jacques Callot but soon developed a style of his own, producing about 1,400 plates in a career which took him to Paris (1639-1650) and to Rome, chiefly under the patronage of the Medici. His prints were very influential, not least in the field of ornament, in which he produced some 82 plates which were frequently reprinted and copied. The appeal of his ornamental style lay in the delicate realism of his often bizarre combinations of natural and abstract forms. The measure of his fame was indicated by the Mercure de France *when it described Meissonnier's pioneering rococo prints of 1734 as being in the taste of Etienne la Belle, no doubt in reference to the flesh-like shelly ornament of which della Bella had been but one of several exponents. This group shows individual motifs borrowed from his prints being carried out in a variety of media, in one instance as far afield as Stockholm, up to the late 18th century.*

2.1.a Stefano della Bella (1610-1664)

A frieze of dogs and putti; *Ornamenti di fregi et fogliami*, pl.12. After 1647.

Lettered *stef. Del. Bella Inu. & fec. Cum Priuil Regis.* Numbered *12*.
Etching. 8.3 cm x 24.8 cm
28190.9

Literature: Baudi de Vesme no.998.

2.1.b Waiter by Benjamin Pyne (working 1676, died 1732). 1698.

Octagonal, with a flat-chased border. The centre engraved with the arms of Sir William Courtney, perhaps by Simon Gribelin (1661-1733).

London hallmarks for 1698.
Silver-gilt. W. 24 cm
Department of Metalwork, M.77-1947

The design of the chasing on the border is based on that of the etched frieze by Stefano della Bella (cat. no. 2.1.a).

2.1.c Stefano della Bella (1610-1664)

Two friezes, the upper incorporating lions' and eagles' heads and the lower two rams; *Ornamenti di fregi et fogliami*, pl.5, 6th state. After 1647.

Lettered *S.D. Bella inu. & fec. Cum Priuil. Regis.* Numbered *5*. Etching. 8.2 x 24 cm
28190.4

Literature: Baudi de Vesme no.991.

2.1.d Attributed to Stephen Wright (working 1746, died 1780)

Plan and elevation of designs for a chimney-piece, with alternatives, hearth and dado for the large dining room at Clumber Park, Nottinghamshire c.1768-78.

Inscribed with notes in pencil and a scale of feet.
Pen and ink and wash. 35.2 x 24.2 cm
211

Literature: H. Colvin, *A biographical dictionary of British architects*, 1978, p.933; 'Clumber Park, Nottinghamshire, I', *Country Life*, Sept. 12, 1908, p.359; C. Hussey, 'Buxted Park, Sussex, 2', *Country Life*, August 11, 1950, p.442, fig. 2 (shown installed at Buxted after the demolition of Clumber in 1938).

The chimney-piece frieze is after the print by Stephano della Bella (cat. no. 2.1.a) and the eagles' heads at the side probably after a detail in another of his prints (cat. no. 2.1.c). The chimney-piece *in situ* is reproduced as pl.2.

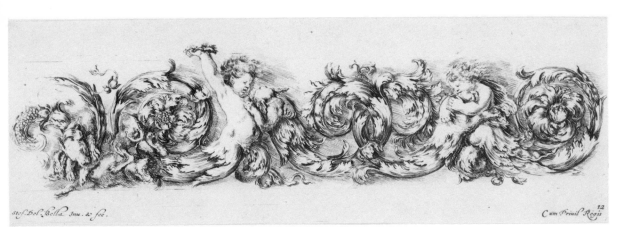

2.1.a

2.1.b

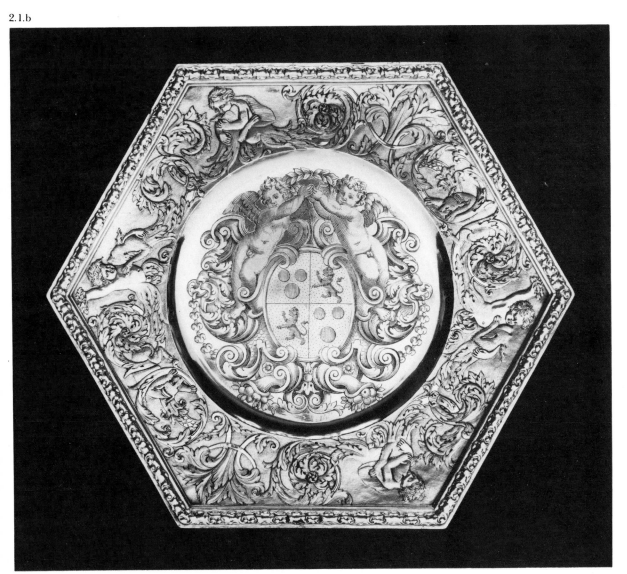

2.1.e Stefano della Bella
(1610–1664)

A frieze of foliage and a triton and tritoness embracing; *Frises, feuillages, et grotesques*, pl.6, 4th state. c.1640.

Numbered *2*.
Etching. 6.1 x 12.3 cm
28189.1

Literature: Baudi de Vesme no.984

2.1.f Tankard with lid

by Ferdinand Sehl I (worked 1688-c.1731). 1691.

Engraved on the lid *OPCS* in monogram and *OPS* on the foot. Stockholm hallmarks for 1691. Silver, parcel gilt. 18.2 x 22.7 cm
Department of Metalwork, 765-1904

Literature: R.W. Lightbown, *Catalogue of Scandinavian and Baltic silver*, 1975, no.81, repr.

Applied to the body above the feet are three plates cast in relief with figures after the print described above (cat. no. 2.1.e).

2.1.g Stefano della Bella
(1610–1664)

Vases. *Raccolta di Vasi diversi*, pl.6, 1st state. 1639-1648.

Lettered *Stef. de la Bella inuent fecit F. L'Anglois alias Ciartres exc. cum Priuil. Regis Christ.* Numbered *6*.
Etching. 8.4 x 20.2 cm
2974A.6

Literature: Baudi de Vesme no.1050.

The vases shown in the *Raccolta di Vasi*, although on occasion mistaken for antique originals, were in fact of della Bella's own invention. They were much used, especially during the period of the English 'vase mania' from about 1770 onwards. A reversed copy of the *Raccolta* was published by

44

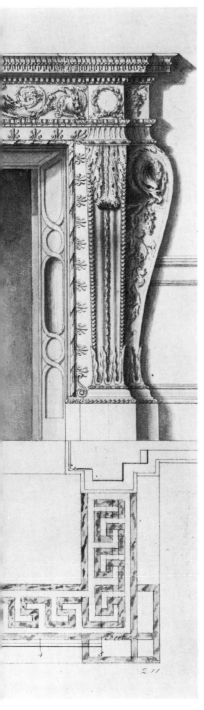

2.11

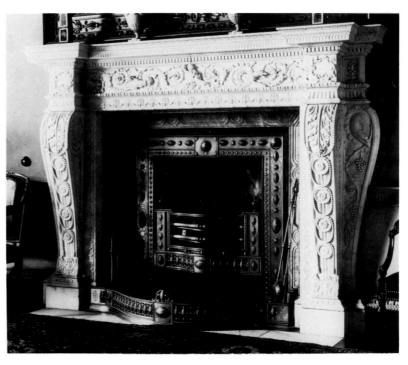

Plate 2 Chimney-piece attributed to
Stephen Wright. c.1768-78.

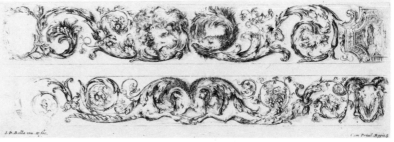

2.1.c

2.1.f

Robert Sayer in *The ladies amusement* (about 1760) and separately under the title *A new book of vases & urns*.

2.1.h Vase and cover by John Parker I (worked c.1758-c.1777) and Edward Wakelin (active 1748-1784). 1770-1771.

Engraved in the 19th century *JCB*. London hallmarks for 1770-1771. Silver. H.21.3 cm; W.8.6 cm Department of Metalwork, 567-1874 Literature: T. Clifford, 'Some English ceramic vases and their sources, pt.1', *English Ceramic Circle Transactions*, 10, pt.3, 1978, pp.166-167, repr. pl.76 b.

The design is derived from a vase with rising hooked handles shown in the etching by Stefano della Bella (cat. no. 2.1.g), probably through a drawing by Robert Adam (Sir John Soane's Museum, Adam Drawings, 25, no.157).

2.1.i Vase and cover by Josiah Wedgwood.

Marked *Wedgwood and Bentley*, impressed.
Black basaltes ware. H. 27 cm; W. 14.6 cm
Department of Ceramics, 280 & A-1893

This vase is loosely derived from a vase with hooked handles in the print by Stefano della Bella (cat. no. 2.1.g) and the figure on the cover is taken from the group of the Fates on the cover of another vase in the same print.

2.1.j Christiania Küsslin (worked early 18th century) after Stefano della Bella (1610–1664)

Jupiter and Semele, Theseus and Ariadne, Jupiter and Callisto, Cephalus and Procris, after the set of playing cards *Jeu des fables* first published in 1644.

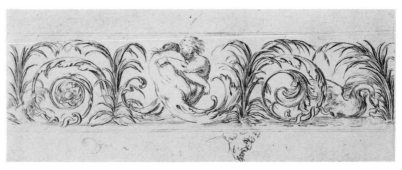

2.1.j

Etching. 11.7 x 13.9 cm
26012.4

Literature: Baudi de Vesme, copy A,
after nos.506, 535, 500, 540.

Stefano della Bella's designs were not
only used widely themselves but many
etched copies of them exist also, of
which this is an example.

2.1.k Tea bowl, English. Mid-18th century.

Decorated with a scene of Cephalus
and Procris.

Marked *A* in underglaze.
Porcelain, enamelled. H. 3.5 cm;
D. 6.7 cm.
Given by Dr Bernard Watney
Department of Ceramics, C.26-1957.

Literature: Dr B. Watney, 'The
origins of some ceramic designs',
English Ceramic Circle Transactions, 9,
pt.3, 1975, pp.269-270, pl.173d.

Again the decoration is based on a
design by Stefano della Bella, this time
one of his figurative subjects (cat.
no. 2.1.j).

MS

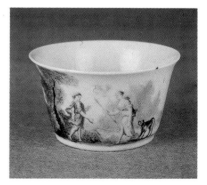

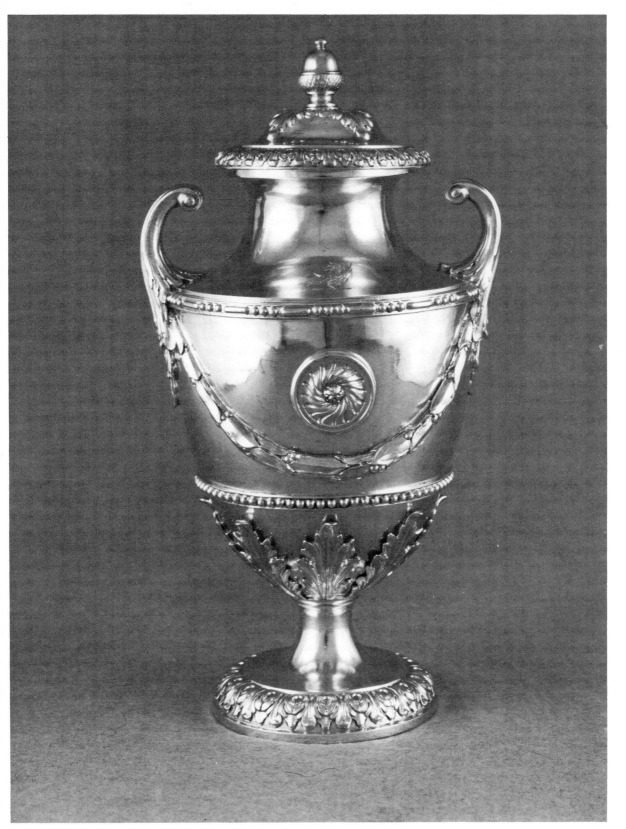

The design of this 18th century English table can be traced back to the ornamental scheme of wall paintings in ancient Roman houses. The group of prints exhibited with it shows the mutation of grotesque decoration with increasing emphasis being given to the basic horizontal and verticals of the table's structure and more and more to a representation of an illusion of three dimensions.

2.2.a Side table, English. c.1740.

Carved and gilded pine with a serpentine marble top.
H. 87.6 cm; L. 179 cm
Department of Furniture and Woodwork, W.3-1961

The legs of the English table are copied from Pineau's design (cat. no. 2.2.f) but whether the carver saw Pineau's print or Langley's copy (cat. no. 2.2.g) is not clear. The sophisticated design of the mask at the centre, which is a departure from Pineau, is probably taken from a French source, perhaps a print, and may show that the carver had direct access to such French material.

2.2.b Agostino de' Musi called Veneziano (c.1490-c.1536)

Grotesque decoration. Plate 16 from the set of ornamental panels, the first re-issue. 1530s.

Lettered *A.V.*
Engraving. 20.1 x 14.1 cm
26446.4

Literature: Bartsch no.579.

2.2.c Agostino de' Musi called Veneziano (c.1490-c.1536)

Grotesque decoration. Plate 17 from the set of ornamental panels published

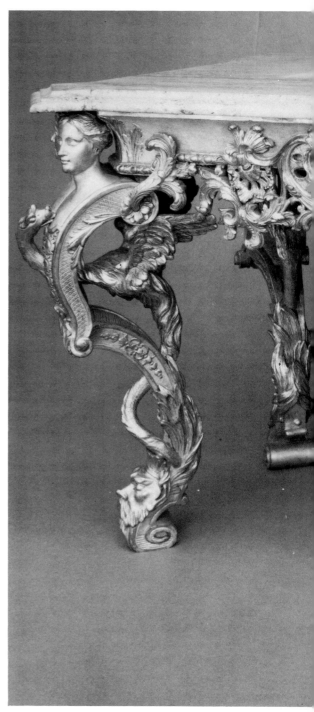

2.2.a

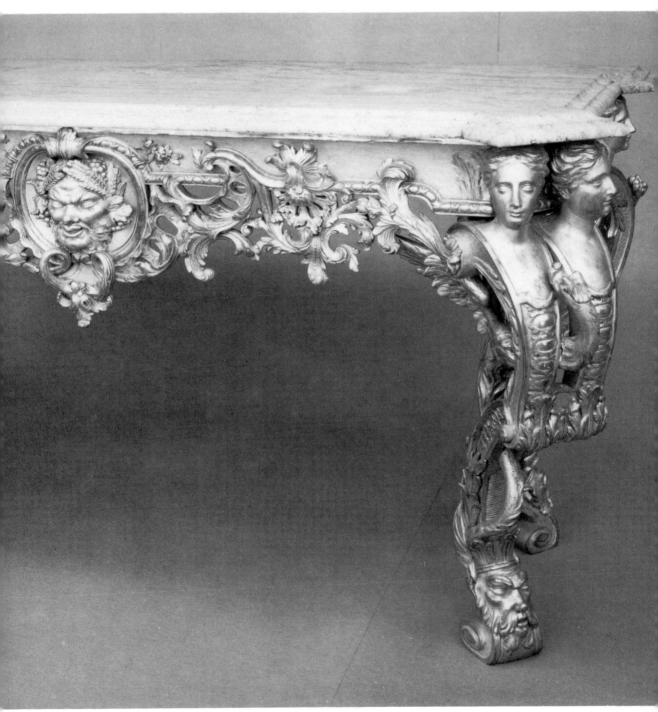

51

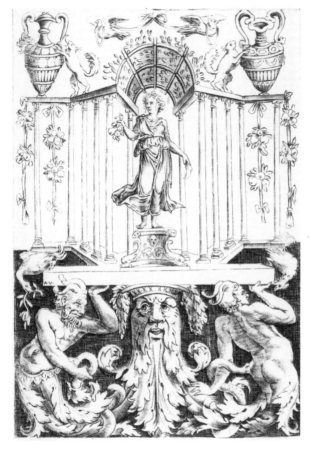

2.2.b

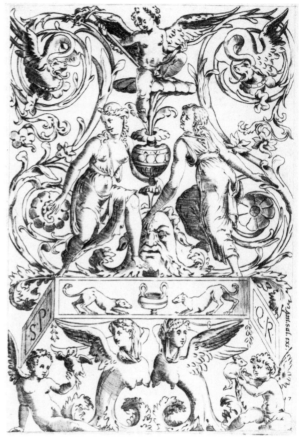

2.2.c

in the 1530s. Antonio Salamanca's re-issue.

Lettered *A.V.* and *Ant. sal. exc.*
Numbered *17*.
Engraving. 20.5 x 14.1 cm
16739

Literature: Bartsch no. 580.

The achievement of Raphael and his followers in the grotesque decoration of the Vatican loggie was to impose a rational and structural order onto the disparate decorative elements of the Ancient Roman wall paintings which were their inspiration (see also cat. no. 1.9.b). These prints by Agostino, which are close in general composition to the Loggie decorations, show how that structure was an illusionistic fictional architecture, with load-bearing and supporting members. In these prints the supports are pairs of satyrs and winged females.

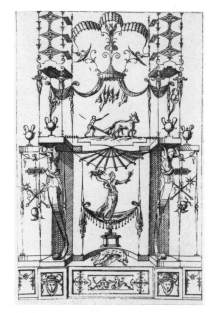

2.2.d

2.2.d Jacques Androuet Ducerceau (c.1510- after 1584)

Grotesque panel, from the set of (?) 54 plates entitled *Nihil Aliud Semper Cogitanti ... etc* 1550, after pl. 7 of the set *Leviores etc. (ut. videtur) extemporanae*, first published anonymously in the first half of the 16th century and later copied by Enea Vico.

Etching. 11.2 x 7.5 cm
23089.24

Literature: Berlin no. 285; Brown University, *Ornament and architecture, Renaissance drawings, prints and books*, 1980, no. 84.

This print, the composition of which originated in Rome at the time of Agostino, shows the use of supporting figures in a more convincing architectural context, and such figures were indeed used on actual buildings.

2.2.e Jean Lemoyne (1638-1713)

Grotesque decoration showing Apollo playing on the lyre, from the set *Ornemens Inventes & Graves par Jean Lemoyne Peintre* published by Jean Berain, 1676. A later state, with the publisher's name erased.

Lettered *I. Lemoyne Sculp*.
Etching. 29 x 19.5 cm
17436

Literature: Berlin no.341.1

This print, made more than a hundred years later than Ducerceau's (cat. no. 2.2.d), is a demonstration of the same system except that the spatial illusion is considerably enhanced.

2.2.f Anonymous, after Nicolas Pineau (1684-1754)

Design for a console table, a stand and a bracket, from the set *Nouveaux Desseins de Pieds de Tables et de Vases et Consoles de Sculpture*, 1732-9.

Lettered *Mariette excudit*. Numbered *5*.
Engraving. 20.3 x 27 cm
E.5946-1908

Towards the end of the 17th century there was a new development: the grotesque framework began to determine the whole shape of three-dimensional objects. Compositions such as the lower half of Lemoyne's print (cat. no. 2.2.e), with its putti supporting a flat table-like surface, clearly lie behind the form of the characteristic French console table of the first half of the century, of which this design after Pineau is a typical example.

2.2.g Thomas Langley (working 1739) after Nicolas Pineau (1684–1754)

Design for a marble table. Pl.143 of Thomas and Batty Langley's *The City and Country Builder's and Workman's Treasury of Designs*, 1740 (other editions in 1745, 1750, 1756, 1770).

Formerly lettered *Marble Table Thos. Langley Invent delin and sculp 1739* and numbered *CXLIII*.
Engraving. Cut to 14.4 x 21.8 cm
E.1132-1888

Pineau's print was copied in the Langleys' *Treasury of Designs*, which asserted that the table was designed by Thomas Langley 'after the French Manner'. The *Treasury* was one of several books which plagiarised French and German baroque and rococo engravings at a period when very few original English prints were available in the new and developing rococo style.

MS

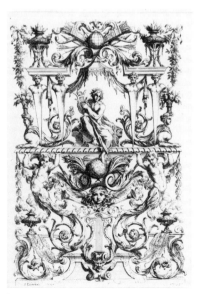

54 2.2.e

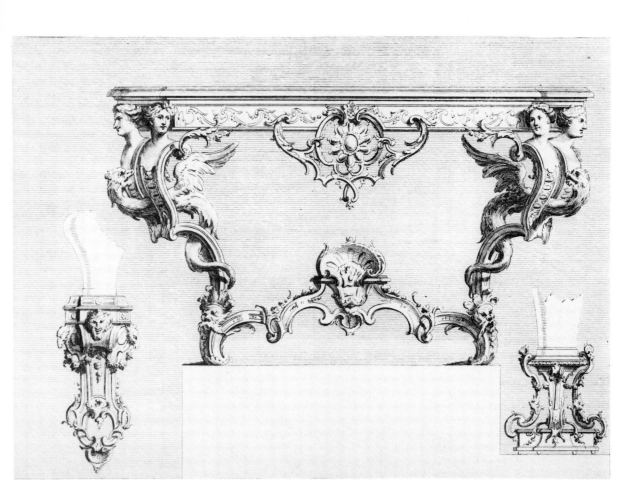

2.2.f

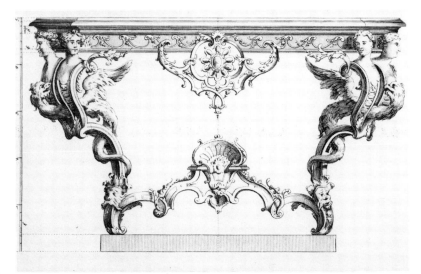

2.2.g

2.3

The focal point of this group is a pair of English rococo candlesticks by G.M. Moser (1706-1783). The group explores two themes: the change in the formal treatment of the story of Apollo and Daphne, and some of the subtle changes in the form of candlestick design during the 17th and 18th centuries.

2.3.a Candlesticks (two pairs) by or after George Michael Moser (1706-1783). c.1740.

The stems formed as Apollo and Daphne.

Silver, unmarked. 37 x 17 cm
Department of Metalwork, M.329-g-1977

2.3.b George Michael Moser (1706-1783)

Design for a candlestick, the stem formed as a figure of Daphne turning into a laurel tree.

Signed *G.M. Moser iv. & delt.*
Pen and ink and wash. 35 x 20 cm
E.4895-1968

Literature: S. Bury and D. Fitz-Gerald, 'A Design for a candlestick by George Michael Moser', *Victoria and Albert Museum Yearbook*, 1969, pp.27-29, fig. 1.

The Swiss-born artist, G.M. Moser, was a gold chaser, enameller and medallist who became a leading figure in the group who helped to introduce the rococo style to England in the 1730s. His candlesticks combine the conception of Bernini's group of Apollo and Daphne with the caryatid candlestick form (and the rocaille of Meissonnier), which are discussed below.

The candlesticks seem to be intended to be seen from two viewpoints, the

56

first of which is shown in the drawing and corresponds to Bernini's. In this view the foliage on the Daphne subject's base appears to impel the figure forward, whereas it is not visible on that of the Apollo subject's identical base, which is at a different angle. The second viewpoint, in which the cartouches on the bases both face forwards, shows both figures running towards the viewer, but looking sideways at each other rather in the way that actors, regardless of their relationship to each other, always face the audience.

2.3.c Italian School, 17th century

Apollo and Daphne.

Oil on canvas. 49.5 x 64.5 cm
Jones Bequest, 567-1882

Literature: C.M. Kauffmann, *Victoria and Albert Museum, Catalogue of foreign paintings*, 1973, 1, no.188.

2.3.d Sir Nicolas Dorigny (1658-1746) after Gianlorenzo Bernini (1598-1680)

Apollo and Daphne, after the marble group of 1625 in the Galleria Borghese. In Paolo Alessandra Maffei, *Raccolta di statue antiche e moderne*, 1704, pl.81.

Lettered *Apollo, e Dafne del Cavalier Gio: Lorenzo Bernini N Dorigny del; et scul. Nelle Stampa di Domco de Rossi erede di Gio. Giaco. de Rossi in Roma alla Pace con Privil. de Som. Pont.*
Etching and engraving. 34.5 x 21.1 cm
National Art Library

Literature: B.N. Fonds 3, p.499.

The story of Apollo's amorous pursuit of Daphne, symbolic of the victory of Chastity over Love, has been popular with artists through the ages. Its most celebrated representation is in Bernini's statue of 1625 which catches

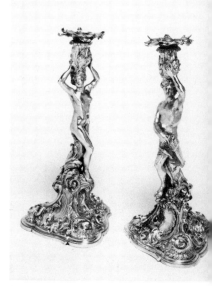

2.3.a

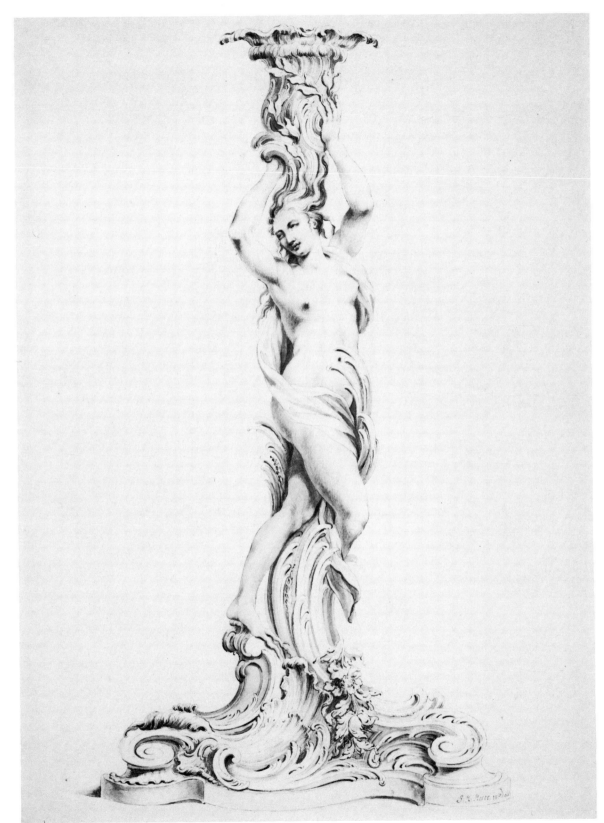

2.3.b

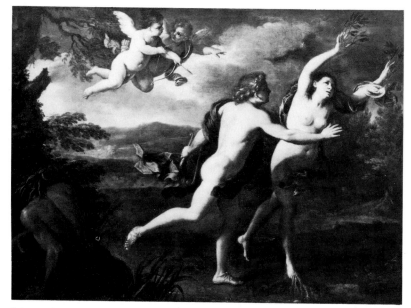

2.3.c

brilliantly the precise moment of the terrified Daphne's transformation into a laurel tree, the bark enveloping her body and leaves and roots sprouting from her hair and limbs. The Apollo is modelled on the famous antique precedent of the Apollo Belvedere in the Vatican (pl.3). In spite of Daphne's twisting pose, the group is intended to be viewed from one side only.

In the candlestick, Moser gives Bernini's Daphne a violent twist, more extreme in the drawing than in the execution, exchanges the enveloping bark for drapery and *rocaille* and turns her terror-struck look into one almost of complacency.

2.3.e Jacques Androuet Ducerceau (c.1515-1585)

Two caryatids and a herm. From the set of 12 plates of caryatids and herms.

Etching. 16.2 x 11.4 cm
E.1211-1923

Literature: H. von Geymüller, *Les Ducerceau*, 1887, no.314; Berlin no.3914.

The caryatid, a standing figure used as an architectural support, became popular in the 16th century.

2.3.f Jean le Pautre (1618-1682)

Designs for caryatids. From the set *Termes, Supports et Ornemens pour embellir les Maisons et Jardins.*

Lettered *fait par I. le Pautre. A Paris Chez N. Langlois rue St Jacques à la Victoire avec Privilege du Roy* and numbered *3.*
Etching. 17.5 x 26.8 cm
29741.A.184

Literature: Berlin no.96.

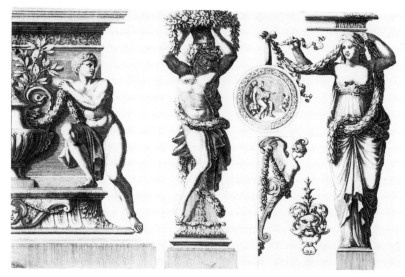

2.3.f

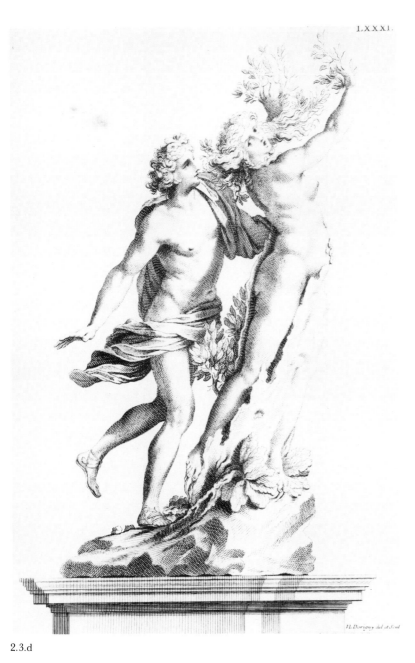

LXXXI.

H. Dorigny del et Scul.

2.3.d

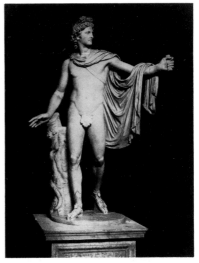

Plate 3 The Apollo Belvedere, antique Roman copy in marble, probably of a Greek bronze by Leochares (c.350 B.C.). The Vatican.

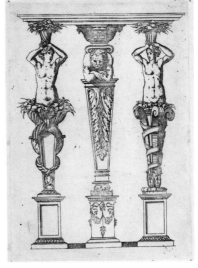

2.3.e

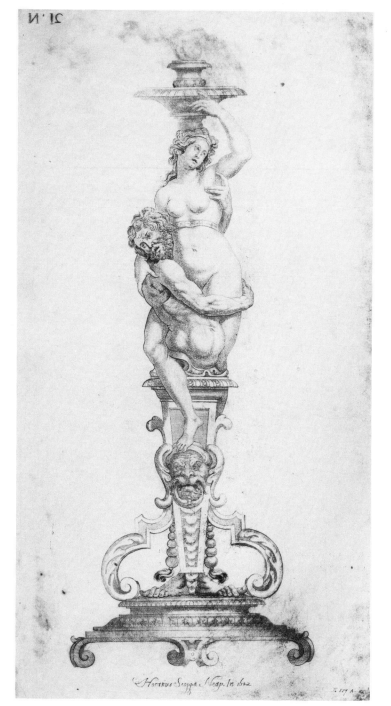

2.3.g Jean le Pautre (1618-1682)

Design for a caryatid stand or candelabrum. Perhaps from *Nouveau Livre de Termes*.

Lettered *Le Potre. fecit. le Blond exc avec Privilege.*
Etching. 29.5 x 22 cm
E.6703-1908

The caryatid was a favourite baroque device for composing a stand or candlestick. These prints of le Pautre show the official French baroque style as used at the Court of Louis XIV and were influential in spreading it abroad. This one was also published later in England. The silver caryatid candlestick also found its way to England in the 1680s, greatly reduced in size but in a form apparently based on le Pautre's print (see C. Oman, *Caroline silver*, 1970, pl.62 b).

2.3.h Orazio Scoppa (c.1607-1647)

A candlestick incorporating, struggling male and female figures.

Lettered *Horatius Scoppa Neap. In 1642.*
Engraving. 42.5 x 22.8 cm
E.517A-1885

Literature: Berlin no.1136.

Groups of twisted figures were also part of the baroque style and they were sometimes incorporated into candlesticks, as in this example by a Neapolitan goldsmith.

2.3.i Louis Desplaces (1682-1739) after Juste Aurèle Meissonier (1695-1750)

Designs (3 on 3 plates) for a silver candlestick.

27988.C.1 lettered *Chandeliers de sculpture en argent Invanté par J. Maissonnier Architecte en 1728. Desplaces sculpsit.* E.1663A-1977 lettered *Meissonier Architecte in. Desplaces*

2.3.h

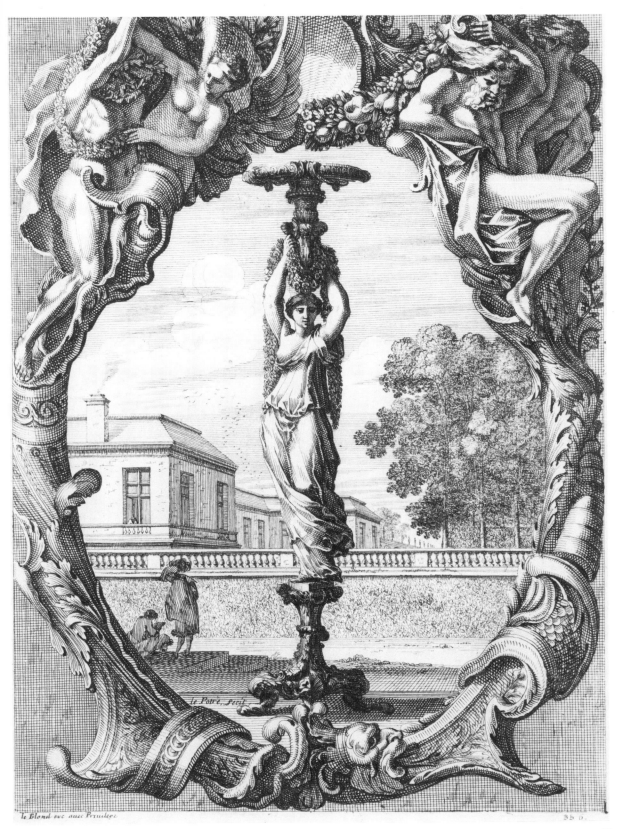

le Poure. fecit

Bb o.

2.3.g

61

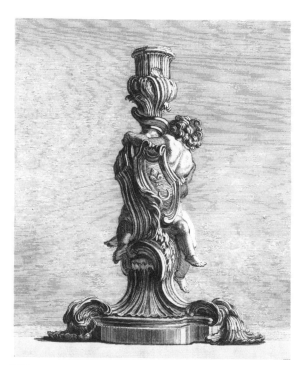

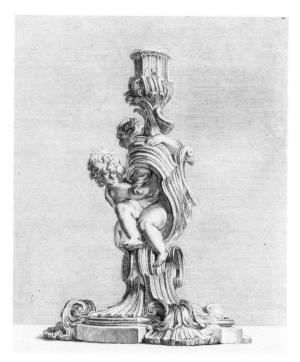

2.3.i

Sculpsit. Avec Privilege du Roi.
Numbered *B.11*. E.1663-1977 lettered
as E.1663A-1977 and *A Paris ches
Huquier rue St Jacques au coin de celle des
Mathurins.* Numbered *B.12.*
Etching and engraving. 27 x 21;
26.9 x 21; 26.9 x 21.2 cm
27988.C.1; E.1663 & A-1977.

Literature: B.N. Fonds p.118, 169-
171; Berlin no.397b.

The twisted figure group was adapted
by Meissonnier for his remarkable
candlestick of 1728, one of the earliest
examples of the ambiguous watery
rock-like ornament called rocaille,
which was a principal component of
the mid-eighteenth century rococo
style. Another feature of the rococo
was asymmetry, which in
Meissonnier's case is so extreme that
three views are needed to show the
whole candlestick.

2.3.j Gabriel Huquier (1695-1772) after Gilles-Marie Oppenord (1672-1742)

Designs for pilasters, from *Quatrième
Livre Contenant des Montans ou Pilastres.*

Lettered *Oppenort in. Avec Privilege du
Roi. Huquier Sculp. et ex.* and numbered
D3.
Etching. 31.8 x 19 cm
12949.5

Literature: B.N. Fonds p.500, 1953.

The chief influence on Daphne's pose
in the Moser candlestick was probably
a nymph in this nearly contemporary
print after Oppenord, which was itself
apparently influenced by a 16th
century etching (cat. no. 2.3.e).

MS

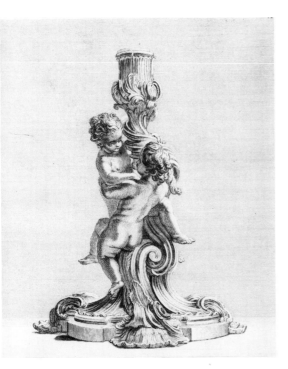

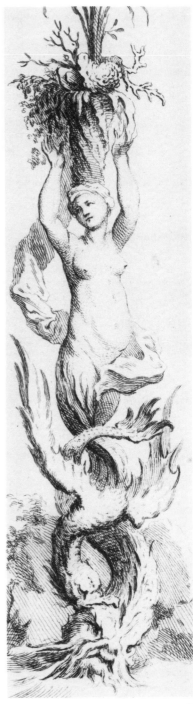

2.4

This group demonstrates the importance in the creation of a style of individual elements in isolation and the configuration in which they are assembled.

2.4.a Wallpaper, Cantonese, c.1730-40.

A fragment showing a Chinese garden scene, with two figures within a decorative cartouche. From the Library of Hampden House, Great Missenden, Buckinghamshire. The fragments have been laid down on a sheet of paper on canvas and some missing parts of the design have been indicated. The Chinese inscription over the gateway in the central scene can be translated as 'The Place of Deception (Error or Illusion)'.

Pen and ink and watercolour.
276.2 x 108.6 cm
Given by the Earl of Buckinghamshire
Far Eastern Department, E.51-1968

Literature: H. Honour, *Chinoiserie: the vision of Cathay,* 1961, pp.49, 50; C.C. Oman and J. Hamilton, *Wallpapers, a history and illustrated catalogue of the collection in the Victoria and Albert Museum,* 1982, no.653.

The decorative motifs of the cartouche of this Chinese wallpaper are derived from a design by Watteau, engraved by Gabriel Huquier (cat. no. 2.4.b).

English, hand-painted wallpapers at Harrington House, Bourton-on-the-Water, Gloucestershire (pl.4) depict the same cartouches after Watteau, but with European central scenes including one also from Watteau's 'L'Inocent Badinage' and, like the English copy printed for Ryall (cat. no. 2.4.c), in reverse of the Huquier print. The effect is main-stream rococo with no chinoiserie overtones.

Strictly speaking 'Chinoiserie' is a European style reflecting a fanciful view of the East. This chinoiserie wallpaper was, however, produced in China for the Western market.
The use of European engravings by Chinese porcelain decorators is well-known but their use on flat wares like wallpapers and textiles was unusual. There is some evidence in the archives of the East India Company that English buyers of Indian chintzes were making their goods wholly acceptable to the English market by sending out patterns to India. In 1662 the London directors of the East India Company wrote to their factors at Surat: 'We now send you herewith enclosed several patterns of Chints for your directions and desire you to cause a considerable quantity to be made of these workes' ... In 1669: 'Now of late, they are here in England come to a great practice of printing large branches for hanging of rooms, and we believe that some of our Callicoes painted after that manner might vent well, and therefore have sent you some patterns, of which sort we would have you send us 2,000 pieces'. John Irwin has pointed out that these patterns were in fact English designs in the Chinese taste. His point is proved by the existence of an English crewel work embroidery of about 1680 and two Gujarat hangings of approximately the same date, all three of which are clearly based on a common English original in the 'China fashion'.

In the early days Chinese wallpapers were presented by the Chinese merchant to his English counterpart as a gift after a sale was consummated, but soon special orders for sets of similar papers were sent back, and the commerce in wallpapers became considerable. It seems likely, as in the case of the 'Chints', patterns in the

■ 2.4.a

form of either engravings or drawings were also sent for the Chinese painters to copy. The rococo element was just as important as the Chinese element to this particular brand of chinoiserie.

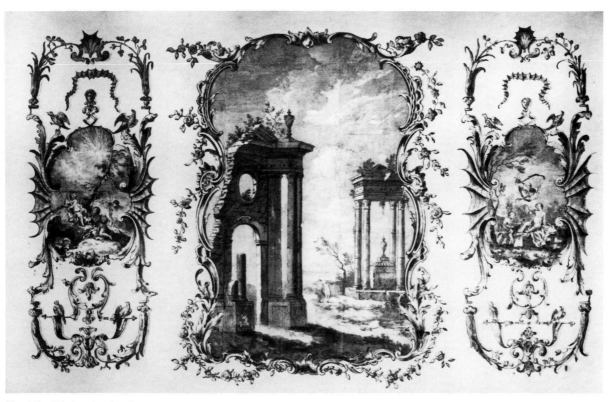

Plate 4 English, hand-painted wallpaper
panels at Harrington House, Bourton-on-
the-Water, Gloucestershire, c.1760-70.

L'INOCENT BADINAGE

A. Watteau Inv. Huquier Sculp.

Paris chez la V. de F. Chereau rue St. Jaques aux deux Pilliers d'or Et chez Huquier vis avis le grand Chatelet Avec Privilege du Roy.

2.4.b Gabriel Huquier (1695-1772) after Jean-Antoine Watteau (1684-1721)

L'Inocent Badinage. Plate 3 from a set of four. c.1730.

Inscribed with title and *A Watteau Inv. Huquier Sculp A Paris chez la V. de F. Chereau rue St. Jacques aux deux Pilliers d'or; Et chez Huquier vis avis le grand Chatelet Avec Privilege du Roy.*
Engraving. Cut to 31.1 x 20.6 cm
29523.A.5

Literature: E. Dacier & A. Vauflart, *Jean Jullienne et les graveurs de Watteau*, Paris, 1929, 3, no.230.

This printed source for some of the elements in the wallpaper's design was itself derived from earlier decorations.

Features such as the birds, the floating head, some of the linking motifs and even the placing of a pictorial composition within such a framework have their origin in the wall decorations of ancient Roman villas filtered through the Renaissance grotesque (see cat. nos. 1.9.a & b). The features themselves appear in works of different styles and periods. Yet the playful way, with a touch of fleshiness and subtle asymmetry, with which they are strung together is in the spirit of the early rococo.

2.4.c Anonymous, after Jean-Antoine Watteau (1684-1721)

L'Inocent Badinage or Boys at Play.

Lettered with title and *Watteau inv. London printed for John Ryall at Hogarth's Head Fleet Street 1761.*
Engraving. 30.3 x 21.9 cm
E.207-1889

Watteau's decorative schemes were popular and widely copied by engravers. This anonymous print, being English and in reverse of the Huquier design may well have been copied from the latter. Made at least forty years after the original drawing, it would have been of no interest to French decorators but is likely to have been among the sources used in the wallpapers at Harrington House (pl.4).

JH

The engraved design for a coffee pot in the rococo style, which is the focal point for this group, made no direct impact when it was published. It was, however, taken up by silversmiths some 75 years later when taste had changed sufficiently for its form to be acceptable.

2.5.a Gabriel Smith (1724-1783) after John Linnell (1723-1796)

Designs for two vases and a coffee pot. From *A New Book of Ornaments Useful for Silver-Smith's & c.*, 1760.

Etching and engraving. Cut to 20.8 x 29 cm
29332.G

Literature: H. Hayward, 'Some English rococo designs for silver-smiths', *Proceedings of the Society of Silver Collectors*, 1968-70, 2, nos.3/4, pp.70-75, fig. 105; H. Hayward and P. Kirkham, *William and John Linnell*, 1980, p.58, fig. 317.

John Linnell was principally a maker and designer of furniture (see cat.

no. 3.3.b), but his set of engraved designs for silver were a major contribution to the very small number of such prints produced in England. They had, however, little or no influence on the silver of their time. This was no doubt because of their extreme and eccentric nature, the product, perhaps, of Linnell's extravagant approach to designing in a field outside his own. The forms and decorations he designed drew on sources used at the time in other areas of design but not in silversmithing.

2.5.b Coffee pot by Robert Innes (worked c.1743-1758). 1745-6.

London hallmarks for 1745-6. Silver, with wooden handle. H. 23.7 cm; W. 10.1 cm
Department of Metalwork, M.858-1926

A standard rococo coffee pot of the kind still made when Linnell produced his design.

2.5.c Anonymous, after Stefano della Bella (1610-1664)

Designs for 8 vases, from a *New Book of Vases & Urns* bound into Robert Sayer's *Ladies Amusement* (about 1760), a reversed copy after *Raccolta di Vasi diversi*, pl.4.

Etching. 8.2 x 19.8 cm
13636.2

Literature: Baudi de Vesme no.1048.

The difference between Linnell's coffee pot and a typical extreme contemporary example (cat. no. 2.5.b) lies chiefly in the shape of the body and its decoration. The shape of the Linnell pot can probably be related to one of the vases on this sheet of designs by Stefano della Bella.

2.5.a

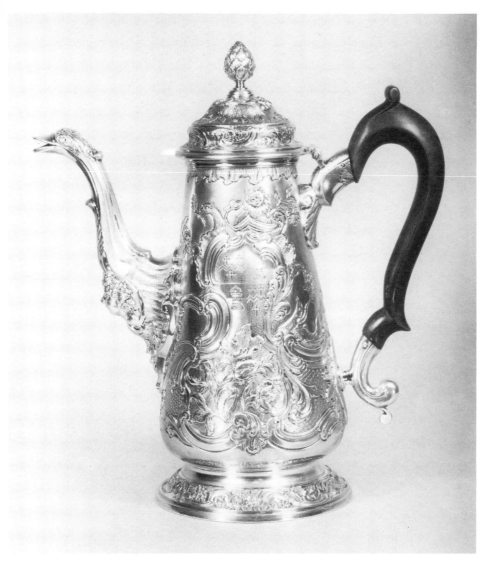

2.5.b

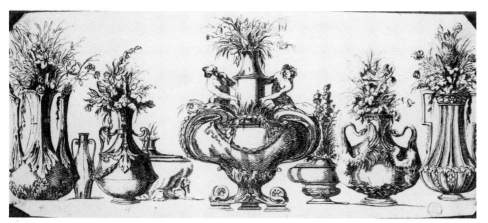

2.5.c

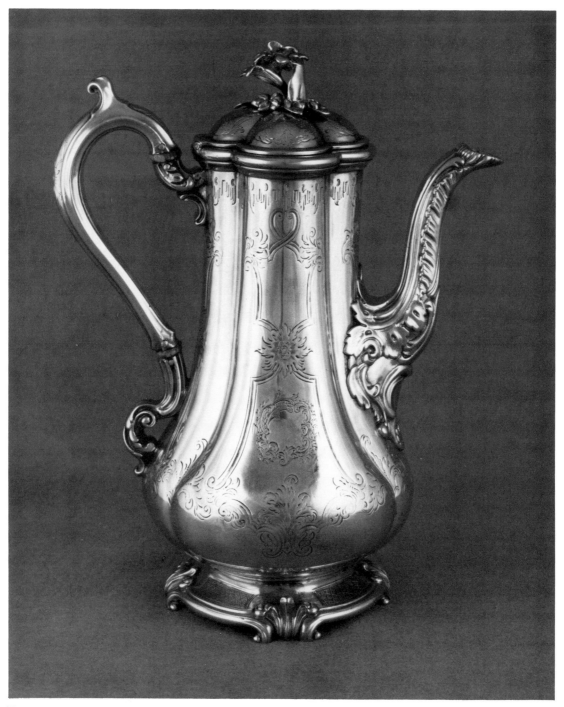

2.5.d Carl Albert de Lespilliez (1723-1796) after Jean François I Cuvilliés (1695-1768)

Design for ornament, from *Livre Nouveau de Paneaux à divers usages,* mid 18th century.

Lettered *F de Cuvillies. In. etc del. C.P.S.M. C A. de Lespilliez Sc.*
Etching and engraving. 34 x 21.4 cm (cut)
24894.14

The delicate interlace decoration on the side of Linnell's pot derived from slightly earlier Régence ornament, although it was found in Continental rococo. This example could have provided a source for the silver pot.

2.5.e William Ince (worked c.1759-c.1798)

Design for a bed. Original drawing for illustration in *Household Furniture In the Genteel Taste for the Year 1760 by A Society of Upholsterers,* p.82.

Pen and ink and wash. 24 x 16.5 cm
D.838-1906

Literature: P. Ward-Jackson, *English furniture designs of the eighteenth century,* 1958, no.149, repr.

This drawing shows contemporary use of similar interlace decoration as that on Linnell's coffee pot under the canopy of the bed. While largely out of use in English rococo of the 1760s, it was found in ceiling decoration and related places.

2.5.f Coffee pot by Robert Garrard II (1793-1881). 1835-6

Silver, with ivory. H 24.5 cm; W 9.8 cm
Department of Metalwork, M.18-1981

This pot is based on Linnell's design of 1760 (cat. no. 2.5.a). It was not until the rococo revival of the 19th century that it became 'acceptable', at the precise moment that the furniture and wood carvers' designs of his contemporaries, Matthias Lock and Thomas Johnson, (see cat. nos. 3.3.f & g) were being reprinted from the original plates.

MS

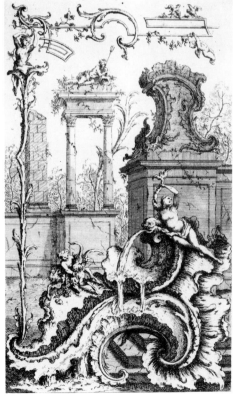

2.5.d

2.5.e

71

2.6

This Leeds Pottery order book and pattern book show something of the inter-action of taste between the manufacturers and their customers in that the require-ments of foreign clients are frequently shown to be somewhat different from those of domestic clients.

They are of great interest in the light they throw upon the methods employed in conveying orders from abroad to the Pottery, methods which would reflect general usage in the pottery trade given the wide sales of English wares (such as those of Wedgwood) on the Continent.

2.6.a Messrs Hartley, Greens & Co (last quarter of 18th century)

An order book of the Leeds firm of potters, Messrs Hartley, Greens & Co, containing sketches of required items of domestic pottery. On loose sheets pasted into a used ledger. Many of the sketches are inscribed with notes in French, German and Spanish (often with English translations added). The volume consists of 108 pages of blue laid paper and contains an index of initials and symbols (presumed to be those of the firm's agents) with appropriate page references. Stitched into a millboard cover.

Inscribed in ink on the front cover *B Original Drawing Book No.1*. The sketches are dated variously from *1778* to *1792*.
Pen and ink, wash, watercolour etc.
Size of volume 35 x 23 cm
Given by A. L. Allen
E.576-1941

Literature: J.R. & F. Kidson, *Historical notices of the Leeds Old Pottery with a description of its wares*, 1892, pp.45, 46; D. Towner, *The Leeds Pottery*, 1963, pp.54, 55.

On the page exhibited (originally a ledger sheet recording orders for

'Triangular Compotiers', 'Ewers and Basons' etc) are pasted a German order of the agent FMK, dated August 1791, for round milk-dishes in the 'Riga style', as shown in the drawing, with two blue bands (vessels in imitation of those made in wood) (top left); two paper discs from the agent BTV indicating the diameters of coffee and chocolate cups required for a Spanish order (top right); an order from the French agent DMF for mugs or tankards apparently relating to creamware pattern no.67 (see cat. no.2.6.b) (centre); another diameter disc for a Spanish order for coffee cups from BTV (dated March 1789) (bottom left); a design for a cruet stand from the German agent CGW (bottom left); and another design from CGW (apparently in Augsburg), dated April 1787, for what appears to be a covered, lugged feeding-cup (bottom right).

The Leeds Pottery under the management which eventually became in 1781 the firm of Hartley, Greens & Co first began operations at an as yet unverified date in the 1750s. It became most celebrated for its cream-coloured earthenware (or 'creamware') which formed the bulk of its output. The factory issued the first pattern book of its creamware designs in 1783, the ware having become extremely popular by then not only on the home market but also abroad. In fact the Pottery's real profitability lay in the volume of its overseas trade. The extent of that trade is indicated by the title-pages in French and Dutch, as well as English, which appear in the pattern book of 1794 (cat. no. 2.6.b). Besides France and the Low Countries it is recorded that the factory issued its list of wares in Spanish and the evidence of the order book also shows substantial trade with German-speaking states.

the Translation at the back of the letter

TMK Phant 2d Aug: 1791

Rigische Milch bitten gantz Round, oben der Rand
10. 11. 12. 13 Zoll breit mus gantz gerad
abgeschnitten
sein, unten auch
gantz gerade

9. 10. 11. 12 Zoll breit unten

die bitte mus gantz weis sein, aber 2 blaue Streifen
angestrichen wie der abris ist oder Französch grau,
es soll vorstellen als wan die Milch Bitte von
Holtz waere und mit 2 baender beschlagen,
Ich bitte mir zu melden was 1 Dosin kosten
von 10. 11. 12. 13 Zoll breit oben Unten muss nur ein
Zoll schmaler sein wie oben, darum habe es angezeich

Grandeza
da Caffé L.H.
diam. I.M.
Size for Coffee Cups

BTV

Grandeza
da Chocolata
diam.º 2 6/10
Size for Chocolates

BTV

DMF

Shape of the
Goblets of the
smallest size
and after these
three sizes layer
raising half an
inch

façon des gobelets
de la moindre Espece
et apres ceux la de trois
Espees plus grandes
gradant de demi pouce
en demi pouce

BTV
24 Jan 89
Grandeza
Caffé
size for Coffee Cups

CGW

CGW
the cover

upon & not cover'd
handed in Translation
size: from Augsbourg

Inevitably the wide spread of these wares led to a certain cross-fertilisation in their style. Such trade was disrupted during the French wars and, in any case, creamware was increasingly imitated by European factories. This latter fact was the main reason for the factory's eventual failure and bankruptcy in 1820.

2.6.b Messrs Hartley, Greens & Co, 1794

Designs for Sundry Articles of Queen's or Cream-colour'd Earthen-Ware, Manufactured by Hartley, Greens, and Co. at Leeds Pottery: with A great Variety of other Articles. The same Enamel'd, Printed or Ornamented with Gold to any Pattern; also with Coats of Arms, Cyphers. Landscapes, &c. &c. Leeds, 1794. Pattern book of the creamware products of the Leeds Pottery, with title-pages and descriptive lists of the contents in English, French and Dutch, consisting of forty-five plates, thirty-eight of which show general wares (152 items) and the remaining seven teawares (33 items).

Engravings. Size of volume
32 x 23.6 cm
National Art Library

Literature: D. Towner, *The Leeds Pottery*, 1963, p.56.

The volume is open at pl.15 which includes item no.67, a mug or tankard which appears to be that illustrated in the drawing in the French order which appears in the middle of the page displayed in the Leeds Pottery order book (cat. no. 2.6.a). Subsequent to this edition a fuller pattern book was published by the factory and an example of about 1814, in the Museum Library, contains seventy-one plates illustrating two hundred and sixty-nine items.

HB

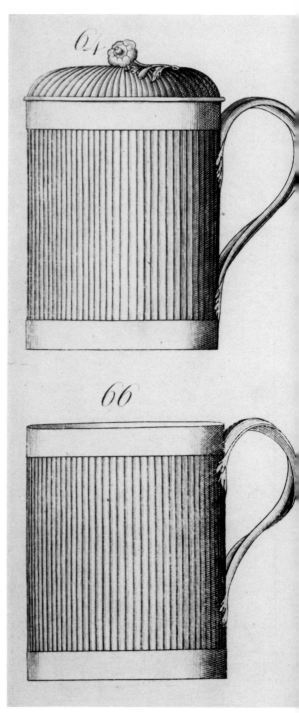

From 2.6.b

The selection of models for interior decoration and furniture from which these plates have been extracted were selected from different epochs yet they are all imbued with the spirit of the period when they were drawn. The apparent dichotomy between the recommendations in the text and the engraved models throws light on the phenomenon of 'taste'.

2.7 Charles Percier (1764-1834) and Pierre-François-Léonard Fontaine (1762-1853)

Plates 6 and 19 from *Recueil de décorations intérieurs, comprenant tout ce qui a rapport à l'ameublement, comme vases, trépieds candélabres ... etc*, including 73 etched and engraved plates. First published Paris, 1801. Later editions 1812, 1827 and 1843.

Etching and engraving. Size of volume 45 x 32 cm
29564.10; 29564.16

Percier and Fontaine stated in the introduction that their aim was not to provide the public with models to imitate: 'Our ambition would be satisfied if we could flatter ourselves to have collaborated to spread and to uphold in a matter as variable, as swayed by changes of opinion and of whim, the principles of taste that we have drawn from antiquity, and which we believe linked, although by a scarcely visible chain, to general rules of truth, simplicity and beauty ... '.

One of these rules concerned the suitability of a piece of furniture for its use: 'Among all the forms of a chair, there are some which are dictated by the shape of our body, by the demands of necessity or of comfort ... What is there that art could add? It should purify the forms dictated by convenience and combine them with

the simplest outlines, giving rise from those natural conditions to ornamental motifs which would be adapted to the basic form without ever disguising nature'. They went on to say how often they have seen ornament applied to different parts of furniture so that it took the place of the part itself. But the furniture they drew is to our present view so encrusted with ornament and its forms so twisted by fashionable configurations that it belies their fastidious strictures. Concepts of purified form, simple outline and the adaptation of ornament to use have substantially changed in the intervening 170 years or so since the book was published.

SL

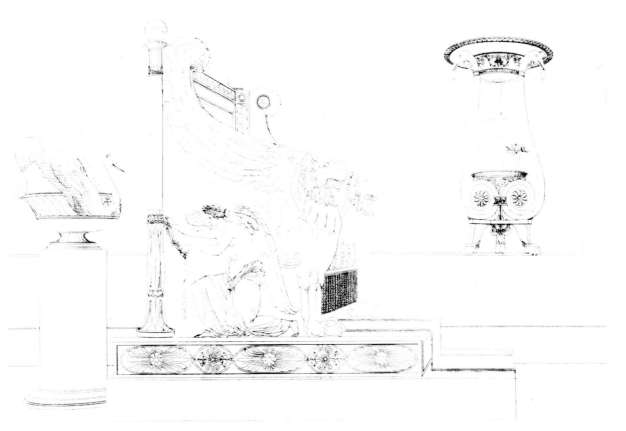

Plate 6 of 2.7

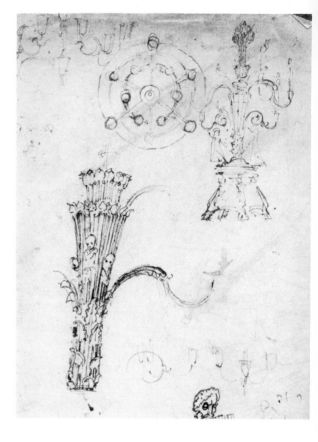

Thomas Stothard is best known as a book illustrator, but he also designed for the applied arts, and indeed began his career in the 1770s as an apprentice to a Spitalfields silk weaver. He was employed by the royal goldsmiths, Rundell, Bridge and Rundell, between about 1809 and 1815 when he made designs for silver which display a remarkable facility for ornamental invention, often outside the conventions of 'Regency' design.

This group uses preliminary sketches and a full-scale design by Stothard for a candelabrum to illustrate what can happen when an artist works in a field with conventions with which he is not completely familiar. The designs are shown with the well-known sources in which he found his inspiration.
His treatment of them was, however, slightly unorthodox, so that his design had to be modified to make it conform to other 'Regency' silver.

2.8.a Thomas Stothard, R.A. (1755-1824)

Sketch designs for a silver candelabrum, on two sheets cut from one. c.1815.

Pencil, pen and ink and wash.
17.2 x 12; 17 x 14.5 cm
9241.8; 9241.9

2.8.b Thomas Stothard, R.A. (1755-1824)

Full-size design for a silver candelabrum. c.1815.

Pen and ink and wash. 58.5 x 33 cm
Dyce 882

These designs seem to show knowledge of le Pautre's prints by which Stothard is known to have been influenced.

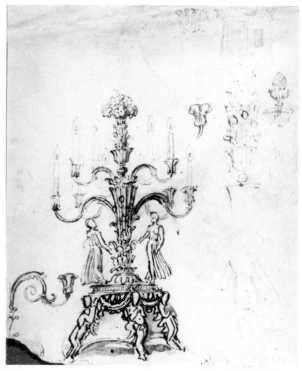

2.8.a

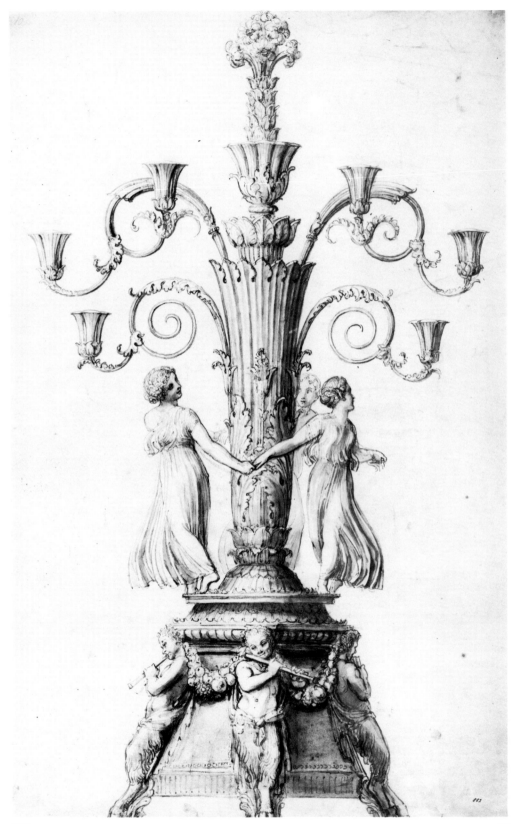

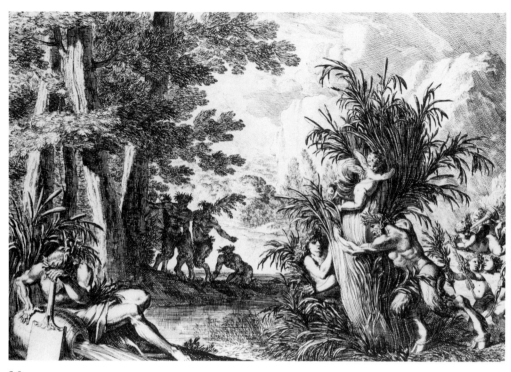

2.8.c

2.8.c Jean le Pautre (1618-1682)

Pan and Syrinx.
Lettered *le Potre Invent. et fecit. le Blond excud. avec privilege du Roy.* Numbered 3.
Etching. 23.1 x 32.5 cm
E.6261-1908

A comparison between the putti about the reeds in le Pautre's print and the putti in the stem of Stothard's sketch (cat. no. 2.8.a) suggests that the original theme for the candlestick was the legend of Pan and Syrinx, in which the nymph Syrinx escapes the god Pan by being transformed into a reed. The noise of the wind through the reed prompts Pan to make the first Pan pipes.

2.8.d Jean le Pautre (1618-1682)

Design for a stand, perhaps from *Nouveau Livre de Termes.*

Lettered *Le Potre fecit cum privil. le Blond excudit.*
Etching. 29.5 x 22.3 cm
E.6707-1908

In Stothard's full-scale design the putti have gone and the stem has become less reed-like, but the subject is still connected with the origin of pipes and flutes. The three Pan figures on the base play on two different sorts of flute and the Pan pipes, to which the nymphs above dance. The form of the base had its origins in the Renaissance filtered through a print such as this.

le Potre fecit cum privil.
le Blond excudet

2.8.d

2.8.g

2.8.e

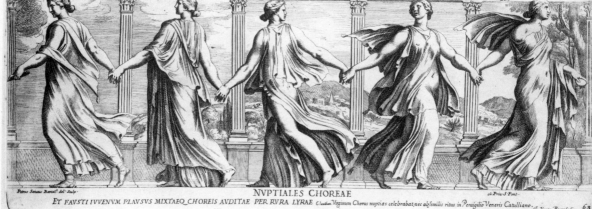

NVPTIALES CHOREAE
ET FAVSTI IVVENVM PLAVSVS MIXTAEQ CHOREIS AVDITAE PER RVRA LYRAE *Claudian.* Virginum Chorus nuptias celebrabat, nec absimilis ritus in Peruigilio Veneris Catulliano. In Hortis Burghesys

63

2.8.f

2.8.e Jean le Pautre (1618-1682) after Etienne le Hongre (1628–1690)

A fountain at Versailles, the basin supported by two nymphs and a cupid.

Lettered with title in French and Latin and *Par Estienne le Hongre de Paris Opus Stephani le Hongre Parisini. In Hortis Versail. le Potre Sculpts. 1673* Etching and engraving. 39 x 28.5 cm E.45-1890

Literature: Berlin no. 2469 (as Pierre le Pautre).

Figures, modelled in the round, arranged around a stem have precedents in Renaissance and Baroque art, including Baroque fountains. In these early examples, however, the figures are usually static in effect and face outwards.

2.8.f Pietro Santo Bartoli (1635-1700)

Nuptiales Chorae. After a frieze of dancing maidens on an antique Roman relief formerly in the Villa Borghese and now in the Louvre. In *Admiranda Romanorum antiquitatum*, 1693 (first edition 1685).

Lettered with title and description in Latin and *Petrus Sanctus Bartoli del. Sculp. cu. Priv. S. Pont.* Numbered *63*. Etching. 16.5 x 45.2 cm National Art Library

Literature: Berlin no. 4203; D. Irwin, *John Flaxman 1755-1826*, 1979, p.22, fig. 26; F. Haskell and N. Penny, *Taste and the antique*, 1981, no. 29.

Dancing classical figures in movement are generally derived from antique reliefs or wall paintings and in their revived form were first employed as reliefs around vases or similar objects.

2.8.g Teapot made by Wedgwood's Factory. Late 18th century.

Impressed in relief with the 'Dancing Hours'.

Impressed WEDGWOOD and A. Black basaltes ware. H. 16.8 cm; D. 14.3 cm Department of Ceramics, 31 & A – 1904

The Borghese dancers (cat. no. 2.8.f) were the basis of Wedgwood's most popular relief decoration, the Dancing Hours, which was modelled by John Flaxman in 1778. The simple drapery of Stothard's maidens suggests, however, that they were derived directly from the Borghese relief or one of a similar type rather than from Flaxman's more complex version.

2.8.h Attributed to Edward Hodges Baily (1788-1867), after Thomas Stothard, R.A. (1755-1824)

Design for a silver candelabrum. c.1820.

Pencil and pen and ink. 49.6 x 29 cm E.111-1964

E.H. Baily was at Rundells in 1815 and became chief modeller and designer in 1826. The upper part of this drawing is an exact copy of Stothard's design: by the early 19th century dancing figures in the round combining the static Renaissance stem with antique examples of figures in movement were the norm. The lower part, however, substitutes two very tame putti seated on a base which repeats the design of the stem above for Stothard's straight lines and the young Pans with their hint of wildness.

2.8.i Attributed to Edward Hodges Baily (1788-1867)

Full-size design for a silver candelabrum. c.1820.

Pen and ink and wash. 59.2 x 26 cm 109

The final stage can perhaps be seen in this drawing attributed to Baily which seems to be a loose variant on Stothard's idea, retaining a straight-sided base.

MS

2.8.h

2.9

Eric Ravilious thought of himself primarily as a painter, especially in watercolour, but he was a distinguished exponent of many other skills, notably those of wood-engraving, lithography, graphic design and – ultimately – of industrial design. These mugs and his design for them are exhibited with an early 19th century pattern book of traditional pottery. They provide an example of a product completely of its own period in spirit and yet reflecting the designer's awareness, probably unconscious, of the tradition in which he was working.

2.9.a Mug to commemorate the expected coronation of Edward VIII. Designed by Eric Ravilious and made by Josiah Wedgwood & Sons Ltd, Etruria, 1936.

Printed mark (in capitals) *To commemorate the Coronation of His Majesty King Edward VIII – 1937 – Wedgwood Made in England – Designed by Ravilious.* Numbered in red *CL 6209 G.*
White earthenware, printed in black and painted in blue and yellow.
H. 10.4 cm; D. 11cm
Department of Ceramics, C.5-1937

Literature: R.Y. Goodden, 'Eric Ravilious as a designer', *Architectural Review*, July – December, 1943, 94, pp.155-162, repr. p.160.

2.9.b Mug to commemorate the coronation of Elizabeth II on 2 June 1953. Made by Josiah Wedgwood & Sons Ltd. Adapted from the design prepared by Eric Ravilious for a commemorative mug for the expected coronation of Edward VIII, a design subsequently adapted and used to commemorate the coronation of George VI in 1937.

Printed mark (in capitals) *To*

commemorate the Coronation of Her Majesty Queen Elizabeth II – 1953 – Wedgwood Made in England – From the design by Eric Ravilious. Numbered in red *C(?) 6485.*
White earthenware, printed in black and pink and painted in yellow.
H. 10.3 cm; D. 10.5 cm
Lent by H. Barkley

2.9.c Eric William Ravilious (1903-1942)

Design for a mug to be produced by the firm of Josiah Wedgwood & Sons Ltd, to commemorate the coronation of Edward VIII expected to take place in 1937. Designs (4), showing both sides of the mug, the handle and inside of the base. Drawn to a scale less than the dimensions of the mug as manufactured. On four sheets cut irregularly and affixed to a larger sheet to provide, with some variants, a detailed design for the entire mug. 1936.

Signed Eric Ravilious and inscribed *Mug to be black blue and yellow* and with other notes.
Pencil and watercolour. Size of sheet 30.7 x 48.2 cm
Given by the designer
E.292-1937

After attending art school in Eastbourne Ravilious attended the Design School of the Royal College of Art, where he was strongly influenced by the teaching of Paul Nash.
His contribution to design in Britain, although sadly short-lived, was substantial. He first worked on the design of lettering in relation to his illustrations for fine editions, most notably those for the Golden Cockerel Press and the Nonesuch Press, and also produced not only illustrations but items such as book-jackets and catalogue-covers for the Curwen Press. In 1935 he produced designs for

■ 2.9.c

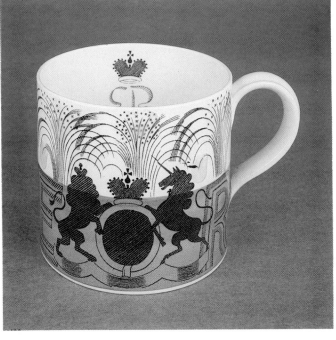

■ 2.9.a

table-glass for Stuart Crystal Ltd and in 1936 designs for furniture for Duncan Hay Ltd, but it was principally through his designs for the firm of Wedgwood that his work became best known to the public.

His association with Wedgwood's began in 1936 and proved to be a very fruitful partnership. The fine traditional shapes still used by the firm, the high quality of their ceramic bodies and their consistently high level of workmanship enabled Ravilious to use to the best advantage his unerring instinct for devising and placing decoration in perfect relationship to the shape of the piece to be decorated. His achievement was possibly the most outstanding of all among those established artists who were employed as designers by the pottery industry in the 1930s. Notable among these were Paul Nash, Vanessa Bell, Duncan Grant and Graham Sutherland who – with others – worked for the Fenton firm of E. Brain & Co. His work was in no literal sense derivative from historic exemplars, but he was clearly deeply

aware of the character and quality of early English hand-decorated and transfer-printed wares and was able to re-express in an entirely contemporary idiom a traditional commemorative theme using twentieth century technical resources to achieve his purpose.

Much of his design work for Wedgwood's achieves its effect through the subtle, varied and always appropriate use as ornament of lettering and numerals, as in this mug design. As may be seen he originally intended the mug to be executed in black, blue and yellow although he indicated the possibility of using pink as a ground and inside the base of the mug. He also showed alternatives for the decoration of the numerals and for the treatment of the formalized firework bursts.

2.9.d Messrs Hartley, Greens & Co

Pattern book of the Leeds firm of potters showing their range of designs

for tea-ware, covered jars, borders etc. 260 pages of white wove paper bound in calf. First quarter of 19th century.

Stamped on the front cover *New Teapot Drawings Book*. The designs numbered throughout from *250* to *610*, with 8 designs for flower-pots numbered *46* to *53*, and 10 designs for sugar jars pasted in the beginning of the volume, numbered *1* to *10*. Inscribed variously with working and colour notes etc.
Pen and ink and watercolour. Size of volume 34.3 x 21.6 cm
Given by A.L. Allen
E.578-1941

The volume is open at a typical page. It shows designs of bold simple shapes decorated in a clear blue and yellow like the colours of the Ravilious design, and another with a star motif, frequently used by designers on ceramics in the 1930s and similar to that on some of Ravilious's lettering.

HB

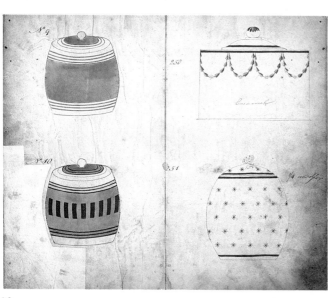

■ *From 2.9.d*

Section 3: Drawings and prints as sources of information

*D*rawing *provides a quick and economical way for the designer to work out an idea intended to be carried out in a less tractable medium and drawings have, therefore, long been valued for the insight they give to the creative mind. The department houses a large number of such drawings but this section is not concerned with them from this aspect. It looks rather at the variety of information that works on paper can provide about an artifact once the creative thinking is over and that of manufacture has begun, and suggests different routes by which similar information may be obtained. Some of the drawings are self-explanatory while others convey little beyond their own image in isolation, but, as one of a large group relating to the same field of design, throw light on workshop practice.*

The section includes working drawings, from which intricate structures can be built with no further input of information, showing details of construction that become hidden in the process of manufacture (cat. no. 3.8.a). It indicates some of the conventions that have been used to convey

information to craftsmen in different fields (cat. nos. 3.2.a, b) and also shows some of the stages a design may go through on paper before it is made in the material for which it has been conceived (cat. nos. 3.4 & 3.6). One group explains how paper itself plays an essential part in transferring an ornamental design to the surface of the finished product (cat. no. 3.5).

The section also suggests how the study of works on paper can place the artifact in a wider context. One group does this in a limited way with drawings of the environment for which the exhibited object was designed (cat. no. 3.7). Another group suggests the artifact's cultural background. An overmantel mirror is exhibited with drawings and prints, some in the form of pattern books, produced during the same period (cat. no. 3.3). A common decorative vocabulary is evident. The similarities of different artifacts produced under the influence of the same ethos is easily seen through representations on paper.

3.1

The Department has a large collection of 16th century Swiss and German designs for stained glass, all in monochrome. This suggests that a set of conventions for the colouring existed and that the glass painter was given a fairly free hand with the limited palette available at this date. Later designs for stained glass went through two distinct stages. First a coloured drawing (called a vidimus), small in scale, was made for the client's approval. Next a full-scale cartoon with cutting lines and colours indicated was produced, over which the glass itself was laid to be cut and painted. The large number in which the early drawings survive enables us to learn something of the earlier practice.

The drawings and panel in this group show the designer employing similar elements in various compositions, thereby giving some idea of the somewhat routine re-use of a stereotyped repertoire.

3.1.a Christoph Murer (or Maurer) (1558-1614)

Design for a panel of painted glass. In the centre, the Descent from the Cross, with St. Ulrich and the Archangel Gabriel. Above, the Annunciation. Below, two kneeling donors (? representatives of religious houses) with their coats-of-arms.

Signed in ink with the monogram *CM*. Dated *1599*.
Pen and ink and wash. 39 x 29.9 cm
Given by the National Art-Collections Fund
E.613-1936

Provenance: William Mayor (Lugt 2799); Henry Oppenheimer.

90

Christoph Murer was a member of a Zürich family of glass-painters of the 16th and 17th centuries. He learned his craft from his father Jodocus Murer and after his father's death in 1580 he left his native city to work in Strasbourg with the Swiss-born artist Tobias Stimmer until Stimmer's death in 1584. In 1586 he returned to Zürich and worked extensively in that city until his own death.

This elaborate composition includes a distant view of Jerusalem – with mountains beyond – which is analogous to the landscape of a distant town and broad river between mountains seen in the panel of painted glass (cat. no. 3.1.c).

3.1.b Christoph Murer (or Maurer) (1558-1614)

Design for a panel of painted glass. Justice, seated within an architectural framework, flanked by amorini to right and left above; one of the latter is blindfolded and handless (symbolizing the uncorrupted impartiality of the Law), the other bears a crown and sceptre (symbolizing the sovereignty of the Law). The central figure pricked for transfer.

Signed in ink with the initial *M* and inscribed with the monogram *TS* (? for *Tobias Stimmer*). Dated *1586*.
Pen and ink and wash. 41.2 x 31.1 cm
1380

The architectural frame shows alternative treatments for the enclosing of the central figure in ornamental strapwork decoration characteristic of the second half of the sixteenth century, ultimately derived from Rosso Fiorentino's work at Fontainebleau in the 1530s but here transmitted through the mid-century designs of such men as Cornelis Floris

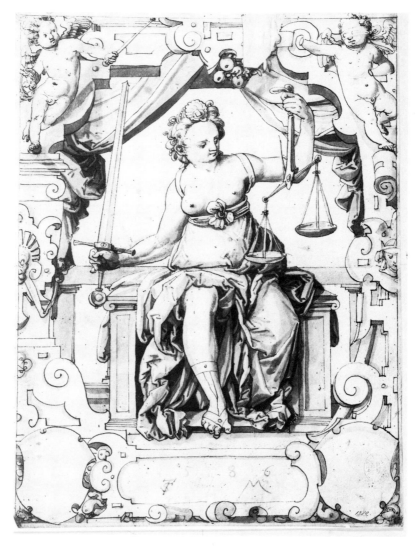

3.1.b

and Hans Vredeman de Vries. The pricking for transfer of the central figure seems to indicate that it was used again.

The amorini shown aloft correspond to their two musical cousins shown in similar position in the panel of painted glass on exhibition. The presence of the apparent monogram of Tobias Stimmer, the former master of Christoph Murer who had died in 1584, may be taken to indicate Murer's indebtedness to Stimmer for the main elements of this design.

3.1.c Panel of painted glass after Christoph Murer (Maurer) (1558-1614). South German (probably Ulm), 1595.

Showing Tobias taking leave of his blind father, Tobit, before setting out with the Angel Raphael to bring back the ten talents of silver from Gabael at Rages. (*Apocrypha, Book of Tobit*, ch.5, v.16). From a series of ten panels depicting the story of Tobit, formerly at Barningham Hall, Cromer, Norfolk.

Size of panel 33 x 21.6 cm
Purchased under the terms of the Bequest of Capt. H.B. Murray
Department of Ceramics, C.563-1921

Literature: *Review of the principal acquisitions during the year 1921. Victoria and Albert Museum*, 1925, p.26, pl.9.

It was customary in Switzerland in the sixteenth century for individuals or societies to commission and present as gifts small panels of stained and painted glass (usually in the format of the present example) either to friends or to institutions with which the donor was associated. The set of ten panels from which this example comes was probably the gift of various members of a bench of magistrates called a *Schöffel*, the name of the individual donor in this case being illegible due to breakage and re-leading. It may be that this set was intended for installation in either a church or a guildhall and the fact that it was probably made in Ulm (about a hundred miles to the north of Zürich, Murer's home town) for use in that city indicates the esteem in which Murer was held as a designer.

Barningham Hall, the Jacobean house from which this panel and its companions come, was partly remodelled in 1805 by J.A. Repton (in association with his father) for T.J. Mott and it may be that the glass was installed at that time.

HB

Designers in many fields use sets of conventions which are understood by the manufacturers of the particular goods for which the designs are made but not necessarily by the uninitiated. This group demonstrates one such convention.

3.2.a Anna Maria Garthwaite (1690-1763)

Design for a woven silk damask. From a set of designs inscribed on the cover 'Damask'. English (Spitalfields), c.1739-42.

Pen, purple ink, wash and preliminary pencil, with a correction cut out and pasted in. 84 x 53.3 cm
5976.12

Literature: J.F. Flanagan, *Spitalfields silks of the 18th and 19th centuries*, Leigh-on-Sea, 1954, pp.12-15.

Anna Maria Garthwaite, daughter of a Lincolnshire parson, was a freelance designer for the Spitalfields workshops from about 1726 to 1746. This design was bought with over fifty others by the Museum in 1868. The purple ink and wash inform the manufacturer that the pattern is of one colour. The purple is a colour code used by Garthwaite for all her damask designs since the pattern is self-colouring relying on the contrasting effects of light reflecting from the vertical warp and the horizontal weft.

3.2.b Petticoat. Silk damask. c.1739-1742.

Made from five widths of silk damask each 21 inches wide.

H. 91.4 cm (approx.) Circumference of skirt 610.5 cm
Given by Mrs G.F. Rollason in

94

memory of Mrs Harriet Eliza Gilbert
Department of Textiles and Dress,
T.254-1981

The green silk damask of this petticoat is similar to that which would have been made from Anna Maria Garthwaite's design of the same date (cat. no. 3.2.a).

3.2.c Wallpaper with a 'blotch' damask design. Last quarter of 19th century.

Monochrome print in greenish cream, on buff, from wood block.
71 x 53.3 cm
E.2239-1913

Literature: C.C. Oman and J. Hamilton, *Wallpapers, a history and illustrated catalogue of the collection in the Victoria and Albert Museum*, 1982, no.398.

The pattern of this wallpaper is related to designs for Spitalfields damasks by Anna Maria Garthwaite. The Museum's collection also includes portions of the wallpaper in green on khaki and pink on beige. The late 19th century re-interpretation of these mid-18th century designs in one colour on a coloured paper cleverly imitates the effect of the damasks with similar economy of method.

JH

3.2.a

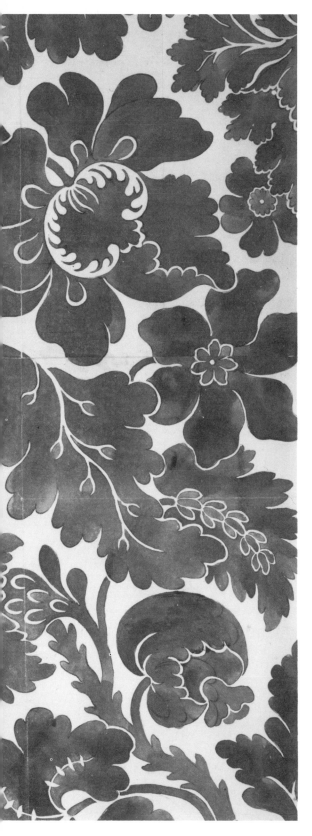

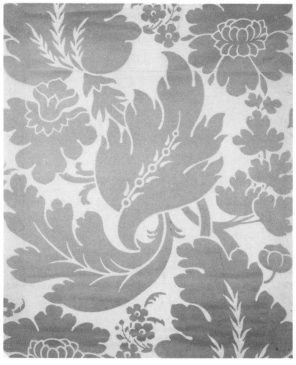

3.2.c

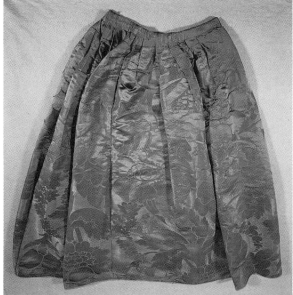

The study of a three dimensional object together with works on paper executed at about the same time containing related elements can often reveal more about the ornamental vocabulary from which they all derive than can the isolated study of the individual items. This group looks at a mid-18th century overmantel mirror and a selection of drawings and prints from this point of view. They share some devices characteristic of rococo chinoiserie, a style which reached the height of its popularity during the period 1745-60, and which drew freely on motifs such as dragons, mythological birds, pagodas, mandarins and bells, to create a fantasy world loosely associated in the contemporary mind with China.

3.3.a Overmantel mirror, English. Mid 18th century.

Carved wood frame, with decoration gilt; gilt on ruby and green lacquer grounds, and painted in colour.

H. 264.2 cm; W. 157.5cm; D. 21.6 cm
Department of Furniture and Woodwork, W. 65-1938
Literature: R. Edwards, 'A chinoiserie lacquered mirror', *Apollo,* 1939, 29, pp.130-1.

The mirror has an irregularly conical frame of gilt rusticated branches with scrolled rococo detail and entwining leaf sprays, some straying across the surface of the glass. At the top beneath a projecting openwork summit of pagoda form, is a seated figure of fanciful Chinese type, flanked by confronting dragons on pedestals. Below, beneath a pair of gilt metal candle-holders of rusticated leafy sconce form, is a splay-fronted alcove, surmounted by a domed top, resting on a recurved balcony-platform

96

approached from lateral platforms by symmetrical flights of six steps.
The base is horizontal in the form of irregular rockwork and moss.

Pl.5 shows a gilt overmantel mirror apparently based on a similar design to the one on exhibition, although far less restrained in treatment, which formerly hung in the Chinese bedroom at Badminton House. The suite of furniture which it accompanied, commissioned by the Duke of Beaufort for the bedroom in 1753, was previously associated with the name of Chippendale, but recent research has revealed that the suite was supplied by the furniture firm of William Linnell. The authorship of this mirror, which was the most elaborate of those hanging in the room, is uncertain, although it is strongly reminiscent of the manner of William's son, John Linnell.

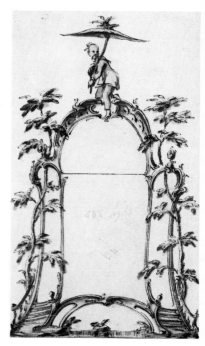

3.3.b

3.3.b John Linnell (1723-1796)

Designs for two rectangular mirror frames. c.1755-60.

E.187 inscribed in pencil *Breakfast room Plate 2 No.1* and with measurements of mirror. Numbered in ink *3.*
Pen and ink and watercolour.
18.4 x 12.5 cm; 18.7 x 11 cm
E.187, 227-1929

Literature: P. Ward-Jackson, *English furniture designs of the 18th century* 1958, pp.54-5; P.A. Kirkham, 'The careers of William and John Linnell', *Furniture History,* 1967, 3, pp.28-44; H. Hayward, 'The drawings of John Linnell in the Victoria and Albert Museum', *Furniture History,* 1969, 5, pp.1-115, repr. figs.76, 77; H. Hayward and P.A. Kirkham, *William and John Linnell, 18th century furniture makers,* 1980, I, pp.10, 76, 77, 97, repr. figs. 180, 181.

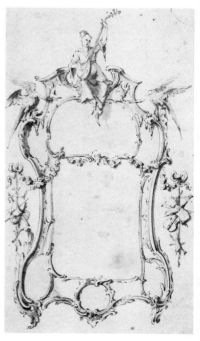

3.3.b

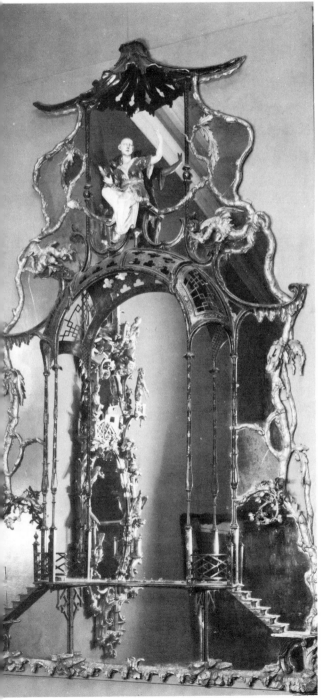

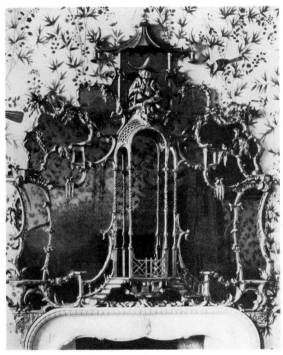

Plate 5 Overmantel mirror, English.
c.1753.

■ 3.3.a

The drawings come from a large album containing designs for furniture, etc, on 356 sheets, each of which is now mounted separately. The album was compiled by the architect Charles Heathcote Tatham, and is entitled in ink *A Miscellaneous Collection of Original Designs, made, and for the most part executed, during an extensive Practice of many years in the first line of his Profession, by John Linnell, Upholsterer Carver & Cabinet Maker. Selected from his Portfolio's at his Decease, by C.H. Tatham Architect. AD 1800.* Two of the drawings in the collection are by Henry Holland, and about twenty-six by Tatham himself. The pencilled inscriptions of plate numbers on many of the designs is evidence that Tatham had gathered them together with a view to publication.

Linnell's two designs include several 'Chinese' motifs: the first mirror frame incorporates a Chinese musician flanked by two ho-ho birds, and the other is an arched structure based on a double flight of curving steps and surmounted by an oriental figure carrying a pagoda-shaped umbrella. The mirror on exhibition embodies elements from both these designs, possibly adapted from common engraved sources. The central Chinese figure, although not carrying an instrument, is similar in pose to the musician in the first of Linnell's drawings, and the alcove supported on tapering columns with two symmetrical flights of steps at its base, echoes the composition of the second.

3.3.c Pierre de Rochefort (1673-1728) after Jean Bernard Honoré Toro (Turreau) (1672-1731)

Two plates from a set of 6 entitled *Livre de Tables de diverses formes,* published by C.N. le Pas Du Buisson, Paris. Early 18th century.

Both lettered *I.B. Toro Inv. et del De Rochefort sculpsit* and *C.P.R.* Engravings. Both 22.5 x 33.5 cm
17534; 17535

Literature: Guilmard no. 79, pp.115-6; Berlin Königliche Museen (Kunstgewerbe Museum): Handbücher: R. Graul, *Das XVIII Jahrhundert, Dekoration & Mobiliar,* 1905, p.19, fig. 10; Berlin no.1251.

The ornamental engravings of French designers such as Bernard Toro, Daniel Marot and Jean Bérain were well known to mid-18th century English furniture-makers and designers. This pair of plates show dragons similar to those which confront each other in the overmantel mirror.

3.3.d Charles Albert de Lespilliez (1723-1796) after John François de Cuvilliés I (1695-1768)

Cartouche. Title-plate from a set of 4 entitled *Morceaux de Caprices, A Divers Usages ... 10me. Livre,* published by the artist and by Poilly, Paris (series letter K). Post 1745.

Lettered with title and *Inventées, par François de Cuvilliés, Premier Architecte de S.A.S.E. de Baviere, se vend chez Lauteur. Gravez par Charles Albert de Lespilliez. Se vend aussi a Paris chez le St. Poilly rüe St. Jacque a limage St. Benoit. Avec Privilege du Roy. C.P.S.C.M.*
Etching. Cut to 35 x 22.1 cm
12950.1

Literature: Guilmard no.31, pp.163-4; Berlin no.146.

Cuvilliés was another French designer of ornament whose influence reached England through his published works. The decorations on this title-page, for example, are a spirited fantasy very much in tune with the drawings by John Linnell (cat. no. 3.3.b).

3.3.c

3.3.c

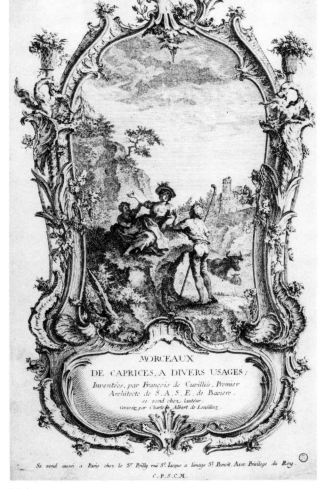

3.3.d

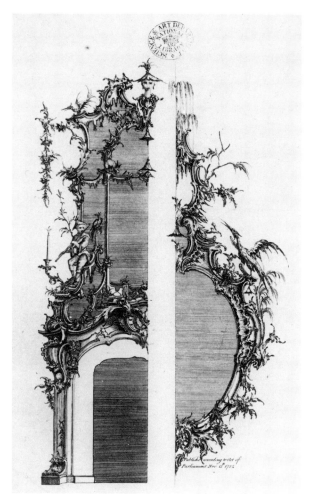

3.3.f

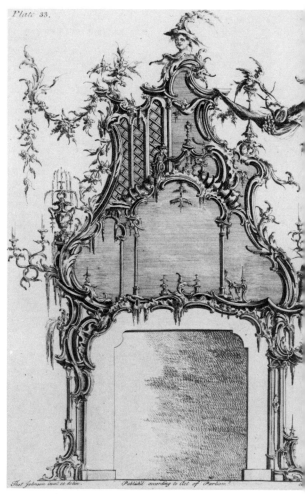

3.3.g

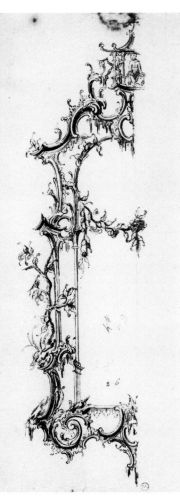

3.3.e

3.3.e Attributed to Thomas Chippendale (c.1718-1779)

Design for a mirror with a 'Chinese' figure. c.1760.

Inscribed in pen and pencil with the mirror's measurements.
Pen and ink and wash. 27.7 x 7.8 cm
D.764-1906

Literature: P. Ward-Jackson, *op.cit.*, p.43.

This drawing by Thomas Chippendale, whose famous book of designs *The gentleman and cabinet-maker's director* was first published in 1754, shares some stylistic features with the overmantel mirror (3.3.a). Both incorporate an arch supported on slender tapering columns which is surmounted by a Chinese figure beneath a pagoda top. The jagged fringes at the base of the design compare with similar decoration on the overmantel mirror, while the composition of both is dependent for its effect on a complex rhythm of sinuous scrollwork and foliage.

3.3.f Matthias Lock (c.1710-1765) and H. Copland (worked 1738 - died 1761)

Designs for two mirrors, one an over-mantel. Plate 4 from a set of 12 in *A New Book of Ornaments with Twelve Leaves. Consisting of Chimneys Sconces, Tables, Spandle Pannels, Spring Clock Cases, & Stands. A Chandelier & Gerandole &c. By M. Lock and H. Copland ... Publish'd ... Nov. 13 1752 & Sold by the Proprietors M. Lock near ye Swan Tottenham Court Road & E. Copland Gutter Lane Cheapside.*

Lettered *Publish'd according to Act of Parliamt. Nov 13 1752.*
Etching. 27.7 x 18.3 cm
E.5050-1907

Literature: Berlin no. 1226; P. Ward-Jackson, *op.cit.*, pp.14, 38; M.

Heckscher, 'Lock and Copland: A catalogue of the engraved ornament', *Furniture History*, 1979, 15, pp.1-23.

3.3.g Butler Clowes (d.1782) after Thomas Johnson (1714-c.1778)

Design for an overmantel mirror. Plate 33 from a set of 53 in an untitled collection of designs, the first page dedicated *To the Right Honble: Lord Blakeney, Grand President of the Antigallican Associations, and the rest of the Bretheren of that most Honourable Order:* etc, and lettered *Sold by T. Johnson Carver, At the Golden Boy, in Grafton Street, St. Ann's Westminster. Publishd ... April 23d. 1758.*

Lettered *Plate 33. Thos: Johnson invt. et delin. B: Clowes sculp. Publish'd according to Act of Parliamt.*
Etching. 24.5 x 17.5 cm
E.3751-1903

Literature: P. Ward-Jackson, *op.cit.*, pp.21, 48-9; H. Hayward, *Thomas Johnson and English Rococo*, 1964, pp.23-6.

Like Linnell and Chippendale, Lock and Johnson lived and worked around the St. Martin's Lane area of London, and during the 1740s and 50s they shared a rococo style characterized by its writhing and fantastic forms, frequently enlivened by the addition of 'Chinese' motifs. Visual cross-references abound in the various pattern books published during this period.

MT

3.4

J.D. Schubert was born in Dresden and studied at the Dresden Academy where he painted mainly battle- and history-scenes and where he eventually became Professor of Painting in 1801. He originally found employment in 1781, along with other academic painters, at the Meissen factory to paint battle-scenes on porcelain. Count Marcolini had taken over the direction of the factory in 1775 and was endeavouring to renew the – by then diminished-appeal of its products to the public by employing young talent. In 1786 Schubert became teacher of drawing in the factory's drawing school where the apprentices had to serve a seven-year term and in 1795 he became principal painter to the factory and head of the workshop. The exhibited drawing throws some light on studio practice in the development of the final design on the saucer.

3.4.a Johann David Schubert (1761-1822)

Preliminary drawing for the figure of Charlotte in a design illustrating the episode of Charlotte giving her husband's pistols to Werther's servant from Goethe's novel *The Sorrows of Young Werther*. The completed design was used for the painted enamel-decoration on a saucer in a Meissen porcelain *tête-à-tête* tea and coffee service of about 1790.

Red chalk. 18.8 x 14.1 cm
Given by M. Whitney
E.545-1975

Literature: W. Pfeiffer, 'Die Werther-Illustrationen des Johann David Schubert', *Schriften des Goethe-Gesellschaft, 46*, Weimar, 1933.

W. Pfeiffer, writing in 1933, recorded eleven watercolours and two vignettes

of *Werther* subjects by Schubert in the Design Collection of the Meissen factory. They did not include, however, the subject to which this present drawing relates and which appears on the saucer exhibited with it.

These designs were produced in 1787-88 and were intended to serve as models for the enamel-painted versions used to decorate the porcelain. This drawing appears to be a preliminary sketch for the now lost or unrecorded finished watercolour serving as pattern for the subject depicted on the saucer. Its liveliness and its close correspondence to the figure of Charlotte as painted demonstrate its important role in the working-out of the design. It must be assumed that the ruled lines forming a border were added subsequently. They may well be a sign of the change in the drawing's status from a working design to a collector's piece.

3.4.b Saucer from a *tête-à-tête* tea and coffee service made by the Meissen Factory, Dresden. c.1790.

Painted with a scene from Goethe's novel *The Sorrows of Young Werther*, showing Charlotte handing her husband's pistols to Werther's serving-boy.

Marks: crossed swords with a star and *Bl* in underglaze blue.
Porcelain painted in enamel-colours and gilt. Diameter 13.5 cm
Department of Ceramics, 1328.F-1871

Literature: W.B. Honey, *Dresden China*, 1954, p.140, pl.61 C;
The age of neo-classicism, Arts Council of Great Britain Exhibition 1972, no. 1439, pl.120b.

Johann Wolfgang von Goethe (1749-1832), poet, dramatist and writer, was invited by the Duke of Weimar to join

his court in 1775, the year after the first publication of his *The Sorrows of Young Werther;* Goethe accepted the invitation and spent the rest of his working life in Weimar. The novel was largely instrumental in reviving the concept of Romantic Love in a most extreme form and exercised a very wide literary influence throughout Europe. It had an enormous success everywhere, was widely translated from the original German and in 1787 Goethe published a revised version.

Despite its wide literary appeal the work was relatively little illustrated and the designs created by Schubert at the Meissen factory in Dresden are unusual in their application of this popular story to the visual and decorative arts.

HB

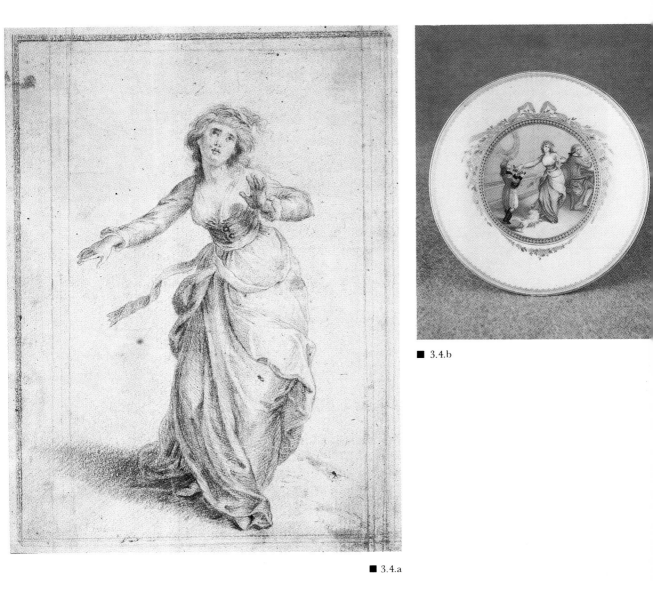

■ 3.4.a

■ 3.4.b

3.5

Transfer-printed earthenware made in Staffordshire became as popular and as widely used at home and abroad during the first half of the 19th century as creamwares had been in the closing decades of the 18th century. This group demonstrates a variety of ways in which looking at works on paper adds to our knowledge of transfer-printed ceramic wares. It shows some sources for decoration and goes some way to explaining how they were changed into decorations and applied to the earthenware.

3.5.a Anonymous, English

Ceramic-transfer showing a tiger-shoot. The 'Burmah' pattern, probably produced by Harding & Cockson, Cobridge, c.1850.

Engraving. 28.5 x 29 cm
8223.25

Transfer-printed earthenware represented an extension of the transfer-printing technique introduced at the Bow and Worcester porcelain factories by Robert Hancock prior to 1760 and subsequently developed in Liverpool for use on Staffordshire creamwares by Sadler and Green. They were intended as cheap wares and for this reason were usually printed in monochrome, blue being the colour most favoured by the public.

The process of transfer-printing involved taking an impression from an engraved copper-plate which had been specially inked for application to the earthenware body. After the design had been transferred it was fixed by a low temperature firing. In this way a single copper-plate could be used to decorate many items.

This example shows a complete transfer from one such copper-plate embodying the central design for the surface of the plate, the decorative borders and the name of the pattern and the maker's initials for printing on the back.

It is interesting to compare this later transfer of a tiger-shoot in progress with the earlier plate (cat. no. 3.5.c) of a similar sort of subject.

3.5.b H. Merke (worked c.1800-c.1820)

The Death of the Bear. Pl.29 of Capt Thomas Williamson's *Oriental field sports*, London, 1807. Engraved after a drawing by Samuel Howitt (c.1765-1822) from an original sketch made in India by Capt Williamson.

Aquatint and stipple-engraving, coloured by hand. 37.1 x 47.6 cm
National Art Library

The engravings, forty in number, were published separately from June 1805.

3.5.c Plate made by Spode, Stoke-on-Trent. c.1810.

'Death of the Bear' pattern, taken from Pl.29 of Capt Thomas Williamson's *Oriental field sports*, London, 1807.

Printed marks *Death of the Bear* and *Spode*. Impressed mark *Spode 27*. Earthenware, transfer-printed in underglaze blue. Diameter 25.2 cm
Department of Ceramics,
Circ.314-1974

The immediate appeal of the new wares lay in the pictorial character of their decoration, which was most commonly copied from engravings already in use as book-illustrations. In this example the central scene is taken from the splendid exhibited print (cat.

3.5.a

104

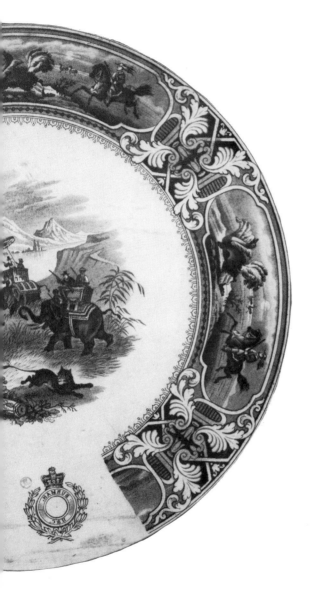

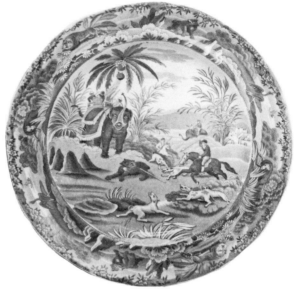

3.5.c

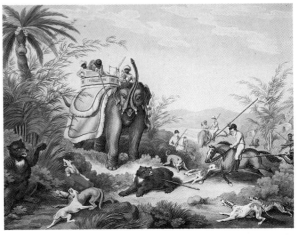

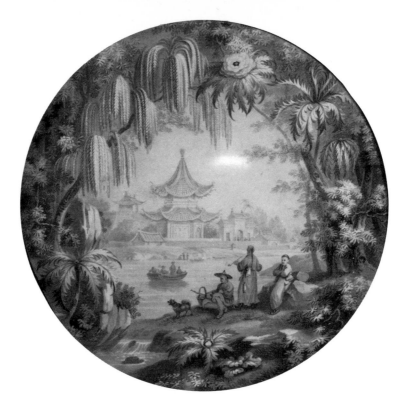

3.5.g

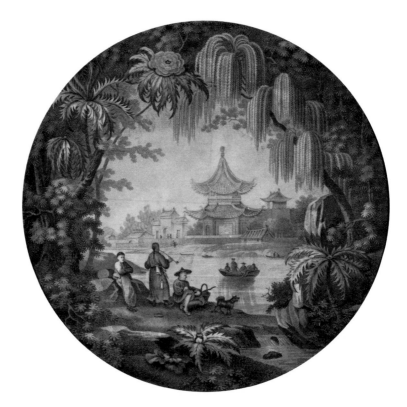

3.5.e

no. 3.5.b), the title of the subject being printed on the base of the plate. The border decoration is made up from elements in other prints in the series.

3.5.d Thomas Bewick (1755-1828)

The Stag, or Red-deer. Late impression of a wood-block illustration to the artist's publication entitled *A general history of quadrupeds*, Newcastle-upon-Tyne, 1790.

Wood-engraving. 8.1 x 8.1 cm
Circ. 532-1965

3.5.e Anonymous, English

Design for a ceramic-transfer showing a stag standing in parkland, with two other stags in the background. c.1820.

Pencil and wash, 9.4 x 15.4 cm
8177.59

The principal stag and the adjacent tree appear to have been adapted from Bewick's wood-engraving of 'The Stag, or Red-deer' in his *A general history of quadrupeds*, 1790.

3.5.f Plate, Unidentified maker, c.1815-20.

Design including a standing stag taken from Thomas Bewick's wood-engraving to his publication entitled *A general history of quadrupeds*, Newcastle-upon-Tyne, 1790.
Unmarked.
Earthenware, transfer-printed in underglaze blue. Diameter 25.2 cm
Department of Ceramics,
Circ. 200-1949

This plate merely uses Bewick's representation of the stag as the principal element in a larger composition devised to fill the surface of the plate. The border decoration is derived from other illustrations to the *Quadrupeds*.

3.5.g Anonymous, English

Design for an engraving to be used as a ceramic-transfer with the engraving from it, showing an exotic Chinese scene. Factory unidentified, c.1820.

Pencil and wash; engraving. Each, diameter 25 cm
8216.62; 8178.49

The Department has a collection of nearly 9000 designs for ceramic transfers and of impressions from ensuing plates acquired as examples of modern decoration in 1877. The engraving is in reverse of the drawing, but once printed onto the earthenware the image reverses again and is the same way round as in the drawing.

HB

■ 3.5.f

3.5.d

107

3.6

William De Morgan produced tiles of the character of the designs and of the actual tile on display throughout his distinguished career as a potter which began in 1872 when he set up his first factory in Chelsea. From 1882 to 1888 he was established as a near neighbour of William Morris at Merton Abbey in Surrey. Tiles such as these were intended either for use singly or as part of a larger group; the factories also produced tiles with repeating patterns and others which were sections of a larger design intended to be assembled together to form a panel. The two drawings, selected from over 1000 by De Morgan in the Department, give an insight into the way he worked.

3.6.a William Frend De Morgan (1839-1917)

Design for a 6 inch ruby lustre tile showing a grotesque bird. Chelsea or Merton period.

Numbered in ink *209*.
Pencil and watercolour. Size of sheet 18.5 x 18.5 cm
Given by Mrs Evelyn De Morgan, widow of the designer
E.970-1917

This design is not pounced (i.e. pricked for transfer) which indicates that it was never used. Many similar designs were used as may be seen from the pounced design exhibited with this sheet and the tile.

3.6.b William Frend De Morgan (1839-1917)

Reverse of a pounced (i.e. pricked for transfer) design in pencil and water-colour for a 6 inch ruby lustre tile showing a grotesque bird. Chelsea or Merton period.

Numbered in ink on the design *203*.
Size of sheet 18.1 x 18.6 cm
Given by Mrs Evelyn De Morgan, widow of the designer
E.971-1917

The pouncing of this design indicates that it was in fact used and that the pricked outline would be transferred to the surface of the blank tile by the application of finely powdered charcoal to the surface of the drawing; this process facilitated the painting of the tile. The tile would subsequently be fired to produce the rich red lustre effect.

3.6.c Tile by William De Morgan. 1880s.

Painted with a grotesque bird.

With the mark of the Merton Abbey factory (1882-1888)
Ruby lustre on white slip. 15.3 cm (i.e. 6 ins.) square
Given by Archibald Anderson
Department of Ceramics, C.270-1915

Literature: R.W. Pinkham, *Catalogue of pottery by William De Morgan, Victoria and Albert Museum*, 1973, no.88, p.96

HB

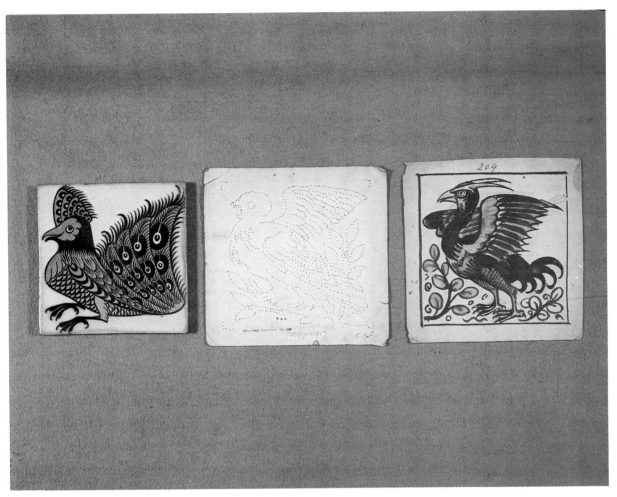

 3.6.a-c

*The works in this group are all
connected with the reconstruction,
decoration and refitting of the offices
of the Essex and Suffolk Equitable
Insurance Company, Capel House,
54 and 62 New Broad Street, London
EC2, 1906-9 by the architect, C.F.A.
Voysey. Writing in* The Builder, 47,
1909, p.466, *he said of this commission:
'We put in new windows, doors, fire-
places and floors, and furnished the
offices; everything being designed by me,
even the calendars, ink-stands, pen-tray,
etc. The principle we worked on was to
have everything durable, and minimise the
cleaning as much as possible. Thus the
upkeep is reduced to a minimum. All the
woodwork and furniture is in oak, left
in its natural colour. The counters are
gilded, with quarter plate glass on top.
All the windows are glazed with
Chance's panels of stained glass
representing the arms of the towns in
which the Society does business:
chimneypieces are unpolished carved
black marble with arms emblazoned.
All furniture fittings, such as handles
and hinges, are in bronze.' The
drawings and chair corroborate and add
to this statement.*

3.7.a Charles Francis Annesley Voysey, F.R.I.B.A. (1857-1941)

Design for a coat-of-arms.

Inscribed with job reference and *Arms
over chimneypiece recess end of female clerks
office carved in black marble* and in ink
*C.F.A. Voysey Architect 23. York Place.
W. January. 20. 1907.*
Pencil. Size of sheet 56 x 77.4 cm
Given by the architect
E.282-1913

3.7.b Charles Francis Annesley Voysey, F.R.I.B.A. (1857-1941)

Design for a coat-of-arms.

Inscribed with job reference and *Arms
over chimneypiece in chief clerks office
carved in black marble.*
Pencil. Size of sheet 56 x 77.9 cm
Given by the architect
E.281-1913

These two designs for coats-of-arms
demonstrate the attention the
architect paid to detail. When the
Museum acquired them in 1913 as a
gift from the architect himself, among
a group of fifty designs for domestic
architecture, stained glass, wallpaper,
furniture and metalwork, they told the
student more about the architect's
method of work than the particular
project for which they were made.
Voysey's own view was that he valued
them little, writing 'It tickles my
vanity to think that anyone should
want my drawings' (letter, 14/1/1913)
and 'I have never regarded my
drawings more than as a means to an
end and the end is all absorbing'
(letter 17/2/1913). But as more
objects connected with the project
have come into the Museum's
collection they have helped to round
out existing knowledge of an interior
which has virtually disappeared.

3.7.c Charles Francis Annesley Voysey, F.R.I.B.A. (1857-1941)

View of the interior of the Board
Room.

Pencil and watercolour.
37.1 x 54.6 cm
E.711-1969

Literature: Repr. J. Brandon-Jones &
Others, *C.F.A. Voysey: architect and
designer 1857-1941*, catalogue to
exhibition, 1978-79, p.62.

3.7.d Charles Francis Annesley Voysey, F.R.I.B.A. (1857-1941)

View of the interior of one of the
general offices.

3.7.a

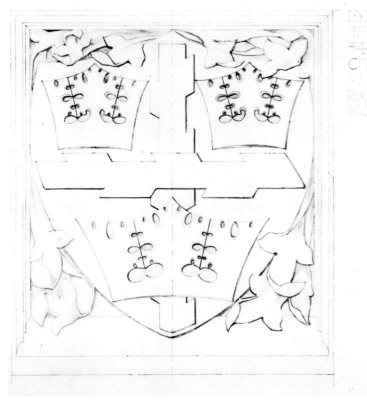

3.7.b

111

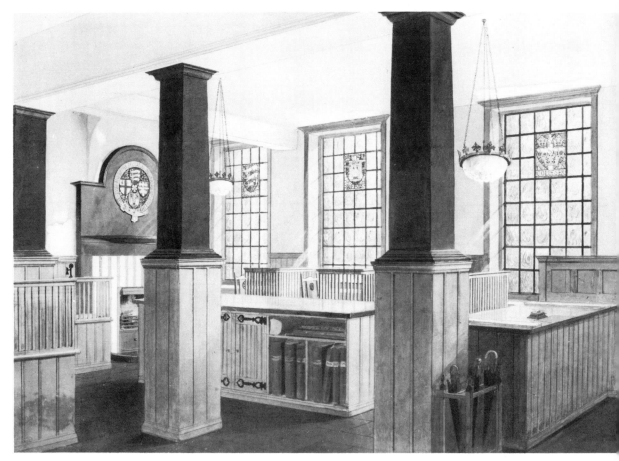

3.7.d

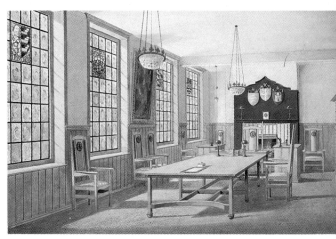

■ 3.7.c

Pencil and watercolour. 37.1 x 54.6 cm
E.712-1969

Literature: A view of a similar office is repr. *The Builder*, 97, 1901, between pp.466-7.

The original purpose of the watercolour views of the offices is not clear. They may have been the architect's vision of the offices made to show his intentions to the client or they may have been made later, as a record of the scheme. The fact that another watercolour from the series was exhibited at the Royal Academy in 1909, while detailed drawings were being made in 1907, suggests that the latter may have been the case. Whatever the reason for their existence, the fact that Voysey, already well-established as an architect, chose to exhibit one is an indication of the importance he attached to the whole scheme.

The offices at Capel House are again being refitted. These drawings have been consulted recently by the staff of the Historic Buildings Division of the GLC in order to help them advise on the alterations under consideration.

3.7.e Armchair designed by C.F.A. Voysey.

One of a set of 12 designed for the offices.

Oak, upholstered in leather. H.140 cm; W. 64.2 cm
Given by the firm of Chase, Henderson and Tennant
Circ. 517-1954

Another from this set is in the Geffrye Museum and two more are in the William Morris Gallery, Walthamstow.

The chair was acquired in the 1950s from the offices when they had been taken over by a different firm. Being a fine piece of furniture designed by Voysey it was a valuable addition to the Museum's collections, but its interest to the historian of design is greatly increased by the discovery of a watercolour view made by its designer showing a set of them in the context for which it was made.

SL

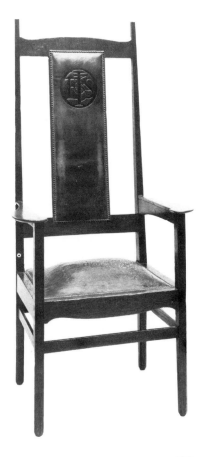

3.8

One of the more obvious ways in which drawings give additional information to that which can be seen from the constructed piece itself, is to show exactly how it has been put together. These two drawings illustrate this point in different ways.

3.8.a Sir Sydney Gordon Russell, C.B.E., M.C., R.D.I., F.S.A. (1892-1980)

Design for an oak chest of drawers. Front elevation, side elevation, part plan of top and feet, scale 3 inches to 1 foot. Full scale details of handle and parting rail.

Signed and dated in ink *GR. 6.27.* Inscribed with title, constructional details and *for drawings, lined white mahogany or Spanish chestnut, laburnum or mulberry handles drawer front with incised and painted numerals 1-50, 51-100, 101-150 etc.* Numbered *No.617.* Stamped *Designed by Gordon Russell. Copyright of the Russell workshops (Russell & Sons) Broadway Worcs. Please return.* Stamped in red *Despatched.*
Pen and ink on tracing paper.
33.6 x 41.5 cm
Given by the designer
E.333-1977

Gordon Russell began his career as manager of the repair shop of his father's antique business. He started designing furniture in about 1910 working in the Arts and Crafts tradition. In 1926 he founded Gordon Russell Ltd and from about that date began using mechanised methods of construction. Around 1930 his firm's designs took on a simpler 'modern' appearance. During the Second World War he headed the team that designed Utility Furniture.

This drawing has been selected from nearly fifty by the firm in the Department's collections. It is the working drawing from which the chest of drawers, thought to have been made to house the firm's drawings, was constructed. It is a traditional piece: its overall lines are simple but the decorative use of a variety of luxury woods and the attention paid to detailing, including chamfered edges and decorative as well as constructional dovetailing are in keeping with the firm's earlier work. The drawing shows the type and dimensions of the various joints in the chest and also draws attention to the two roles of the dovetailing.

3.8.b Brian Long, M.S.I.A. (born 1934)

Chair specification, designed to a competition brief. Sheet 8 of 9. c.1965.

Inscribed with descriptions of component parts and various notes. Lettered with title and *TOM-BU* and numbered *8.*
Pencil, indian ink and poster colour.
56.7 x 76 cm
Given by the designer
E.1612-1977

The drawing presents an 'exploded' view of a dining chair, showing its component parts and how they fit together. A version of the chair was made by Heal Furniture Ltd as part of the 'Catena' range of dining room furniture. The collection includes two other drawings for the project, one showing the projected interior and the other an 'exploded' view of a dining table.

SL

114

3.8.a

■ 3.8.b

115

Section 4: The Museum's collections as a grammar of design

The Victoria and Albert Museum owes its existence, indirectly, to the findings of a committee of the House of Commons set up in 1836 to investigate the promotion of art in Britain. The report stated that 'from the highest branches of practical design, down to the lowest connexion between design and manufacturers, the arts have received little encouragement in this country'.[7]

It made two major recommendations in order to help remedy the situation. One was to establish schools of design where the application of art to industry would play a central part. The other was that encouragement should be given to the formation of museums and galleries throughout the country with the suggestion that their collections should not be restricted to examples of ancient art but should include also 'The most approved specimens, foreign as well as domestic, which our extensive commerce would readily convey to us from the most distant quarters of the globe.'[8]

One aspect of the report was acted on immediately. The School of Design (later to become the Royal College of Art) was opened in London in rooms in Somerset House in 1837, with a selection of books and casts for guidance, followed during the next few years with examples of contemporary decorative art. In 1841 the Government set up 17 similar schools in the main manufacturing towns with the result that the London School became increasingly a training ground for teachers for the provinces. During the next few years the school's reputation declined, impetus went out of the scheme, and the casts and examples of decorative art were no longer available to the students, having been relegated to the cellars.

It was with these objects, expanded with £5000 worth of purchases from the Great Exhibition of 1851, that Henry Cole set up the museum called at

different times 'The Museum of Manufactures' or 'The Museum of Ornamental Art' (the V&A in embryonic form) at Marlborough House in 1852. The following year the School of Design moved to the same premises.

The Catalogue of the Museum of Ornamental Art, at Marlborough House, fifth edition (May 1853) stated that 'The objects of the Museum are three-fold. Some specimens are included which, as the collection increases, are intended to illustrate the history of various manufactures, – some for extreme skill of manufacture or workmanship, whilst others are intended to present to the manufacturer and to the public choice examples of what science and art have accomplished in manufactures of all kinds, and this not so much with a view to the works being copied or imitated, as to show that perfection and beauty in art are not matters of caprice or dependent upon the fancy of the beholder any more than perfection and beauty in nature.' It goes on to expound on the 'General Principles of Decorative Art'.

The catalogue was preceded by a list of rules to be enforced to insure that the Museum 'be kept as a place of study'. Among these were that 'All registered Students of the Department of Practical Art will have free admittance daily, upon production of their Fee-Receipts.' 'All Students in the Special Classes of the Department will have, in addition, the privilege of examining and copying any examples, without payment of any additional fee.' 'On Mondays and Tuesdays, PERSONS NOT STUDENTS will be admitted free; but on these days Examples cannot be removed from their cases for study.' 'On Wednesdays, Thursdays, and Fridays, PERSONS NOT STUDENTS will be admitted on payment of 1s. additional each person: Manufacturers and others, by payment of

an Annual Subscription of £1. 1s., may enjoy the same privileges, and obtain a ticket, transferable to any member of the firm, or any person in their employ.' In all cases a member of the Museum staff had to be present and students were to wash their hands before being allowed to handle any object.

The Museum's links with the Royal College have remained strong even since the latter became totally independent in 1949, but it only takes a walk through the galleries on any day to see that the collections are studied and drawn copies are made by a far wider clientele.

This small group of exhibits aims to show how the Museum's collections have been in different ways a source of inspiration to a variety of designers, at all stages of their careers. At the same time it indicates some of the ways the Museum has used 'works on paper' to spread the 'good principles of design' beyond the confines of the Museum building itself.

4.1 Wallpapers, English. c.1853.

Five samples used to demonstrate 'False Principles of Decoration' at the Museum of Ornamental Art, Marlborough House, Pall Mall, London: three of the samples bearing labels with the numbers etc. listed in the catalogue of the Marlborough House Collection, issued by the Department of Science and Art, 1853.

Colour prints from wood blocks, and some machine printing.
Average size 53.5 x 53cm E. 158-1934; 99.4 x 53.3 cm
E.558-1980; E.158-1934;
E.560-562-1980

No.27 'Perspective representations of a railway station, frequently repeated and falsifying the perspective.'
Produced by Potters of Darwen.
E.558

No.28 'Perspective representation of the Crystal Palace and Serpentine; with flights of steps and architectural framework, causing the same error as in No.27'. Probably produced by Heywood, Higginbottom & Smith, Manchester, c.1853-55.
E.158-1934

[No.32]? 'Imitation of a picture repeated all over a wall, although it could be correctly seen from only one point.'
E.560

No.35 'Horses, water, and ground floating in the air;
landscape in perspective.'
E.561

No.36 'Objects in high relief; perspective representations of architecture employed as decoration for a flat surface.'
E.562

Literature: C.C. Oman and J. Hamilton, *Wallpapers, a history and illustrated catalogue of the collection in the Victoria and Albert Museum,* 1982, nos.270A, 271.

[7] Quoted from J. Physick, *The Victoria and Albert Museum, the history of its building,* 1982, p.13.

[8] Ibid.

Obviously the Museum of Ornamental Art concentrated on what those involved saw as objects displaying the 'correct principles of design', but for a short while the first room was devoted to a demonstration of what was termed Examples of False Principles in Decoration: 'a collection of articles such as are of daily production, which are only remarkable for their departure from every law and principle, and some even from the plainest common sense, in their decoration'. The correct principles for paper-hangings were said to be:

'1 The decoration of paper-hangings bears the same relation to the objects in a room, that a background does to the objects in a picture.

2 It should not, therefore, be such as to invite attention to itself – but be subdued in effect, and without strong contrasts either of form, colour, or light and dark.

3 Nothing should be introduced which disturbs the sense of flatness.

4 All natural objects, therefore, when used as ornament for these manufactures, should be rendered conventionally flat and in simple tints.

5 While the decorative details should be arranged on symmetrical bases, these should be so resolved into the minor forms as not to be intrusively prominent.

6 Colour should be broken over the whole surface so as to give a general negative hue – rather than masses of positive colour.'

How the wallpaper exhibited here departed from these principles was explained in the catalogue entries, quoted in the descriptions given above.

Other objects submitted to this derisive treatment included a pair of scissors in imitation of a stork with the beak opening the reverse way, 'glass tortured out of its true quality to make it into a cup of a lily or an anemone' and a gas burner with 'Gas flaming from the petal of a convolvulus'.[9]

[9] Quotations from Department of Science and Art, *A Catalogue of the Museum of Ornamental Art, at Marlborough House, Pall Mall, For the use of Students and Manufacturers, and the Public*, 1853.

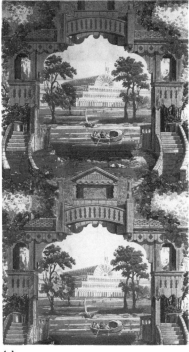

4.1

4.1

121

4.2.a Sir Edward Coley Burne-Jones, A.R.A., R.W.S. (1833-1898)

Sketch-book containing studies of works of art including a bronze and part of a frieze and a metope in the British Museum, two sculptures by Pierino da Vinci in the Victoria and Albert Museum, and part of a fresco by Andrea Mantegna. 46 pages of white wove Whatman paper together with several unused sheets at the back, quarter bound in green leather, gold tooled, with canvas boards. After 1862.

Pencil and red chalk. Size of volume 18.4 x 26 cm
Given by Dr W. L. Hildburgh, F.S.A.
E.2-1955

4.2.b Attributed to Pierino da Vinci (1531-1554)

Boy and girl with a goose.

Terracotta, probably a 19th century cast from a marble. H. 71.5 cm
Department of Sculpture, 8527-1863

The group was acquired in Florence in 1863. Burne-Jones's sketch-book is open at a study of it. He had little formal art training but he valued drawing from life and from sculpture highly. One of his students at the Great Ormond Street Working Men's College, where he taught from January 1859 to March 1861, recalled 'he left with his pupils a feeling that he was their fellow-worker as well as their master ... He encouraged them to draw sculptures in the British Museum'.[10] Whereas his wife reminisced 'Sometimes, after a day in the studio, he would go for a change to the South Kensington Museum in the evening, either to draw or to look at books in the Reference Library'.[11]

Other sketch-books by Burne-Jones in the Museum include studies of the following sculptures from the Museum's collection: Donatello's 'The Lamentation over the dead Christ' (No.8552-1863), the twelve roundels 'The Labours of the Months' by Luca della Robbia (Nos.7632-7643—1861), the bust of Giovanni Chellini by Antonio Rossellino (No.7671-1861), the plaque 'The Assumption of the Virgin' by Andrea della Robbia (No.6741-1860) and the northern German limewood reliefs of St Matthew and St Luke from a set of the Evangelists (Nos.4841-4844—1858). There are also studies of two 15th century South German tapestries entitled 'In Search after Trew' and 'The Buzzard' (Nos.4025-1856, 4509-1858).

SL

[10] G. Burne-Jones, *Memorials of Edward Burne-Jones*, 1904, 1, p.192.

[11] Ibid., 2, p.6

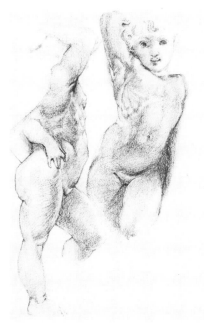

From 4.2.a

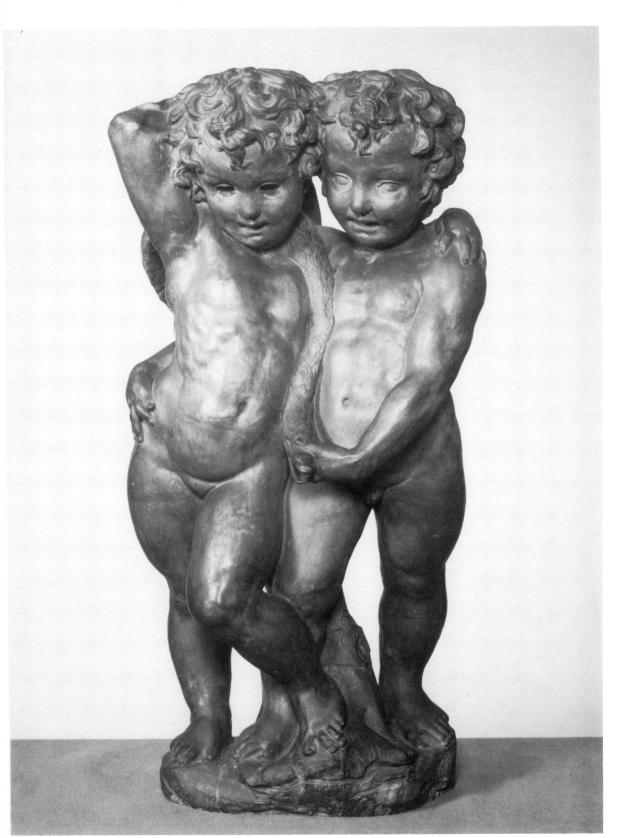

4.2.b

4.3.a Edward William Godwin, F.S.A. (1833-1886)

Sketch-book containing studies of stained glass, windows, capitals, fonts, bench-ends and other ecclesiastical details. 44 pages of laid paper, thread-stitched in marbled boards. With sketches on various papers inserted, and pasted onto the main sheets.

Inscribed by the artist inside the front cover *Book 2* and throughout with notes, place names, measurements etc. Dates ranging from 1855 to 1869. Pencil, pen and ink and water-colour. Size of volume 22.4 x 16.5 cm
Given by Edward Godwin, son of the designer
E.269-1963

Open showing a sheet pasted in with a study of an embroidered motif on a 13th century chasuble drawn in this

Museum. The drawing includes a detail showing *embroidery stitch real size* and is dated *Feb.3.66*.

4.3.b Edward William Godwin, F.S.A. (1833-1886)

Sketch-book containing studies of Egyptian and Assyrian, mediaeval, and 18th century costume (some after George Morland) with others copied from sources in the South Kensington and the British Museums. 144 pages (others missing) of metallic surfaced paper, full-bound in leather, metal clasp, pencil holder, a pocket in the front cover, and an almanac for the year 1882 pasted in.

Inscribed by the artist throughout with notes, references etc.
Pencil and water-colour. Size of volume 17.5 x 10.2 cm

Given by Edward Godwin, son of the designer
E.256-1963

Open showing a study of a female figure to the left of the centre in Edward Dayes's watercolour, Buckingham House, St James's Park (see cat. no. 4.3.c), inscribed with detailed colour notes. The next page in the sketch-book (pl.6) has a study of the small boy dressed in pink with a blue sash, to the right of the picture.

The two sketch-books are sixteen years apart in date.

4.3.c Edward Dayes (1763-1804)

Buckingham House, St James's Park.

Signed and dated *Edw. Dayes 1790*. Watercolour. 39.3 x 64.2 cm
Given by William Smith
1756-1871

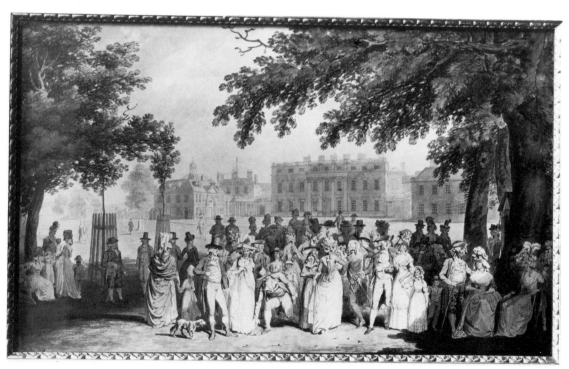

■ 4.3.c

4.3.b

Literature: Repr. M. Hardie, *Watercolour painting in Britain ... 1967-72*, I, pl.194

Godwin made studies from this watercolour in 1882. Some fifty years later it was featured in the Museum as the 'Masterpiece of the week'. The beautifully presented label said of it 'There was a vogue in the latter half of the 18th century for engravings showing groups of well-dressed people at fashionable places of resort. Debucourt, Desrais and Gabriel de St Aubin made drawings for prints of this kind in France: Rowlandson, Bunbury and Dayes designed their English counterpart ... From the technical aspect, this is a fine example of the so-called 'stained' or 'tinted' drawing which was in vogue at the end of the 18th century. The subject was drawn in pen outline: all the shadow effect next added with a monochrome wash, in this case a mixture of indigo and Indian ink; then the colour was washed over the monochrome underpainting.'

The Museum possesses over 60 sketch-books by Godwin, spanning the whole of his career. Although primarily an architect, his interests spread to almost every area of design. The sketch-books are filled with drawn and written notes of things seen and for projects in hand.

That these sketches were made as an aid to inspiration rather than to provide patterns to follow is made clear by his statement in the sales catalogue of *Art Furniture by Edward W. Godwin, F.S.A. and manufactured by William Watt*, 1877 p.VIII that 'It is easy enough to make furniture in *direct imitation* of any particular style, especially the old English styles, with such Museums as that at Kensington open to us. What I have endeavoured to secure in design, has rather been a modern treatment of certain well-known and admired styles than a reproduction of old forms.'

The costume studies from Dayes's watercolour were made in the year Godwin was elected the Honorary Secretary of the Costume Society. Dudley Harbron, his biographer, stated that even in his teens he had drawn constantly from J.R. Planché's *History of British costume from the earliest period to the close of the 18th century*, 1834, and that he saw this appointment as an opportunity 'to prepare a series of plates to fill a portfolio consisting of forty drawings of historic costume each year. At long last he was able to become his own Planché.'[12] In fact these plates do not appear to have materialized. He did however publish, *Dress, and its relation to health and climate* for the International Health Exhibition in 1884. He was also taken on by Liberty's, as the catalogue *'Liberty' developments in form and colour* issued in 1890 stated, 'to re-establish the craft of dressmaking upon some hygienic, intelligible and progressive basis; to initiate a renaissance that should commend itself artistically to leaders of art and fashion, and to challenge on its merits the heretofore all-powerful and autocratic fiat of Paris for 'change' and 'novelty' so far as it was oblivious of grace and fitness.' One of the sketch-books in the collection includes a study of a fashion parade at Liberty's.

SL

[12] D. Harbron, *The conscious stone, the life of Edward William Godwin*, 1949, p.161.

■ *From 4.3.b*

4.4

4.4 Arthur Edward Perkins, F.R.I.B.A. (d.1904)

Sheets (2) from a sketch-book, showing a variety of objects copied from the collection of the South Kensington Museum.

Inscribed variously with descriptive titles, colour notes, measurements and dates.
Pencil. Size of sheets, each 36 x 26 cm
D.125.30, 32—1905

Perkins was the son of an architect under whose direction the general restoration of Worcester Cathedral was carried out. After leaving school he joined the office of Sir Gilbert Scott before becoming an assistant to

Thomas G. Jackson for fourteen years. Later he set up his own small private practice, concentrating on domestic work. He was also known for his watercolour perspective views, a number of which were exhibited at the Royal Academy from 1889 to 1895.

These two sheets come from a group of 28 drawings made in the Museum between 1881 and 1884. They were acquired, with a number of sketch-books showing measured drawings of architecture, ironwork, wood carving etc, from his widow who suggested that they might be of use 'as examples to set before Branch Schools of Art' (letter 30/1/1905). The fact that the

drawings had remained in Perkins's studio indicates that they were made for his private use: to train his eye and his hand, and to build up a store of ideas. But they were purchased by the Museum as examples for other students to study. The correspondence dealing with their acquisition is full of comments from Museum staff like 'the style of drawing is excellent from the technical point of view' and 'This very valuable collection ... will not only be useful owing to the richness and variety of the objects selected but will also, if framed for school use, set an admirable example of useful sketch-book work for students to follow ... '
SL

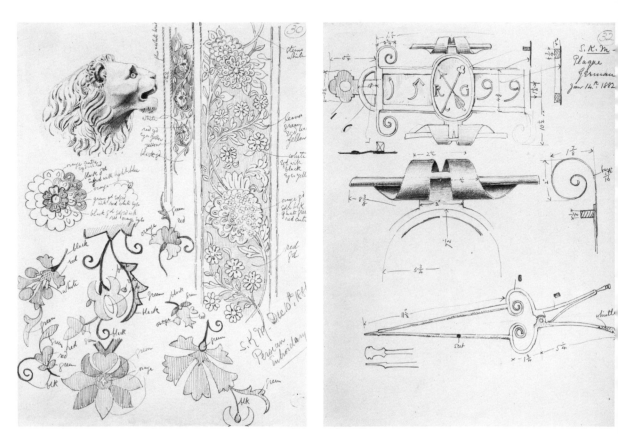

4.5.a Ethel Willis (worked early 20th century)

Copy from a fragment of a 14th-15th century Spanish woven silk.

Signed and dated *E. Willis. 03.*
Watercolour. 56.2 x 45.3 cm
D.268-1903

4.5.b Woven silk, probably Spanish, 14th-15th century.

Lampas, satin ground, pattern in tabby with a lion brocaded in silver thread, now tarnished to black.
28 x 20 cm max.
Department of Textiles and Dress, 350-1901
Provenance: Forrer Collection

Such was the Museum's desire to make fine examples of design available to a wide public by circulating them to art schools and to show that they could be adapted to a modern market that it commissioned a considerable number of artists to make copies of selected pieces both from its own and from private collections. Ethel Willis accepted commissions from 1900 to 1904. Her copies vary from hand-coloured photographs to meticulous watercolours such as that after the exhibited fragment of silk, for which she was paid £5 10 shillings.

SL

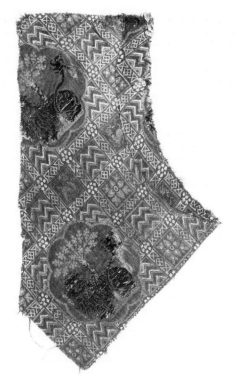

4.5.a 4.5.b 127

4.6 John Wateridge (born 1884)

Volumes (2) containing drawings and sketches recording designs by the designer and D.C. Veazey for chandeliers, candelabra, lanterns, brackets, inn signs, fenders, coalboxes etc. for manufacture by Perry & Co, London, and sketches of chandeliers, candelabra etc. from various sources including the Soane Museum, Winchester City Museum, the Wallace Collection and the Victoria and Albert Museum. Each 164 pages of white laid paper quarter bound in black leather, paper boards, with additional sheets pasted in.

Each inscribed with descriptive notes, scales, measurements and the initials *J.W.* and *D.C.V.* E.2062 inscribed inside the front cover *J. Wateridge, started dec 1909 A few Records of my designs & others when with Perry & Co.* E.2063 dated variously *1915-1935* and inscribed inside the front cover *John Wateridge A few Records of my designs & others. abt 1910 when with Perry & Co.* Pencil, pen and ink and watercolour.
Size of volumes 22.8 x 18.4 cm
Given by the designer
E.2062, 2063—1952

These sketch-books were made by a designer working for the traditional lighting and metalwork firm of Perry & Co of Grafton Street, W.1 from about 1909 to 1935. Their products included straightforward reproductions and pieces based on time-approved designs catering for a public with expensive middle-of-the-road rather than avant-garde tastes. These studies provide an example of the Museum's collections being used as guidance by an employee of a standard manufacturer.

Volume E.2062 is open at a page of drawn copies, including to the left a scale study of a folding lantern frame. E.2063 shows a candlestick from the Museum's collection. An 18th century pattern book of silver and Sheffield plate (cat. no. 1.8.a) was donated to the Museum by the designer at the same time as these volumes of his own drawings.

SL

1.2.b Maiolica dish by The Master of the Milan Marsyas, Urbino, c.1530

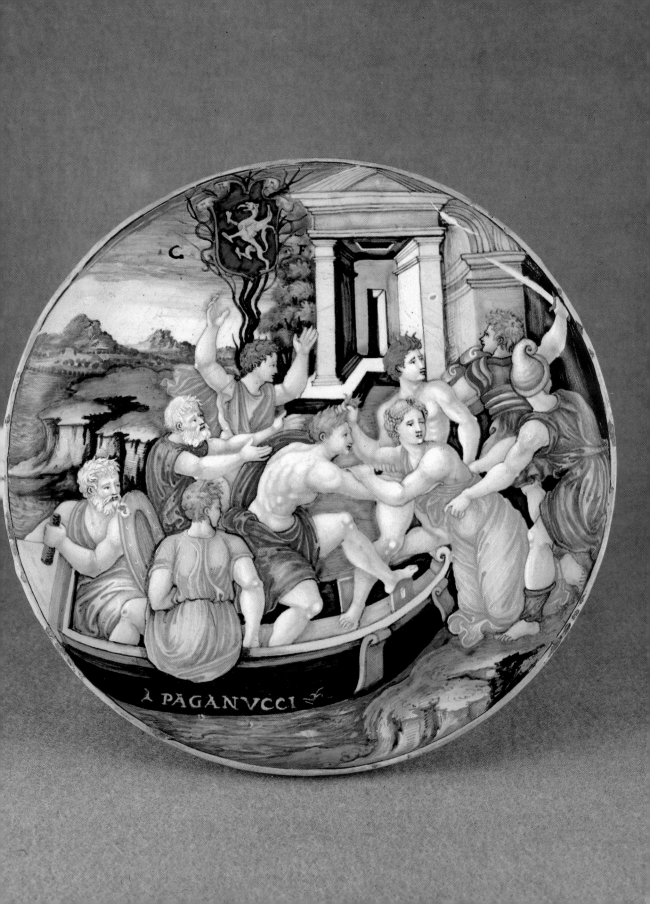

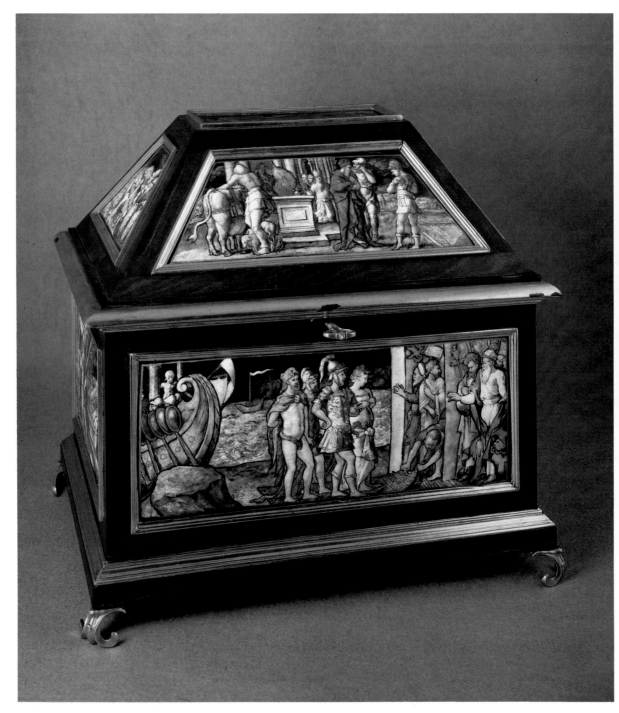

1.7.c 'Pagoda'; plate-printed cotton, printed at
Bromley Hall, c.1774-80

1.3.e Casket of plaques in Limoges enamel by
Léonard Limosin, c.1570

1.9.c Drawing for pl.24 'Pompeian No.2' for
Owen Jones, The grammar of ornament,
1856

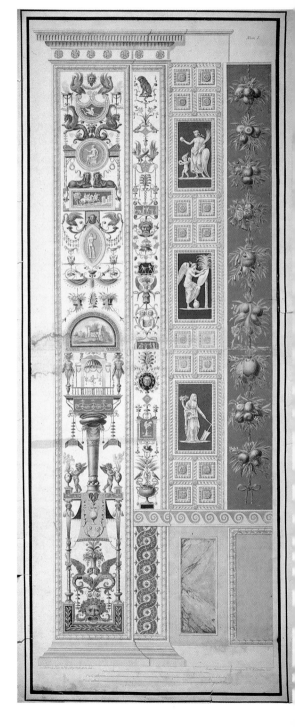

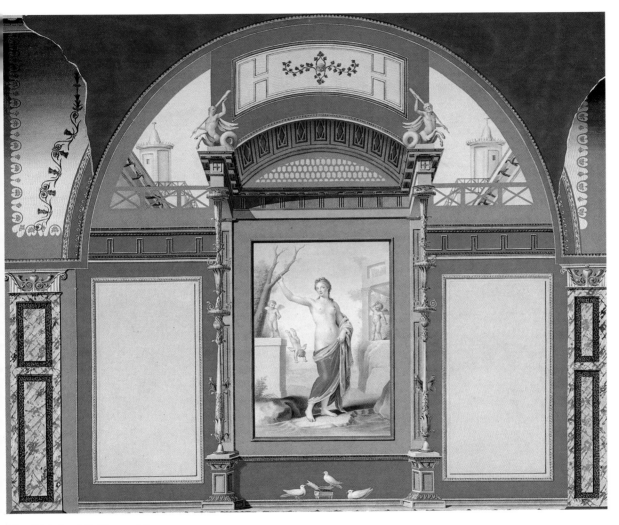

1.9.a Print after A.R. Mengs and A. von Maron of frescoes at the Villa Negroni, Rome, 1778-93

1.9.b Print from the set 'Loggie di Rafaele nel Vaticano', Rome, 1772-77

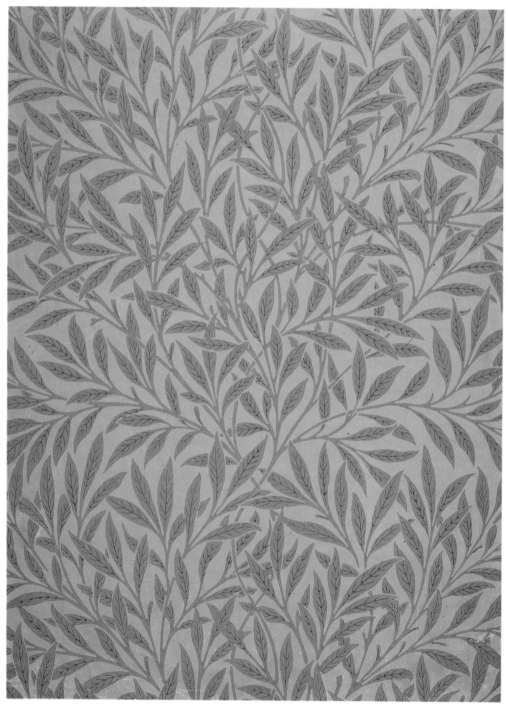

134 *1.10.b 'Willow'; wallpaper by William*
 Morris, 1874

2.1.k Tea bowl bearing a scene after Stefano della Bella, English, mid-18th century

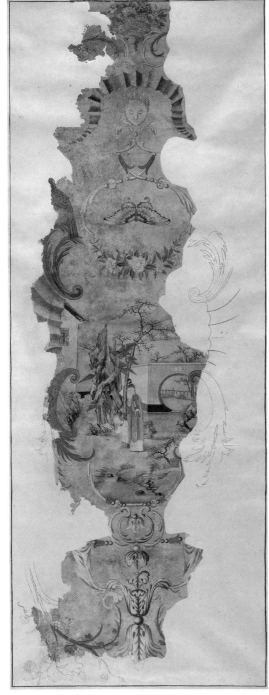

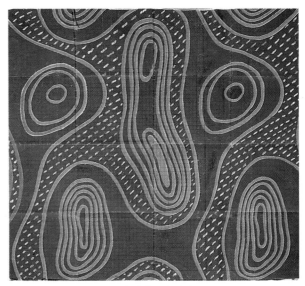

2.4.a Wallpaper, Cantonese, c.1730-40 including a scene after Watteau

1.11.e 'Surrey'; design for a furnishing fabric by Marianne Straub, 1951

135

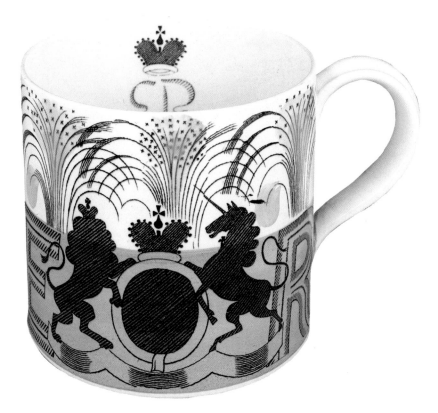

2.9.a Mug designed by Eric Ravilious and made by Wedgwoods, 1936

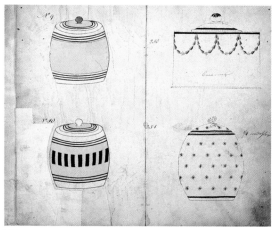

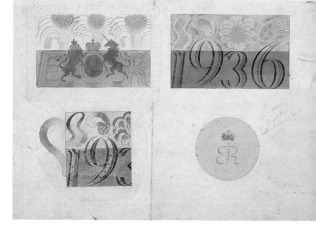

2.9.d Page from the pattern book of the Leeds pottery firm Messrs Hartley, Greens & Co, early 19th century

2.9.c Design for a mug to commemorate the expected Coronation of Edward VIII, by Eric Ravilious, 1936

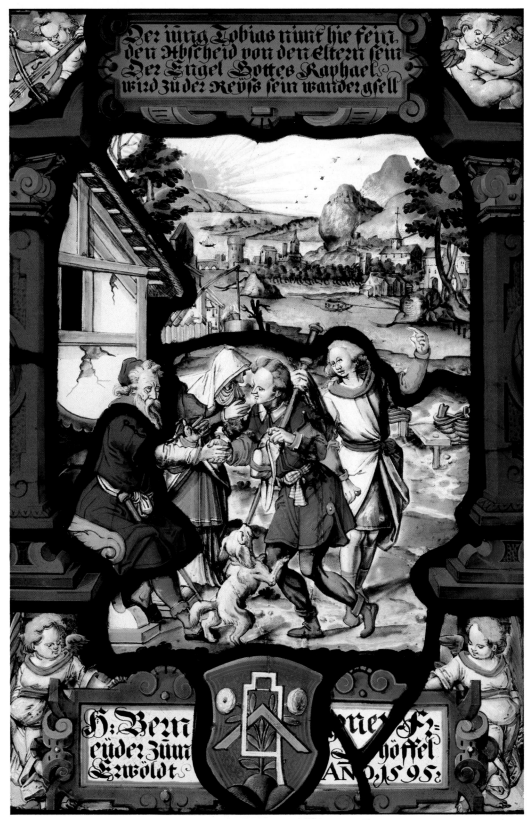

Der jung Tobias nimt hie seim,
den Abscheid von den Eltern sein
Der Engel Gottes Raphael
wird zu der Reyß sein wander gsell

H: Bern... ner Fr:
eyder zum... höffel
Erwöldt ANO 1595

3.1.c Panel of painted glass after Christoph
Murer, 1595

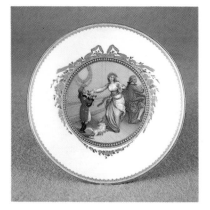

*3.4.b Saucer from a Meissen tea and coffee
service, c.1790*

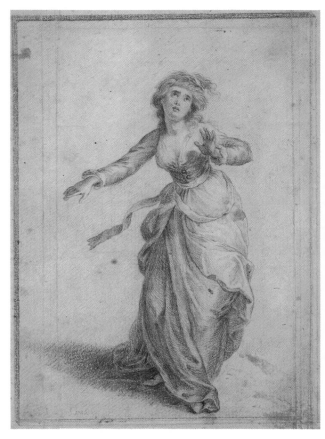

*3.4.a Drawing by J.D. Schubert for painted
enamel-decoration on a Meissen saucer, 1790*

3.2.b Silk damask petticoat, c.1739-1742

*3.3.a Overmantel mirror, English, mid-18th
century*

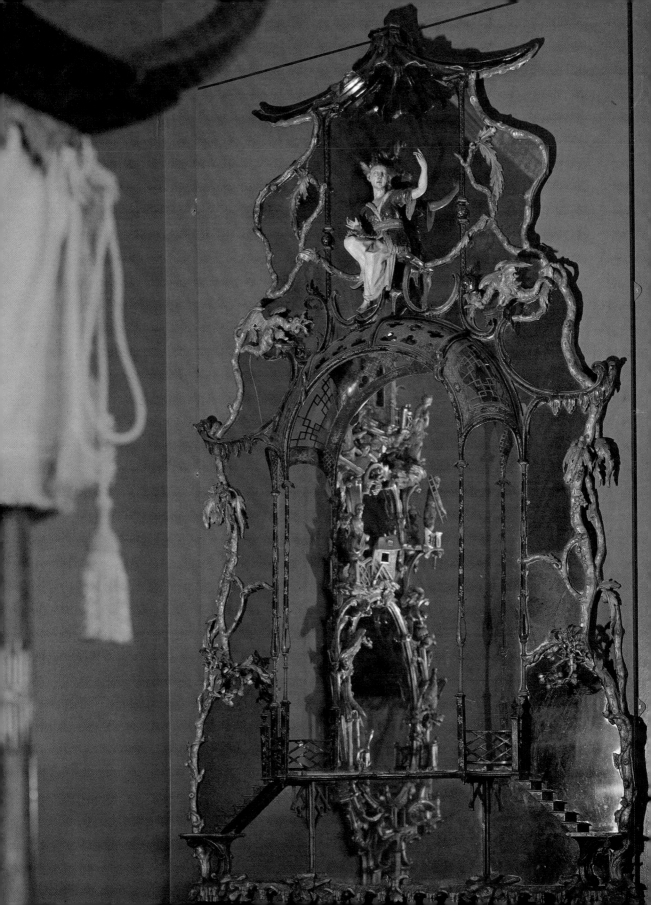

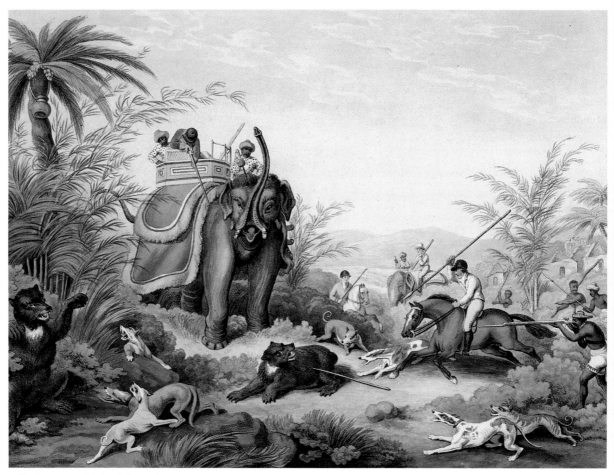

3.5.b 'The death of the bear', illustration to Williamson's Oriental Field Sports, *1807*

3.6.a-c Designs, one showing its back, with a tile by William De Morgan, 1880s

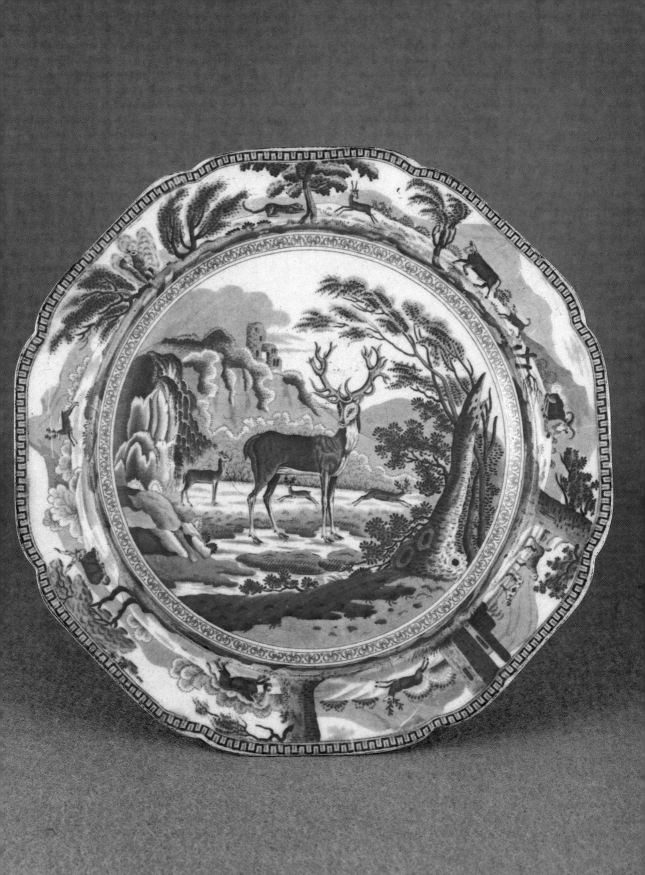

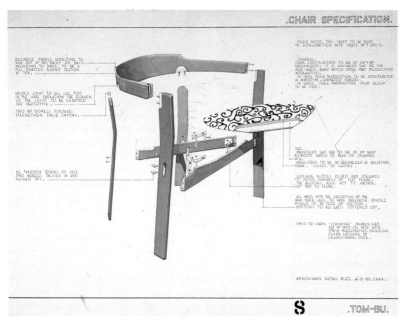

3.8.b Chair specification by Brian Long, c.1965

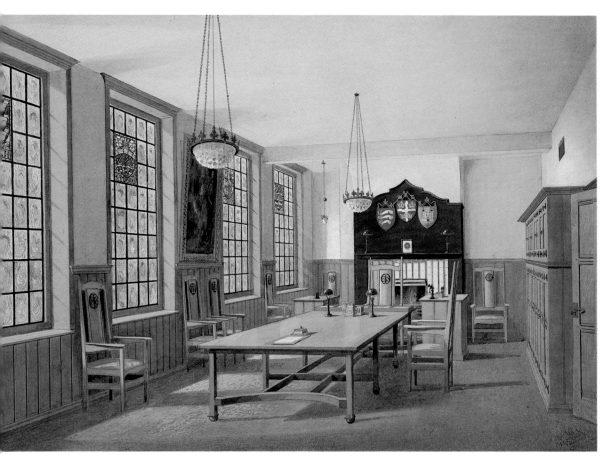

*3.7.c View of the boardroom of the Essex and
Suffolk Equitable Insurance Co., Capel House,
by C.F.A. Voysey, c.1908*

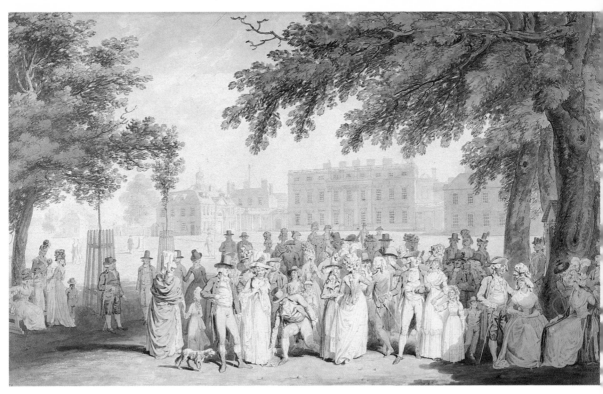

4.3.c 'Buckingham House, St James's Park' by
Edward Dayes, 1790

4.3.b Copy of a figure in Edward Dayes's
'Buckingham House, St James's Park' by E.W.
Godwin, c.1882

Indexes to Designers' drawings in the Victoria and Albert Museum

*A*ccording to the Oxford English Dictionary *a designer is 'One who makes an artistic design or plan of construction; a draughtsman;* spec. *one whose business is to invent or prepare designs or patterns for manufacturer or constructor'. This definition has been used in compiling the present list. Drawings, therefore, intended as ends in themselves or for illustration or as preliminary sketches for paintings are not included, and similarly, drawings which can be identified as records of objects, even if made by the designer, have also been left out.*

The fields of work that the list covers are:

Architecture: including everything to do with building except interior design.

Ceramics: including decorative and functional pottery, porcelain and glass but not stained glass.

Fans.

Furniture: including wood-carving.

Gardens: including grottoes.

Interior Design: a very broad category including such things as plaster-work, wall decorations (murals and mosaics), flooring, as well as general room layouts.

Jewellery.

Metalwork: including anything made of metal with a functional purpose however rudimentary, excluding jewellery.

Ornamental designs: intended for use in a variety of materials on a wide range of objects.

Sculpture: made in any material and including tombs and purely decorative work such as fountains.

Stained Glass.

Textiles: including woven textiles, embroidery, tapestry, lace, carpets and dress (except for theatrical costume).

Theatre: including costume and scenery, and also film.

Transport: for example coaches, boats and trains, including their interiors.

Designs for wallpaper have been omitted because they are included in Charles C. Oman and Jean Hamilton, Wallpapers, a history and illustrated catalogue of the collection in the Victoria and Albert Museum, *1982.*
The categories are not meant to be absolute. Some of them overlap; for example it is hard to separate sculpture from architecture and both from some kinds of interior design. It has often been difficult to decide in which category to place some decorative piece made, for example, in metal which is so ornamented that its function has disappeared in its sculptural treatment. Some objects may appear under several categories: a drawing for a single chandelier may appear under ceramics, furniture and metalwork. Moreover in some cases it is not clear from the drawing in what material it was intended that the design should be carried out.

Nevertheless, in spite of their inadequacies, the categories do function as a simple subject index.

Inevitably we have had to use the existing catalogues, which include entries made in the last century, to compile the list. Although as many drawings as possible have been checked, it is likely that some of the attributions are incorrect and some of the dates inaccurate. Moreover the collection includes a large number of anonymous drawings from all periods. Research on them would without doubt introduce more named designers. All the same it is hoped that the list will help those working on the history of design to be able to use the collection more effectively both from a distance and in conjunction with the unpublished catalogues of the collection available in the Print Room.
The list is presented in two ways: in alphabetical order of the designers' names pp.147-171, and in a quarter century date sequence p.172-196. The dates given for firms are those spanned by the drawings in the collection not those during which the firms are known to have been in business.
Drawings attributed to a designer are only listed if they fall into a category not covered by drawings known to be from the designer's hand.

Designers' names in alphabetical order

*ittle is known about many of the designers listed. The dates
iven for them try to convey as briefly as possible the full extent
f our knowledge, sometimes based solely on the drawings in
he collection. The majority of the fans were exhibited while
he designers were students.*

	ARCHITECTURE	CERAMICS	FURNITURE	FANS	GARDENS	INTERIOR DESIGN	JEWELLERY	METALWORK	ORNAMENT	SCULPTURE	STAINED GLASS	TEXTILES	THEATRE	TRANSPORT
ABBS, George Cooper (worked c.1927-c.1932)											●			
ADAM, Robert (1728-1792)	●							●	●	●				
ADAMS, Robert (b.1917)										●				
ADLER, Jankel (1895-1949)												●		
ADRON, Ralph (b.1937)			●			●								
AGOMBAR, Elizabeth (worked 1950s)														●
AGUILAR, Sergi (b.1946)							●							
AKBER, Mirza (worked first half of 19th century)	●	●							●					
ALABASTER, Annie (worked c.1880)							●	●						
ALBECK, Pat (b.1930)												●		
ALBERTI, Cherubino (known as Il Borgheggiano) (1553-1615)									●	●				
ALDRIDGE, James (worked 1785-1825)							●	●						
ALDROVANDINI, Tommaso (1653-1736)													●	
ALEXANDER, John (b.1888)						●								
ALEXANDRE, M (worked second half of 19th century)				●										
ALLEN, C Bruce (exhibited 1854-1857)	●													
ALKMAAR, Master of (worked c.1490-1524)											●			
ALMA-TADEMA, Sir Lawrence (1836-1912)													●	
ALMEIDA Braz (Blazius) de (worked last quarter of 17th century)						●								
AMADEI, Amadio (worked c.1790)						●								
AMES, Victor (worked last quarter of 19th and first quarter of 20th century)								●						
AMMAN, Jost (1539-1591)											●			
ANDERSON, Emily (worked last quarter of 19th century)												●		
ANDERSON, Percy (1851-1928)													●	
ANDREENKO, Michel (b.1894)													●	
ANDREÜ, Mariano (1888-p.1978)													●	
ANDREWS, Dorothy (worked c.1935-c.1939)												●		
ANDREWS, George Townsend (worked mid-19th century)	●													
ANDROUET DUCERCEAU, Jacques (1510-p.1584)			●			●								
ANDROUET DUCERCEAU, Paul (c.1630-1710)												●		
ANGUS, Peggy (Mrs. Richards) (b.1904)		●												
ANNALS, Michael (b.1938)													●	
ANREP, Boris (1883-1969)		●										●		
APPLETON, Ian (b.1939)										●				
ARAM, Zeev & Associates (c.1975)						●								
ARCHAMBAUT, A (worked mid-19th century)			●											
ARCHIGRAM ARCHITECTS (1965-1972)	●													
ARCHER, Henry (worked c.1870)			●											
ARMFIELD, Maxwell (1881-1972)												●		
ARMITAGE, Edward Liddell (worked 1950s)											●			
ARMITAGE, Kenneth (b.1916)										●				
ARTHUR, Messrs (c.1920)						●								
ARMSTEAD, Henry Hugh (1828-1905)								●						
ARMSTRONG, John (1893-1973)						●						●		
ASHBEE, Charles Robert (1863-1942)	●						●	●		●				
ATKINSON, Lawrence (1873-1931)										●				
ATKINSON, William (c.1773-1839)						●								
AUSTEN, Matilda (worked 1869)				●										
AUSTIN, Jesse (1806-1879)		●												
AVADIS, Marcus (1887-1980)												●		
AYRTON (Ayrton Gould), Michael (1921-1976)														●

147

B

	ARCHITECTURE	CERAMICS	FURNITURE	FANS	GARDENS	INTERIOR DESIGN	JEWELLERY	METALWORK	ORNAMENT	SCULPTURE	STAINED GLASS	TEXTILES	THEATRE	TRANSPORT
B , M.M *(worked second quarter of 16th century)*										•				
BABIN, François *(worked first quarter of 18th century)*								•						
BACON, John I *(1740-1799)*										•				
BACON, John II (1777-1859)										•				
BAGGE, Eric (b.1890)												•		
BAILY, Edward Hodges *(1788-1867)*, attributed to								•						
BAKER, Martin *(worked last quarter of 20th century)*							•							
BAKST, Léon Nikolaievitch *(Lev Samoilovitch Rosenberg) (1866-1924)*		•											•	
BALDUNG, Hans *(c.1480-1545)*											•			
‚BALFOUR, Ronald Egerton *(1896-1941)*													•	
(?) BAMBAIA *(Agostino Busti) (1483-1548)*										•				
BAN, Jules O de *(worked 1914-1920)*												•	•	
BANNENBERG, Jon *(b.1929)*						•								
BARDER, Daphne Rosalind *(1913-1977)*												•		
BARDOT, T *(worked third quarter of 19th century)*												•		
BARKER, Thomas *(1778-1865)*, probably by													•	
BARNES, Brian *(b.1944)*						•								
BART *(Barthe)*, Victor Sergeevich *(1887-1954)*													•	
BARTLETT – *(c.1841-1925)*	•							•						
BARTON, S & J *(worked 1860)*														•
BASOLI DI CASTELGUELFO, Antonio *(1774-1848)*													•	
BATES, John *(b.193?)*												•		
BAURSCHEIT, Jan Pieter van, ?II *(1699-1768)*										•				
BEATON, Cecil Walter Hardy *(1904-1980)*													•	
BEAUMONT, *(Charles)* Edouard de *(1821-1888)*				•										
BEAUMONT, William *(worked 1834-1868)*													•	
BEDFORD, Richard Perry *(1883-1967)*			•							•				
BEDOLI, Girolamo *(self-styled Girolamo Mazzola) (c.1500-1560)*									•					
BEESOLA, P Giovanni *(worked c.1750-c.1760)*						•								
BELL, John *(1811-1895)*		•						•						
BELL, Joseph *(1810-1895)*		•												
BELL, Robert Anning *(1863-1933)*		•									•			
BELL, Vanessa *(1879-1961)*												•		
BELLA, Stefano della *(1610-1664)*	•							•					•	
BELLI, Pietro *(1780-1828)*								•						
BENNEY, *(Adrian)* Gerald *(Sallis) (b.1930)*								•						
BENOIS, Alexandre Nikolaevich *(1870-1960)*													•	
BENOIS, Nadia *(1896-1974)*													•	
BENSON, William Arthur Smith (1854-1924)	•							•						
BENTLEY, John Francis *(1839-1902)*	•		•	•	•					•				
BÉRAIN, Jean (Louis), I *(1637 or 40-1711)*									•				•	
BÉRAIN, Jean, II *(1674-1726)*									•					
BERETI, F, *(worked mid 18th century)* attributed to								•						
BERNINI, Giovanni Lorenzo *(1598-1680)*										•				
BERNINI, Giovanni Lorenzo *(1598-1680)*, school of														•
BERTHELIN, Max *(1811-1877)*					•									
BERTOIA *(Jacopo Zanguidi) (1544-c.1574)*					•									
BERTOLI, Antonio Daniele *(1678-1743)*													•	
BESCHE, Lucien *(worked last quarter of 19th century)*													•	
BESOZZI, Giovanni Ambrogio (1648-1706)			•						•					

148

	ARCHITECTURE	CERAMICS	FURNITURE	FANS	GARDENS	INTERIOR DESIGN	JEWELLERY	METALWORK	ORNAMENT	SCULPTURE	STAINED GLASS	TEXTILES	THEATRE	TRANSPORT
BEVAN, Charles (worked c.1864)			•											
BEVERLEY, William Roxby (1824-1889)													•	
BICAT, André (worked 1930s-p.1982)												•		
BIGIARELLI, A (worked last quarter of 19th century)												•		
BILBIE, Joseph Percy (1879-1949)												•		
BILBIE, Olive (née Harrison) (1884-1953)												•		
BILIBIN, Ivan Jakovlevich (1876-1942)													•	
BILLINGS, Robert William (1813-1874)								•		•				
BILLINGSLEY, William (1758-1828)		•												
BISHOP, Vyvian (worked c.1900)													•	
BISON, Giuseppe Bernardino (1762-1844)								•						
BLAHNIK, Manolo (b.1943)												•		
BLAND, Sarah (worked mid 19th century), possibly by												•		
BLOMFIELD, Sir Arthur William (1829-1899)						•								
BLORE, Edward (1787-1879), and assistants	•		•			•								
BLOUNT, Gilbert J (d.1877)	•		•					•						
BOCK, Hans (c. 1550-?1624)											•			
BODLEY, George Frederick (1827-1907)						•		•						
BOILEAU, Jean Jacques (worked c.1787-1827)								•						
BOMBERG, David Garshen (1890-1957)												•		
BÖÖCKE, R L (worked last quarter of 19th century)												•		
BOOTH, Lorenzo (worked mid-19th century), possibly by			•											
BOQUET, Louis René (1717-1814)													•	
BORRA, Giovanni Battista (1717-p.1786) attributed to	•													
BORROMINI, Francesco (1599-1667)	•													
BORSATO, Giuseppe (1770/1-1849), probably by									•					
BOS, Cornelis (1506-1556), in the style of									•					
BOSCHI, Guiseppe (worked last quarter of 18th century)								•						
BOSCOLI, Andrea (c.1550-c.1606)										•				•
BOSDET, H T (worked first quarter of 20th century)											•			
BOSHIER, Derek (b.1936)										•				
BOSSANYI, Ervin (1891-1975)											•			
BOSWELL, James (1906-1971)						•								
BOSWELL, John Edward (1860?-1940)								•						
BOTT (Bodt), Johann von (1670-1745)	•													
BOUCHARDON, Edmé (1698-1762)								•						
BOUCHENE, Dimitri (b.1893)													•	
BOUCHER, François (1703-1770), possibly by									•					
BOUCHER, François (1703-1770), after										•				
BOUCHERON, Giovanni Battista (1742-1815)								•						
BOUVIER, Alain (b.1951)				•										
BOWLER, Henry Alexander (1824-1903)		•												
BOWYER, Carolyn (worked third quarter of 20th century), probably by												•		
BOYD, Arthur (b.1920)													•	
BRADSHAW, Lawrence (1899-1980)						•		•		•				
BRANDON, David (1813-1897)	•													
BRAQUE, Georges (1882-1963)													•	
BRAUTIGAN, Ch and J (worked c.1881)														•
BREUER, Marcel (1902-1981)			•											
BRIDGENS, Richard (worked c.1812-c.1838), probably by or after			•											
BROADLEY, Frances (worked 1869)					•									
BROADFOOT, - (worked last quarter of 19th century)														•

	ARCHITECTURE	CERAMICS	FURNITURE	FANS	GARDENS	INTERIOR DESIGN	JEWELLERY	METALWORK	ORNAMENT	SCULPTURE	STAINED GLASS	TEXTILES	THEATRE	TRANSPORT
BRODZKY, Horace *(1885-1969)*													●	
BROOKS, Maria *(worked c.1868-c.1890)*			●											
BROSAMER, Hans *(worked c.1500-1552)*								●						
BROWN, Ford Madox *(1821-1893)*											●			
BROWN, J W *(worked c. 1874-c.1914)*											●			
BROWNE, Hablot Knight *('Phiz') (1815-1882)*		●				●								
BUCKLER, John Chessel *(1793-1894)*										●				
BUCKLER, George *(1811-1886)*										●				
BUCKNELL, John *(worked mid-20th century*											●			
BUGGÉ, Margarita *(worked second quarter of 20th century)*											●			
BULL, H J *(worked 1933)*												●		
BUNDY, Stephen *(worked 1947)*													●	
BUNT, Camilla *(worked 1976)*					●									
BUONTALENTI, Bernardo *(1531-1608)*	●												●	●
BURGES, William *(1827-1881)*	●	●	●				●	●	●	●	●			
BURNE-JONES, Sir Edward Coley *(1833-1898)*		●	●				●	●	●		●	●		
BURLISON AND GRYLLS, Messrs *(c.1880-1893)*											●			
BURRA, Edward *(b.1905)*													●	
BURTON, Decimus *(1800-1881)*	●													
BURY, Claus *(born 1946)*							●							
BURY, Thomas Talbot *(1811-1877)*			●											
BUTLER, Reginald Cotterel *(b.1913)*										●				
BUTTERFIELD, Lindsay Phillip *(1869-1948)*												●		
BUTTERFIELD, William *(1814-1900)*	●		●			●				●		●		
C														
C, A *(worked late 19th or early 20th century)*													●	
C, A B *(worked 1839)*										●				
CAILLARD, Jacques *(worked 1627), after*						●								
CALAMATTA, Joséphine *(née Rochette) (exhibited 1867)*				●										
CALANDRUCCI, Giacinto *(1646-1707)*						●								
CALDARA, Polidoro *(Polidoro da Caravaggio) (1496/1500-1543)*	●													
CALTHROP, Gladys E *(d.1980)*													●	
CALTHROP, Peggy *(worked 1935)*													●	
CAMERON, Arthur *(worked c.1896-c.1911), possibly by*								●						
CAMPBELL, Sarah *(b.1945)*												●		
CAMPI, Antonio *(d.post 1591)*									●					
CANEY, Robert *(1847-1911)*													●	
CANO, Alonso *(1601-1667)*										●				
CARBONI, Angelo *(worked c.1758)*													●	
CARRICK, Edward *(pseudonym of Edward Anthony Craig) (b.1904)*													●	
CAPRONNIER, François *(1789-1853)*		●												
CAPRONNIER, Jean-Baptiste *(1814-1891)*		●												
CARAN D'ACHE *(pseudonym of Emanuel Poiré) (1859-1909)*												●		
CARLONE, Carlo *(1685-1775)*						●								
CARR, John, of York *(1723-1807)*						●								
CARRASSI *(Carassi), Antoine (worked first quarter of 19th century)*														●
CARWITHAM, Thomas *(worked c.1713-1723)*									●					
CASS, Charles Melville *(b.1903)*						●								
CASS, Christopher *(1678-1734)*										●				
(?) CATI, Pasquale *(1550-c.1620)*										●				
CAUS, Isaac de *(worked c.1625-c.1656), attributed to*					●									
CHADWICK, Lynn *(b.1914)*										●				

	ARCHITECTURE	CERAMICS	FURNITURE	FANS	GARDENS	INTERIOR DESIGN	JEWELLERY	METALWORK	ORNAMENT	SCULPTURE	STAINED GLASS	TEXTILES	THEATRE	TRANSPORT
CHAMBERLAIN, John Henry *(1831-1883)*						●								
CHAMBERS, Sir William *(1723-1796)*	●				●	●			●	●				
CHAMPNEYS, Walpole *(1879-1961)*						●								
CHAPELAIN-MIDY, Roger *(b.1904)*													●	
CHAPMAN, Howard *(worked 1976)*				●				●						
CHAPELL, William *(worked 1930s)*													●	
CHARBONNIER, Frances *(worked 1905)*					●									
CHARDON, Ferdinand Eugène Léon *(1878-p.1935)*							●							
CHARLES, Richard *(worked c.1860-p.1976)*			●											
CHARLTON ALLEN & CO *(Last quarter of 19th century)*		●	●											
CHARLTON, Thomas, & Co *(1860)*			●			●								
CHARMETON *(Charmetton)*, Georges *(1623-1674)*									●					
CHARRON, William *(worked 1779)*								●						
CHARPENTIER, Renat *(worked last quarter of 18th century)*										●				
CHASEMORE, Archibald *(worked c.1868-1901)*													●	
CHAUFOURIER, Jean *(1679-1757)*										●				
CHAUVEAU, François *(1613-1676)*			●					●						
CHEERE, Sir Henry *(1703-1781)*						●			●					
CHERMAYEFF, Serge *(b.1900)*						●								
CHIAVISTELLI, Jacopo *(1618-1698)*						●								
CHIPPENDALE, Thomas *(c.1709-1779)*			●						●					
CHRISTOFLE – *(worked third quarter of 19th century)*							●							
CHURCHILL, Robert *(worked first quarter of 18th century)*										●				
CIBBER, Caius Gabriel *(1630-1700)*										●				
(?) CINGANELLI, Michelangelo *(c.1580-1635)*									●					
CLARK, George *(worked c.1820)*	●													
CLARKE, G *(worked c.1850-1860)*														●
CLARKE, Hilary A *(b.1925)*							●							
CLARKE, Somers *(d.1926)*			●											
CLATWORTHY, Robert *(b.1928)*										●				
CLENDINNING, Max *(b.1930)*			●			●								
CLERGET, Charles Ernest *(1812-?)*									●		●			
CLERMONT, Andien de *(worked c.1716-d.1783), attributed to*						●			●					
CLEYN, Franz *(or Francis) (1582-1658)*									●					
CLOUGH, Prunella *(b.1919)*											●			
COATES, Nigel *(b.1949)*	●													
COCHRANE, J D *(worked 1953)*		●												
COCKERELL, Charles Robert *(1788-1863)*	●						●		●	●	●			
COCKERELL, Douglas Bennett *(1870-p.1928)*												●		
COCKERELL, Frederick Pepys *(1833-1878)*										●				
COCKERELL, Samuel Pepys *(c.1754-1827)*	●													
COECKE *(Coeke Van Aelst)*, Pieter *(1502-1550)*												●		
COHEN, Harold *(b.1928)*												●		
COKE, Alfred Sacheverell *(exhibited 1869-1892)*												●		
COLE, Sir Henry *('Felix Summerly') (1808-1882)*			●					●	●					
COLFAX, Louisa *(exhibited 1869)*					●									
COLLIER, Susan *(b.1938)*												●		
COLLMAN, Leonard W *(worked second quarter of 19th century)*	●		●			●		●	●	●				
COLQUHOUN, Robert *(1914-1962)*													●	
COMBA, Pierre *(1859-1934)*														●
COMELLI, Attilio *(c.1858-1925)*													●	
COMPER, Sir *(John)* Ninian *(1864-1960)*											●			

	ARCHITECTURE	CERAMICS	FURNITURE	FANS	GARDENS	INTERIOR DESIGN	JEWELLERY	METALWORK	ORNAMENT	SCULPTURE	STAINED GLASS	TEXTILES	THEATRE	TRANSPORT
COMPTON, Lord Alwyne Frederic, Bishop of Ely *(1825-1906)*						●								
CONDER, Charles *(1868-1909)*				●								●		
CONNER, T *(worked 1972)*			●											
CONRAN ASSOCIATES *(1972-1976)*			●			●								
CONSAGRA, Pietro *(b.1920)*										●				
COOK, Peter *(worked third quarter of 20th century)*	●													
COOKE, Edward William *(1811-1880)*				●										
COOMBS, Henrietta *(exhibited 1870)*				●										
COOPER, Susie *(Mrs Susan Vera Barker) (b.1902)*		●												
COOPER, J C *(worked second half of 19th century)*														●
CORBOULD, Edward Henry *(1815-1905)*													●	
CORNACCHINI, Agostino *(1683-1740)*						●								
CORNUAUD, J D *(worked c.1840-c.1880)*												●		
CORTONA, Pietro da *(Pietro Berretini) (1596-1669)*								●						
COTTINGHAM, Lewis Nockalls *(1787-1847)*			●			●								
COTTINGHAM, N J *(worked 1852)*										●				
COUSTOU, Guillaume *(d.1685)*										●				
COXIE, Michiel, I *(1499-1592)*									●					
CRABB, James *(worked second quarter of 19th century)*			●			●								
CRACE, John Dibblee *(1838-1919)*			●			●		●	●	●				
CRACE, John Gregory *(1808-1889)*			●			●								
CRAGE, Basil *(worked last quarter of 19th century)*													●	
CRAIG, *(Edward Henry)* Gordon *(1872-1966)*													●	
CRANE, Walter *(1845-1915)*						●						●	●	
CRAVEN, Hawes *(worked 1890s)*													●	
CREES, Margaret *(worked late 19th and early 20th century)*											●			
CRIVELLI, D *(worked 1890)*						●								
CROOKE, Frederick *(b.1908)*													●	
CROSSLEY CARPET DESIGN STUDIO *(1956-1972)*												●		
CROW *(?pseudonym) (worked c.1889-c.1920)*													●	
CROWLEY, Graham *(b.1950)*						●								
CRUNDEN, John *(1740-c.1828)*	●					●			●					
CRUDDAS, Audrey *(b.1914)*													●	
CSAKY, Joseph *(b.1888)*										●				
CUMMINS, Catherine *(worked 1930)*													●	
CUTTS, John *(1772-1851)*		●												
D														
DALE, Mary Frances *(worked c.1812-1822)*												●		
DANDY, Leslie G *(b.1923)*			●			●								
DANSEY, Helen *(worked c.1835)*												●		
DANSEY, S J *(worked first quarter of 19th century)*									●			●		
DARCY BRADDELL, Dorothy *(b.1889)*								●						
DAVEY, Leon *(George) (b.1904)*													●	
DAVIES, Frank *(b.1925)*												●		
DAVIS, Mary *(worked 1914)*				●										
DAY, Allan Edward Robert *(b.1939)*						●								
DAY, Lewis Foreman *(1845-1910)*	●	●	●			●					●	●		
DAY, Lucienne *(b.1917)*												●		
DEARE, John *(1759-1798)*										●				
DEARLE, John Henry *(1860-1932)*												●		
DÉGAN, Joël *(b.1941)*							●							
D'EGVILLE, James *(worked second quarter of 19th century)*	●													

Name	ARCHITECTURE	CERAMICS	FURNITURE	FANS	GARDENS	INTERIOR DESIGN	JEWELLERY	METALWORK	ORNAMENT	SCULPTURE	STAINED GLASS	TEXTILES	THEATRE	TRANSPORT
DELAFOSSE, Jean Charles *(1734-1789)*	●								●	●				
DELANY, Edward *(b.1896)*													●	
DELAUNE, Etienne *(1519-1583)*								●						
DE MORGAN, William Frend *(1839-1917)*		●								●				
DEMPSEY, C W *(worked first quarter of 20th century)*		●												
DENNISON, S *(worked second half of 19th century)*														●
DERAIN, André *(1880-1954)*													●	
DERBY CROWN PORCELAIN CO LTD *(c.1820-1880)*		●												
DERRICK, Thomas *(1885-1954)*											●		●	
DESIGNERS GUILD *(1975-1977)*												●		
DEVLIN, Stuart *(b.1931)*								●						
DIBBETS, Jan *(b.1941)*									●					
DICKIN, Nevil *(b.1911)*												●		
DICKINSON, Henry D *(worked 1870s)*	●													
DOBENECKER, Johann *(worked 1640)*									●					
DOBSON, Frank *(1889-1963)*										●		●		
DOBOUJINSKY, Mstislav Valerjanovich *(1875-1957)*													●	
DODD, Robert W *(b.1934)*												●		
DOMECHIN DE CHAVANNE, Pierre Salomon *(1673-1744)*			●											
DORAN, Joseph M *(worked 1910-1912)*												●		
DORN, Marion V *(1899-1964)*												●		
DRAPER, Frank *(b.1919)*						●								
DREWRY, W T *(worked 1817)*			●							●				
DRUMMOND, Samuel *(worked second quarter of 18th century)*														●
DUCA, Giacomo del *(c.1520-p.1601)*									●					
DUFY, Raoul *(1877-1953)*												●		
DUGOURC *(Dugoure)*, Jean Démosthène *(1749-1825)*						●								
DURHAM, Joseph *(1814-1877)*										●				
DUTTON, Ronald *(b.1935)*										●				
DYCE, William *(1806-1864)*										●				
DYSTHE, Sven Ivan *(worked 1965)*			●											
E														
E S, Master, of 1466, attributed to											●			
EAMES, Charles *(1907-1978)*, after			●											
EASTON, Hugh Ray *(1906-1965)*											●			
EDEL, Alfredo *(1859-1912)*													●	
EDEN, Frederick Charles *(1864-1944)*											●			
EDLER, Eduard *(worked third quarter of 19th century)*								●						
EDNIE, John *(worked c.1900-c.1935)*						●								
EDWARDS, Albert *(worked 1901)*												●		
EDWARDS, Carl *(b.1914)*											●			
EDWARDS, Edward *(1738-1806)*									●					
EGINTON, William Raphael *(d.1834)*											●			
EISLER, Johann Leonhard *(c.1670-1733)*								●						
ELLIS, Michael T *(worked 1936)*													●	
EMDEN, Henry *(worked 1903-1908)*													●	
EMETT, Rowland *(b.1906)*						●								
ERRIDGE, A F *(worked c.1913-c.1940)*										●				
ERTÉ *(pseudonym of Romain de Tirtoff)* *(b.1892)*												●	●	
ESPLIN, Mabel *(worked first quarter of 20th century)*											●			
ETCHELLS, Frederick *(b.1886)*												●		
EVANS, Emily *(exhibited 1869)*				●										

	ARCHITECTURE	CERAMICS	FURNITURE	FANS	GARDENS	INTERIOR DESIGN	JEWELLERY	METALWORK	ORNAMENT	SCULPTURE	STAINED GLASS	TEXTILES	THEATRE	TRANSPORT
FRY, P.A *(exhibited 1869)*				●										
FRY, Roger Eliot *(1866-1934)*			●									●		
FUNK, Hans *(d.1539)*											●			
FULLARD, George *(1923-1973)*										●				
FURSE, Roger *(worked 1945-1950)*													●	
G														
G, A *(worked 1850)*														●
G, F *(worked last quarter of 19th century)*												●		
G, M.L *(worked c.1603)*											●			
G-PLAN DESIGN STUDIO *(1953-1962)*			●											
G, T H *(worked c.1615)*											●			
GALILEI, Alessandro *(1691-1737), attributed to*	●													
GALLI DA BIBIENA, Ferdinando *(1657-1743)*													●	
GALLI DA BIBIENA FAMILY, *(mid 17th century to early 18th century)*, attributed to various members	●					●							●	
GALLIARI, Fabrizio *(1709-1790)*													●	
GALLIARI, Gaspare, *(1761-1823)*													●	
GAMBLE, James *(1835-1911)*	●					●				●				
GAMES, Abram *(b.1914)*												●		
?GANDOLFI, Gaetano *(1734-1802)*										●				
GANDY, Joseph Michael *(1771-1843)*	●							●						
GANELLA, D *(worked c.1770)*						●								
GANTZ, John *(worked c.1810-c.1830)*										●				
GARTHWAITE, Anna Maria *(1690-1763)*												●		
GASKIN, Arthur Joseph *(1862-1928)*							●							
GASKIN, Georgina Evelyn Cave *(née France) (1868-1934)*							●							
GAUDIER-BRZESKA, Henri *(1891-1915)*										●		●		
GEDDES, Wilhelmina Margaret *(d.1956)*											●			
GELDART, Ernest M *(1848-1929)*				●								●		
GELDER, Peter Mathias van *(1793-1809)*										●				
GEORGE, Sir Ernest *(1839-1922)*	●													
GEORGIADIS, Nicholas *(b.1925)*													●	
GIANI *(Gianni)*, Felice *(?1760-1823)*									●					
GIARDINI, Giovanni *(1646-1722), attributed to*								●						
GIAQUINTO, Corrado *(1703-c.1765)*						●		●						
GIBB, Bill *(b.1943)*												●		
GIBBS, James *(1682-1754)*	●		●	●	●			●	●					
GIBSON, Frank R *(worked c.1925-c.1933)*												●		
GIBSON, John *(1790-1866)*										●				
GILFOY, J *(worked 1855 to 1860)*														●
GILL *(Arthur)* Eric Rowton *(1882-1940)*										●				
GILLIE, Ann *(b.1906)*												●		
GILLOW & CO *(c.1806-1833)*			●			●								
GIORDANO, Luca *(1632-1705)*										●				
GISSEY, Henri *(1608-1673)*													●	
GIULIO ROMANO *(Giulio Pippi) (c.1499-1546)*							●	●	●		●			
GLADSTONE, Gerald *(b.1929)*										●				
GLASBY, William *(exhibited 1900-1923)*											●			
GLOAG, Isobel Lilian *(1865-1917)*											●			
GNOLI, Domenico *(b.1934)*													●	
GODDARD, Lily *(worked 1952-1983)*												●		
GODWIN, Edward William *(1833-1886)*	●	●	●		●	●		●		●	●	●	●	

	ARCHITECTURE	CERAMICS	FURNITURE	FANS	GARDENS	INTERIOR DESIGN	JEWELLERY	METALWORK	ORNAMENT	SCULPTURE	STAINED GLASS	TEXTILES	THEATRE	TRANSPORT
GOFFIN, Peter *(1906-1974)*													●	
GONTCHAROVA, Natalie Sergeevna *(1881-1962)*									●				●	
GONZALEZ, Julio *(1876 or '81-1942)*										●				
GOODAY, Rita *(née Andrews) (1886-1941)*												●		
GOODDEN, Robert Yorke *(b.1909)*		●	●					●	●					
GOODRIDGE, Henry Edmund *(c.1800-1863)*										●				
GOODWIN, Francis *(1784-1835)*	●													
GORDON, George *(worked c.1870-c.1880)*													●	
GOSSE, Nicholas Louis François *(1787-1878)*						●								
GOTTSTEIN-IVO, Gerda *('Gerdago') (worked 1934-1937)*													●	
GOUGH, A *(worked 1825)*	●													
GRAHAM, Robert *(born 1938)*									●					
GRAHAM, Sheila *(worked 1950)*													●	
GRANGE, Kenneth *(b.1929)*			●											
GRANT, Duncan James Corrowr *(1885-1978)*							●					●		
GRASSI, Orazio *(1583-1654)*	●													
GRAVELOT, Hubert François *(Hubert François Bourguignon d'Anville) (1699-1773)*							●							
GRAY, Eileen *(1878-1976)*	●		●									●		
GRAY *(Grivois)*, Henri *(pseudonym of Boulanger) (1858-?)*													●	
GREENLEES, Georgiana M *(worked c.1870)*				●										
GREENWOOD, Thomas *(worked c.1780)*													●	
GRIEVE, Thomas *(1799-1882)*													●	
GROAG, Jacqueline *(b.1903)*												●		
GROGNARD – *(worked last quarter of 18th century)*						●								
GROSE, Anne *(worked c.1868)*				●										
GRYLLS, Harry *(worked second quarter of 20th century)*											●			
GUADRO, Gaetano *(worked 1732)*								●						
GUARDI, Francesco *(1712-1793)*													●	●
GUERRA, Giovanni *(c.1540-1618)*						●								
GUGLIELMI, Gregorio *(1714-c.1773)*						●								
GUIDI, Mauro *(worked last quarter of 18th century)*								●						
GUILD, Tricia *(worked third and last quarters of 20th century)*												●		
GULDI, Heinrich *(worked c.1594-1604)*										●				
GUY, Lucien *(worked early 20th century)*												●		

H

	ARCHITECTURE	CERAMICS	FURNITURE	FANS	GARDENS	INTERIOR DESIGN	JEWELLERY	METALWORK	ORNAMENT	SCULPTURE	STAINED GLASS	TEXTILES	THEATRE	TRANSPORT
H, H *(worked c.1824)*						●								
H, I *(worked second quarter of 20th century)*													●	
H, L A *(worked third quarter of 19th century)*											●			
H, S *(worked second quarter of 19th century)*							●							
HAINES, Wilfrid Stanley *(1905-1944)*												●		
HAITÉ, George *(d.c.1871)*												●		
HAITÉ, George Charles *(1855-1924)*		●	●								●	●		
HAITÉ, John *(c.1790-?)*												●		
HALL, Nigel *(b.1943)*										●				
HALL, Stafford *(1858-1922)*													●	
HAMILTON, Douglas *(worked second quarter of 20th century)*											●			
HAMILTON, G Q *(worked last quarter of 19th century)*												●		
HAMILTON, William *(1751-1801)*											●			
HAMMOND, Aubrey Lindsay *(1893-1940)*													●	
HAMON, Jean Louis *(1821-1874)*				●										
HAMPER, W *(worked last quarter of 18th century)*								●						
HANDLEY-SEYMOUR LTD, House of *(1910-1940)*												●		

Name	ARCHITECTURE	CERAMICS	FURNITURE	FANS	GARDENS	INTERIOR DESIGN	JEWELLERY	METALWORK	ORNAMENT	SCULPTURE	STAINED GLASS	TEXTILES	THEATRE	TRANSPORT
HANN, Walter *(1838-1922)*													●	
HARBINGENSIS, Peter *(worked last quarter of 16th century)*											●			
HARBUTT, William *(worked 1871)*	●													
HARDGRAVE, Charles *(worked c.1871-1915)*						●					●			
HARDING, Gillian *(b.1936)*		●												
HARDY, C *(worked c.1820-c.1870)*														●
HARFORD, William *(1842-1919)*													●	
HARKER, Joseph Cunningham *(1855-1927)*													●	
HARPIN – *(worked first half of 19th century)*													●	
HART & SON *(worked second half of 19th century)*								●						
HARTNELL, Norman *(b.1901)*												●		
HATCH, C *(worked 1850-1865)*													●	
HATCH, W *(worked 1855)*														●
HAVEL, Miroslav *(born 1922)*		●												
HAVINDEN, Ashley Eldrid *(1903-1973)*												●		
HAWARD, Sidney *(worked c.1882-c.1940)*												●		
HAWKINS, L Leila Waterhouse *(worked 1880)*		●												
HAWKSMOOR, Nicholas *(1661-1736)*	●					●				●				
HAYBROOK, Rudolf A *(b.1898)*						●								
HAYES, Albert Edward (1880-1968)											●			
HAYES, Michael *(worked c.1888)*											●			
HAYNES, William Henry & Co , *(c.1925-c.1935)*						●								
HEAL, J Christopher *(b.1911)*			●											
HEASMAN, Ernest *(1874-1927)*	●							●			●			
HEATON, BUTLER & BAYNE, Messrs *(c.1850-c.1940)*						●								
HECKEL, Augustin *(c.1690-1770)*								●						
HEDLINGER, Johann Karl *(1691-1771)*									●					
HEEMSKERCK, Maarten van *(Maarten van Veen) (1498-1574)*											●			
HEMBROW, Victor *(worked 1920-1925)*													●	
HENNINGES, Anna *(worked 1595)*											●			
HENRY, T *(or ?J) (exhibited 1867)*				●										
HEPWORTH, Barbara *(1903-1975)*												●		
HERITAGE, Robert *(b.1927)*			●											
HERON, Susanna *(b.1949)*							●							
HERTZOG, Anna Margaretha *(worked c.1774)*											●			
HESELTINE, Barbara *(worked 1937)*													●	
HEYTHUM, Antonin *(worked 1925)*													●	
HICKS, William Searle *(d.1902)*						●								
HILLER, Eric *(c.1932-c.1938)*													●	
HILLERBRAND, Josef *(b.1892)*												●		
HODGES, W E *(worked c.1890-c.1939)*											●			
HOFFMANN, Joseph *(1870-1956)*		●	●			●	●	●				●		
HOFLEHNER, Rudolph *(b.1916)*										●				
HOGAN, Edmond H *(worked c.1930-c.1936)*											●			
HOGAN, James Humphries *(1883-1948)*		●												
HOLIDAY, Henry George Alexander *(1839-1927)*											●			
HOLLAND, Anthony *(worked 1949)*													●	
HOLLAND, Henry *(1745-1806)*						●								
HOLSCHER, Knud *(b.1929)*			●											
HONEY, Christopher *(b.1942)*			●											
HOOK, James Clarke *(1819-1907)*						●								
HOOPER, George Norgate *(worked 1897)*														●

	ARCHITECTURE	CERAMICS	FURNITURE	FANS	GARDENS	INTERIOR DESIGN	JEWELLERY	METALWORK	ORNAMENT	SCULPTURE	STAINED GLASS	TEXTILES	THEATRE	TRANSPORT
HOPPENHAUPT, ? Johann Michel (1709-p.1750)			●											
HOREAU, Hector (1801-1872)	●													
HORNE, Herbert Percy (1864-1916)	●		●					●				●		
HORNICK, Erasmus (d.1583), attributed to								●						
HOUGHTON, J W (worked c.1886-c.1900)														●
HOWARD, Frank (1805-1866)								●						
HUET, Jean Baptiste (1745-1811)								●						
HUGH MACKAY & CO LTD, Design Studio (1963-1974)												●		
HULSE, James (worked c.1839)		●												
HUNTER, Alec B , (1899-1958)												●		
HUNTER, Edmund Arthur (1866-1937)												●		
HURRY, Leslie (1909-1978)													●	
HUTTON, Mary (worked second and third quarters of 19th century)												●		
I														
IMAGE, Selwyn (1849-1930)											●	●		
IRVING, Laurence Henry Forster (b.1897)													●	
J														
J, H (worked last quarter of 16th century)											●			
JACK, George (1855-1931)	●		●			●		●		●				
JACKSON, Mike (b.1951)							●							
JAMES, Charlotte J (worked 1878)				●										
JAMES, Susan (exhibited 1871)				●										
JAMNITZER, Christoph (1563-1618)								●						
JAMNITZER, Wenzel (1508-1588), attributed to								●						
JECKYLL, Thomas (1827-1881)	●	●				●								
JEFFERIES, Paul (worked third quarter of 20th century)											●			
JEFFERSON, Robert (d.1870)						●								
JOHNSON, Ernest Borough (1867-1949)	●													
JOHNSON, John (1754-1814)	●													
JOLLI (Joli), Antonio (1700-1777)												●		
JONES, John (worked c.1840-1860)		●						●						
JONES, Owen (1809-1874)	●		●			●	●	●	●		●	●		
JORDAENS, Jacob (1593-1678)												●		
JORDAN, J E (worked 1907-1947)												●		
JUHL, Finn (b.1919)			●											
JUNGER, Herman (b.1928)							●							
JUVARRA, Filippo (1676-1736)													●	
K														
K, T (worked 1930)												●		
KARNAGEL, Wolf (born 1946)		●												
KAUFFER, Edward McKnight (1890-1954)												●	●	
KAUFFMANN, Maria Anna Angelica Catharina (1741-1807)			●			●								
KAY, Barry (b.1932)													●	
KAY, Joseph (1775-1847)						●								
KAYE, Margaret (worked 1953)												●		
KEEN, Richard Wynne ('Dykwyn kyn') (1811-1887)													●	
KEENE, Henry (1726-1776)	●		●	●	●					●				
KEMPE, John (worked last quarter of 19th century)						●								
KENNERLEY, G R (worked last quarter of 19th century), after												●		
KENNY, Sean (1932-1973)													●	
KENT, William (1684-1748)	●		●			●				●				
KENT, William (1684-1748), after						●								

	ARCHITECTURE	CERAMICS	FURNITURE	FANS	GARDENS	INTERIOR DESIGN	JEWELLERY	METALWORK	ORNAMENT	SCULPTURE	STAINED GLASS	TEXTILES	THEATRE	TRANSPORT
KILBURN, William *(1745-1818)*												●		
KING, Jessie Marion *(Mrs E A Taylor) (1876-1949)*		●										●		
KING, Lawrence *(1907-1982)*	●		●							●				
KINGMAN, George *(worked c.1850-c.1890)*												●		
KESSELL, Mary *(b.1914)*												●		
KLIMT, Gustav *(1862-1918)*						●								
KLUTSIS, Gustav *(1895-1944)*			●											
KNOWLES, John Alder *(1881-1961)*											●			
KNOX, Archibald *(1864-1933)*							●	●						
KNOX, Archibald *(1864-1933)*, in the style of												●		
KOKOSCHKA, Oskar *(1886-1980)*													●	
KOROVIN *(Korovine)*, Konstantin Alexeivich *(1861-1939)*													●	
KRISTIAN, Roald *(Edgar de Bergen) (worked 1913-1919)*													●	
KUBLER, Werner *(1582-1621)*											●			
KÜNZLI, Otto *(b.1948)*							●							
L														
L F *(worked c.1925)*						●								
L, P V *(worked first half of 17th century)*						●								
LAKE, Richard *(worked 1949)*													●	
LALIQUE, René *(1860-1945)*							●							
LANCASTER, Osbert *(b.1908)*													●	
LANE, E *(worked 1938)*												●		
LANG, Hans Casper *(1571-1645)*, school of											●			
LANG, Hieronymus *(worked c.1540-1582)*											●			
LARIONOV, Mikhail Fyodorovich *(1881-1964)*													●	
LA RUE, Louis Félix de *(1731-1765)*, attributed to													●	
LASDUN, Sir Denys *(b.1914)*	●													
LAURENS, Henri *(1885-1954)*										●				
(?) LAURENTIANI, Giacomo *(d.1650)*								●						
LAVALLÉE-POUSSIN, Etienne de *(1740-1790)*, attributed to	●													
LAVIGERIE, J Clédat de *(worked 1889)*													●	
LAWSON, John *(worked c.1850)*												●		
LAYTON, Susan *(b.1948)*			●											
LEACH, Bernard Howell *(1887-1979)*		●												
LEBAN, H *(worked third quarter of 19th century)*						●								
LEE & SONS, Arthur H *(1888-1907)*												●		
LEE, C W *(worked c.1820)*	●													
LEE, Ernest Claude *(worked c.1878-c.1887)*	●													
LEE, Lawrence *(worked third quarter of 19th century)*											●			
LÉGER, Fernand *(1881-1955)*													●	
LEIGHTON, Frederic, Baron Leighton of Stretton *(1830-1896)*						●								
LEMAN, *(Lemon, Lemmon)* James *(worked first half of 18th century)*												●		
LENOIR, Clodimer *(exhibited 1855)*								●						
LEONI, Leone *(1509-1590)*										●				
LEPAPE, Georges *(1887-1971)*													●	●
LEPEC, Charles *(1830-p.1880)*			●						●					
LESEURE – *(worked third quarter of 18th century)*								●						
LEVASSEUR, E *(worked 19th and early 20th century)*			●											
LEWIS, Percy Wyndham *(1884-1957)*			●											
LEWIS, Roger *(b.1946)*			●											
LIDDELL, John *(worked third quarter of 19th century)*	●													
LIEBART, Philip *(worked c.1804-c.1820)*						●								

	ARCHITECTURE	CERAMICS	FURNITURE	FANS	GARDENS	INTERIOR DESIGN	JEWELLERY	METALWORK	ORNAMENT	SCULPTURE	STAINED GLASS	TEXTILES	THEATRE	TRANSPORT
LIEVESLEY, S K *(worked c.1869-c.1875)*														•
LIGOZZI, Jacopo *(c.1547-1626)*								•						
LINDBERG, Stig *(b.1916)*		•												
LINDTMEYER, Daniel *(1552-1606)*											•			
LINNELL, John *(1723-1796)*			•			•								•
LIOR, P *(worked second quarter of 18th century)*, attributed to												•		
LISSIM, Simon *(Semen Mikhailovich) (1900-1981)*		•	•				•	•				•		
LLOYD, Yvonne *(b.1913)*												•		
LOCK, Matthias *(worked 1740-1769)*			•						•					
LOCKE, Alice *(worked 1870)*				•										
LOEWY, Raymond *(born 1893)*			•			•								
LONDON, George *(d.1713)*, attributed to					•									
LONG, Brian *(b.1934)*			•			•								
LOOSCHEN, L *(worked c.1872)*														•
LORENZEN, Rudiger *(b.1942)*							•							
LOUDON, John Claudius *(1783-1843)*	•													
LOUNSBACH, Eric *(worked 1959)*												•		
LOUIS, Victor *(1731-1800)*	•					•								
LOUTHERBOURG, Philip James de *(1740-1812)*									•				•	
LOWINSKY, Thomas Esmond *(worked 1892-1947)*													•	
LULLS, Arnold *(worked late 16th and early 17th century)*							•							
LUXTON, John *(b.1920)*		•												
LUZZI, *(de Lucij, de Lutiis)*, Luzio *(Lutio)* da Todi *(known as Luzio Romano) (worked c.1528-c.1575)*						•			•					
LYONS, A *(worked c.1887)*, attributed to												•		
M														
M, A *(worked 16th century)*									•					
McCLEERY, Robert Charles *(d.1927)*													•	
McGEE, Mary A *(exhibited 1870)*				•										
McGOWAN, Peter *(b.1934)*												•		
McGRATH, Raymond B *(1903-1977)*			•			•								•
MACKINTOSH, Charles Rennie *(1868-1928)*						•						•		
MACKMURDO, Arthur Heygate *(1851-1942)*						•								
MACKMURDO, Arthur Heygate *(1851-1942)*, after												•		
MACLIESH, Minnie *(1876-p.1956)*												•		
MACLISE, Daniel *(1806-1870)*								•		•				
McNISH, Althea *(worked 1950-p.1982)*												•		
MACQUOID, Percy *(1852-1925)*													•	
McWILLIAM, Frederick Edward *(b.1909)*										•				
MADERNO, Stefano *(1571-1636)*										•				
MAHNKE, Adolf *(worked 1935-1936)*													•	
MAHNONEY, Cyril *(worked 1928)*													•	
MAILLOL, Aristide Joseph Bonaventure *(1861-1944)*										•				
MAKEPEACE, John *(b.1939)*			•											
MALENFANT, Jean Eloi Ferdinand *(b.1802)*								•						
MANN, Cathleen *(Marchioness of Queensberry) (1896-1959)*													•	
MANOCCHI, Giuseppe *(c.1731-1782)*								•	•	•				
MANT, Major Charles *(worked third quarter of 19th century)*	•													
MANUEL, Niklaus *(known as Deutsch) (?1481-1530)*											•			
MARCHETTI, Marco *(Marco da Faenza) (d.1588)*									•					
MARINOT, Maurice *(1882-1960)*		•												
MARKS, William *(worked c.1901-c.1909)*								•						

160

	ARCHITECTURE	CERAMICS	FURNITURE	FANS	GARDENS	INTERIOR DESIGN	JEWELLERY	METALWORK	ORNAMENT	SCULPTURE	STAINED GLASS	TEXTILES	THEATRE	TRANSPORT
MAROT, Daniel *(c.1663-1752)*					●									
MAROT, Jean *(? 1619-1679)*								●						
MARRE, Jules *(worked last quarter of 19th century)*													●	
MARSHALL, Peter Paul *(1830-1900)*											●			
MARUCELLI, Valerio *(worked 1589-1620), attributed to*	●													
MASKALL, Nicholas *(worked last quarter of 18th century)*	●									●				
MATEAR, Huon A *(worked 1915)*	●													
MATURINO, B C *(1490-1527/28)*								●	●					
MAWSON, Sidney G *(worked c.1882-d.1941)*												●		
MAYNARD, Alister *(1903-1976)*			●									●		
MAZEROLLE, Alexis Joseph *(1826-1869)*						●								
MAZZONI, Gaetano *(worked third quarter of 18th century)*										●				
MEADOWS, Bernard *(b.1915)*										●				
MEIER, Conrad *(1695-1766)*											●			
MELLIER & CO, Charles *(worked c.1840)*			●											
MESSEL, Oliver Hilary Sambourne *(b.1904)*												●	●	
MEWES & DAVIS, Messrs *(1900-1914)*			●		●	●		●						
MICHETTI, Niccolò *(d.1759)*													●	
MILLAR, Cecil *(worked 1904-1905)*												●		
MILLER, William *(1828-1909)*						●								
MILLWARD, John, of Olney *(worked 1822-1850)*												●		
MILNE, Drew H *(worked 1933)*			●											
MINKIN, Robert *(b.1928)*		●												
MINON – *(worked c.1888-1890)*													●	
MINNS, Fanny M *(exhibited 1867)*				●										
MINTON, *(Francis)* John *(1917-1957)*													●	
MITELLI, Agostino *(1609-1660)*						●			●					
MODIGLIANI, Amadeo *(1884-1920)*										●				
MOIRA, Gerald *(Edward) (1867-1959)*											●			●
MOITTE, Jean-Guillaume *(1746-1810)*			●											
MOITTE, Jean-Guillaume *(1746-1810), attributed to*								●						
MOISEIWITSCH, Tanya *(Mrs. Felix Krish) (b.1914)*													●	
MOLA, Giovanni Battista *(d.1665)*	●									●				
MOLLO, Eugene *(worked 1928)*													●	
MONDO, Domenico *(1717-1806)*						●								
MONDON, François-Thomas *(c.1709-1755)*						●		●						
MONGARINI, V *(worked third quarter of 19th century)*							●							
MONGENOR – *(worked third quarter of 18th century)*								●						
MONGENOT, John *(worked 1813)*		●												
MONNINGTON, Sir *(Walter)* Thomas *(1902-1976)*						●								
MONTALBA, Ellen *(worked 1868-1902)*				●										
MONTALBA, Henrietta *(exhibited 1870)*				●										
MONTALBA, Hilda *(worked c.1870-d.1919)*				●										
MONTANO, Giovanni Battista *(1534-1621)*			●							●				
MOODY, Francis Wollaston *(1824-1886)*						●								
MOORE, Albert Joseph *(1841-1893)*						●								
MOORE, C Rupert *(b.1904)*												●		
MOORE, Charles E *(1880-p.1954)*												●		
MOORE, Henry Spencer *(b.1898)*										●		●		
MOORE, John Francis *(worked c.1760-d.1809)*										●				
MOREAU, Gustave *(1826-1897)*													●	
MOREAU Le Jeune, Jean Michel *(1741-1814)*						●								

161

Name	ARCHITECTURE	CERAMICS	FURNITURE	FANS	GARDENS	INTERIOR DESIGN	JEWELLERY	METALWORK	ORNAMENT	SCULPTURE	STAINED GLASS	TEXTILES	THEATRE	TRANSPORT
MORNAY – *(worked third quarter of 18th century)*								●						
MORGAN, Alfred *(1836-1924)*						●								
MOROSOFF, Vera *(worked 1930s)*												●		
MORRIS, Mary (May) *(1862-1938)*												●		
MORRIS, Roger *(b.1946)*						●								
MORRIS, William *(1834-1896)*							●				●	●		
MORRISON, R Boyd *(b.1896)*													●	
MORTON, Gavin *(1867-1954)*, possibly by												●		
MORTON, Richard *(worked last quarter of 18th century)* attributed to								●						
MOSER, George Michael *(1706-1783)*								●						
MOSTYN, Elfrida *(worked first half of 20th century)*						●								
'MOTLEY' *Audrey Sophia Harris (1901-1966), Margaret F Harris (b.1904), Elizabeth Montgomery (b.1902)*													●	
MOUCHERON, Isaac de *(1667-1744)*			●											
MOUCHERON, Isaac de *(1667-1744)*, in the style of					●									
MUIR, Jean *(b.c.1932)*												●		
MÜLLER, Robert A *(worked third quarter of 19th century)*				●										
MUNRO, Ian *(b.1929)*												●		
MURER *(Maurer)*, Christoph *(1558-1614)*											●			
MURRAY, George *(1875-1933)*						●								
MUZIANO, Girolamo *(1528-1592)*						●								

N

Name	ARCHITECTURE	CERAMICS	FURNITURE	FANS	GARDENS	INTERIOR DESIGN	JEWELLERY	METALWORK	ORNAMENT	SCULPTURE	STAINED GLASS	TEXTILES	THEATRE	TRANSPORT
NAPPER, Harry *(d.1930)*												●		
NASH, John *(1752-1835)*	●													
NASH, John Northcote *(1893-1977)*						●								
NASH, Paul *(1889-1946)*												●	●	
NAYLOR, Martin *(b.1944)*										●				
NEAGU, Paul *(b.1938)*										●				
NERONI, Bartolommeo *(known as Il Riccio) (c.1500-1571/3)*													●	
NESFIELD, William Eden *(1835-1888)*	●							●						
NEWALL, Josephine Mary *(née Moody) (1848-1923)*												●		
NICHOLSON, Sir William Newzam Prior *(1872-1949)*													●	
NICOLETTO *(Rosex)* DA MODENA *(worked c.1500-1513)*									●					
NIEDECKEN, George M *(1878-1945)*, attributed to						●								
NIELSEN, Kay *(1886-1957)*													●	
NOBLE, Matthew *(1818-1876)*										●				
NOGUCHI, Isamu *(b.1904)*													●	
NOLLEKENS, Joseph *(1737-1823)*										●				
NOLLI, A *(worked third quarter of 18th century)*										●				
NOLLI, Carlo *(1749-1770)*										●				
NORRIS, Herbert *(d.1950)*													●	

O

Name	ARCHITECTURE	CERAMICS	FURNITURE	FANS	GARDENS	INTERIOR DESIGN	JEWELLERY	METALWORK	ORNAMENT	SCULPTURE	STAINED GLASS	TEXTILES	THEATRE	TRANSPORT
OAKLEY, Violet *(worked first quarter of 20th century)*						●								
'ODILON' *(Elizabeth Boedecker, Mrs Fritz Mühsam) (worked 1928-1936)*													●	
OMAN, Julia Trevelyan (Lady Strong) *(b.1930)*													●	
OMEGA WORKSHOPS LTD *(1913-1919)*												●		
OPPENORD *(Oppenort, Oppenordt, Oppenoordt)*, Gilles Marie *(1672-1742)*									●					
ORLIK, Emil *(1870-1932)*													●	
ORSO, Filippo *(worked 1554)*								●						
OSTERWALD, Georg *(1803-1884)*								●		●				

	ARCHITECTURE	CERAMICS	FURNITURE	FANS	GARDENS	INTERIOR DESIGN	JEWELLERY	METALWORK	ORNAMENT	SCULPTURE	STAINED GLASS	TEXTILES	THEATRE	TRANSPORT
P														
P, A L *(worked late 19th and early 20th century)*													●	
PAINE, Charles *(worked 1920-1940)*												●		
PAINE, James I *(c.1716-1789)*	●					●								
PAINE, James II *(1745-1829)*	●					●				●				
PALLADIO, Andrea *(1508-1580)*	●													
(?) PALOMBO, Bartolomeo *(d.1690)*					●									
PANNINI, Francesco *(worked last quarter of 18th century)*						●								
PAOLOZZI, Eduardo *(b.1924)*										●				
PAPWORTH, John Buonarotti *(1775-1847)*		●	●					●						
PARDOE, Thomas *(1770-1823)*		●												
PARIGI, Alfonso, the younger *(d.1656)*													●	
PARKS, John Gower *(1904-1955)*													●	
PARLBY, George Measures *(1856-1944)*											●			
PARMIGIANINO *(Girolamo Francesco Maria Mazzola, known as Il Parmigianino) (1503-1540)*						●								
PARODI, Domenico *(1668-1740)*						●			●					
PARR, James *(1870-1947)*		●												
PASCATTI, A *(worked third quarter of 19th century)*				●										
PATON, Joseph Neil *(1797-1874)*												●		
PAXTON, Sir Joseph *(1801-1865)*	●													
PÉCHEUX, Benoît *(c.1779-p.1831)*								●					●	
PEMBERTON, Reece *(1914-1977)*													●	
PERETTI, Luigi *(worked 1679)*								●						
PERGOLESI, Michaelangelo *(worked late 18th century)*, attributed to						●								
PERRAULT, Claude *(1613-1688)*, attributed to														
PERRY & CO *(1814-1830)*			●					●						
PERUZZI, Baldassare *(1481-1536)*										●				
PERUZZI, Baldassare *(1481-1536)*, school of														●
PETIT, Jacob *((1796-1868)*								●						
PETITOT, Ennemond Alexandre *(1727-1801)*										●				
PFÄNDER, Caroline *(exhibited 1869)*				●										
PHILLIPS, Tom *(b.1937)*												●		
PHILPOT, Glyn Warren *(1884-1937)*													●	
PICAUT – *(worked c.1760)*, attributed to		●												
PICOU, Henri Pierre *(1824-1895)*				●										
PIERCE, *(Pearce)*, Edward *(d.1695)*										●				
PILLEMENT, Jean *(1727-1808)*								●						
PILLEMENT, Jean *(1727-1808)*, school of												●		
PIOLA, Domenico *(1627-1703)*						●		●						
PIPER, John *(b.1903)*										●	●		●	
PIRANESI, Giovanni Battista *(1720-1780)*			●											
PLANAT, Emile *('Marcelin') (1825-1887)*													●	
PLEPP, Hans Jacob *(worked 1576-1595)*											●			
PLUMMER, Caroline Scott *(worked 1948)*													●	
PLUNKETT, William *(b.1928)*			●											
POGEDAIEFF, George Anatol'evich *(b.1897)*													●	
POLETTI, Ferdinando *(worked first quarter of 18th century)*	●									●				
POLUNIN, Elizabeth (née Hart) *(1875-1950)*													●	
POMODORO, Gio *(b.1930)*							●			●				
POMODORO, Arnaldo *(b.1926)*							●			●				
PONSONELLI *(Ponzanelli)*, Giacomo Antonio *(c.1654-1735)*						●								

	ARCHITECTURE	CERAMICS	FURNITURE	FANS	GARDENS	INTERIOR DESIGN	JEWELLERY	METALWORK	ORNAMENT	SCULPTURE	STAINED GLASS	TEXTILES	THEATRE	TRANSPORT
PORDENONE, *(Giovanni Antonio de Lodesanis or de Sachis) (1484-1539)*									●					
PORTA, Giacomo della *(c.1537-1602)*	●													
PORTA, Guglielmo della *(known as Fra Guglielmo del Piombo) (d.1577)*										●				
POSNER, A F *(worked first half of 20th century)*												●		
POWELL, James and Sons, firm of *(1899-1948)*			●						●	●				
POWELL, James Crofts *(worked late 19th century-c.1916)*						●		●	●					
POWELL, John Hardman *(1827-p.1889)* and assistants, probably by											●			
POYNTER, Sir Edward John *(1836-1919)*						●		●			●			
PRICE, H C *(worked c.1840)*	●													
PRITCHARD, Jack *(b.1899)*			●											
PRIZEMAN, John B *(b.1930)*	●		●		●									
PUGIN, Augustus Welby Northmore *(1812-1852)*	●	●	●				●	●			●	●		
PUGIN, Edward Welby *(1834-1875)*			●					●						
PURKISS, Alice B *(worked 1869-p.1881)*				●										
Q														
QUAINI, Luigi *(1643-1717)*									●					
QUANT, Mary *(b.1934)*												●		
QUELLINUS, Jan Erasmus *(1634-1715)*	●					●								
QUENNELL, Charles Henry Bourne *(1872-1935)*												●		
R														
R, F *(worked first quarter of 19th century)*														●
R, H *(worked c.1608)*										●				
RAFFAELLINO DA REGGIO *(Raffaello Motta) (c.1550-1578)*						●								
RAMSDELL, Roger *(worked 1943)*														●
RAMSDEN, Omar *(1873-1939)*								●						
RAMSHAW, Wendy *(b.1939)*							●							
RANDALL, William Frederick *(1846-p.1894)*								●						
RAVILIOUS, Eric William *(1903-1942)*		●				●								
RE, Vincenzo da *(d.1762)*										●				
REDGRAVE, Richard *(1804-1888)*						●		●						●
REEVES, Shiela *(worked 1975)*												●		
REGNIER, François *(worked last quarter of 17th century)*								●	●					
REHN, Jean Eric *(1717-1793)*										●				
REID, James Eadie *(worked last quarter of 19th and first quarter of 20th century)*											●			
REID, John *(b.1925)*			●											
REID, Sylvia *(b.1924)*			●											
RELLING, Ingmar *(b.1920)*			●											
REYNOLDS, W P *(worked third quarter of 19th century)*		●												
RHOADES, Geoffrey Hamilton *(b.1898)*													●	
RHODES, William *(worked second quarter of 19th century)*	●													
RICARDO, Halsey Ralph *(worked last quarter of 19th century)*		●												
RICE, Peter *(b.1928)*												●		
RICHARDS, Ceri Giraldus *(1903-1971)*												●		
RICHARDSON, Charles James *(1806-1871)*	●						●	●						
RICHMOND, G *(worked late 18th century)*							●							
RICHMOND, Sir William Blake *(1842-1921)*						●					●			
RICKETTS, Charles de Sousy *(1866-1931)*													●	
RIEDT, Niklaus von *(worked last quarter of 16th century)*											●			
RIGAUD, Stephen Francis *(1777-1861)*								●		●				
RIGBY, John Scarratt *(worked c.1887-c.1940)*												●		
RINGLER, Ludwig *(c.1535-1605)*											●			
RINGUET, J P *(worked third quarter of 18th century)*, possibly by												●		

	ARCHITECTURE	CERAMICS	FURNITURE	FANS	GARDENS	INTERIOR DESIGN	JEWELLERY	METALWORK	ORNAMENT	SCULPTURE	STAINED GLASS	TEXTILES	THEATRE	TRANSPORT
RINKA, Max *(worked 1933)*													●	
RISCH, Mathias *(c.1860-p.1940)*												●		
RISS, Egon *(worked second quarter of 20th century)*			●											
ROBERTS, Martin *(worked 1970s)*						●								
ROBERTSON, Nora Murray *(worked 1905-1909)*				●										
ROBINSON, Frederick Cayley *(1862-1927)*													●	
ROBINSON, Gerrard *(1834-1891)*			●											
ROBINSON, George Thomas *(d.1897)*			●					●						
ROBINSON, Simpson *(worked 1935)*													●	
ROBINSON, *(Thomas)* Osborne *(b.1904)*													●	
RODGER, Eliza *(exhibited 1869)*				●										
ROERICH, Nicolas Konstantinovich *(1874-1947)*													●	
ROGERS, Frederick Horace *(worked second and third quarters of 19th century)*			●					●	●					
ROGERS, William Gibbs *(1792-1875)*			●					●	●					
ROGERS, William Harry *(worked second and third quarters of 19th century)*			●					●	●					
ROMANELLI, Giovanni Francesco *(?1610-1662)*						●								
ROSE, Yootha *(worked 1929)*													●	
ROSENBERG, Johann Georg *(1739-1808)*													●	
ROSENFELT, Peter *(worked 1972)*			●											
ROSSI, Angelo de *(1670-1742)*										●				
ROUBILIAC, Louis François *(1702/5-1762)*										●				
ROUSSEAU, Jacques *(1630-1693)*						●								
ROUVENAT, M Léon, firm of *(c.1867)*							●							
ROVERE, Giovanni Battista della *(known as Il Fiammenghino)* *(c.1561-1627)*						●								
ROWE, Samuel *(worked last quarter of 19th century)*, after												●		
ROWELL, Kenneth *(worked 1952)*													●	
RUGGIERI, Ferdinando *(1691-1741)*, attributed to	●													
RUNDELL, BRIDGE AND RUNDELL, Messrs *(first quarter of 19th century)*								●						
RUSSELL – *(worked 1950s)*												●		
RUSSELL, J. Howell *(worked last quarter of 19th century)*													●	
RUSSELL, Sir (Sydney) Gordon *(1892-1980)*		●	●					●						
RUSSELL, Richard Drew *(1903-1981)*			●					●						
RUSSELL, Wiliam Henry (Curly) *(1907-1973)*			●											
RUSSELL, William Henry *(1907-1973)*, possibly by						●								
RUTHERSTON, Albert Daniel *(1881-1953)*			●	●									●	
RYAN, Thomas Edward *(1847-1920)*													●	
RYSBRACK, John Michael *(1693-1770)*										●				
S														
SACCHETTI, Lorenzo *(1759-1829)*													●	
SAINT-ANGE, Louis *(1780-p.1831)*												●		
SAINT-AUBIN, Augustin de *(1737-1807)*								●						
SAINT-AUBIN, Charles Germain de *(1721-1786)*, school of												●		
SAINT-AUBIN, Gabriel Jacques de *(1724-1780)*								●						
SAINTHILL, Loudon *(b.1921)*													●	
SALVIATI, Francesco (de' Rossi) *(1510-1563)*						●		●	●					
SALVIATI, Giuseppe (Giuseppe Porta) *(c.1520-1575)*						●								
SAMPSON, Helen *(1885-1976)*												●		
SANDBY, Thomas *(1721-1798)*	●				●									
SANDFORD, George G *(worked c.1775)*	●													
SANSOVINO, Andrea *(Andrea Contucci) (1467/70-1529)*										●				
SANTI, Giovanni Giuseppe *(1644-1719)*													●	

165

	ARCHITECTURE	CERAMICS	FURNITURE	FANS	GARDENS	INTERIOR DESIGN	JEWELLERY	METALWORK	ORNAMENT	SCULPTURE	STAINED GLASS	TEXTILES	THEATRE	TRANSPORT
SANTINI Family *(worked first half of 18th century)*						●								
SAUR, Hans Rudolph *(worked last quarter of 16th century)*											●			
SCARFE, Laurence *(b.1914)*	●	●				●								
SCHEEMAKERS, Pieter, I *(1640-1714)*										●				
SCHEEMAKERS, Pieter *(Gasper)* II *(1691-1781)*										●				
SCHEEMAKERS, Thomas *(1740-1808)*										●				
SCHNEBBELIE, Robert Blemmell *(worked c.1803-d.c.1849)*	●													
SCHNEIDER, H *(worked first quarter of 20th century)*								●						
SCHNORR VON CAROLSFELD, Julius Veit Hans *(1794-1872)*											●			
SCHMIDT, T *(worked first quarter of 20th century)*								●						
SCHOUVALOFF, Paul *('Sheriff') (1903-1961)*													●	
SCOTT, Fred *(worked second half of 20th century)*			●											
SCOTT, George Gilbert *(1842-1894)*	●													
SCOTT, Sir George Gilbert *(1811-1878)*	●													
SCOTT, Major-General Henry Young Darracott *(1822-1883)*	●													
SCOTT, William Bell *(1811-1890)*						●					●			
SCOTTI, Domenico *(worked last quarter of 18th century)*						●				●				
SCHREITER, Johannes *(b.1930)*											●			
SCHUBERT, Johann David *(1761-1822)*		●												
SCHÜRER, Arnold *(b.1929)*			●											
SCHWABE, Randolph *(1885-1948)*													●	
SEDDON, John Pollard *(1827-1906)*	●	●	●			●				●	●	●		
SÉGALLA, Irène *(1894-1982)*													●	
SEGONI, V *(worked c.1770)*			●											
SELWOOD, Cordelia *(b.1920)*												●		
SENSANI, Gino *(worked 1933)*													●	
SHARAFF, Irene *(b.1908)*													●	
SHARP, Thomas *(1805-1876)*								●						
SHARP, W *(worked third quarter of 19th century)*			●											
SHARPE, Sutton *(worked 1802)*			●											
SHAW, Richard Norman *(1831-1912)*	●		●											
SHELVING, Paul *(pseudonym of Frederic William Severne North) (1888-1968)*													●	
SHEPPARD, Guy *(b.1912)*													●	
SHERINGHAM, George *(1884-1937)*				●								●	●	
SHOUT, Robert *(worked 1770-1830)*									●					
SHIELDS, Frederic James *(1833-1911)*						●				●				
SILAS, L *(worked c.1890)*						●								
SILVER, Arthur *(1852-1896)*						●						●		
SILVER, *(Reginald)* Rex *(1879-1965)*								●						
SIME, Sidney H *(1867-1941)*													●	
SIMPSON, Ronald D *(b.1890)*												●		
SLINGER, Martha Maude *(exhibited 1869)*				●										
SLOCOMBE, Charles Philip *(1832-1895)*			●											
SLUTZKY, Naum J *(b.1898)*							●							
SMIRKE, Sir Robert *(1780-1867)*	●													
SMIRKE, Sydney *(1798-1877)*						●								
SMITH, Edward *(worked 1852)*	●													
SMITH, Francis *(1672-1738), probably by*	●													
SMITH, James *(1775-1815)*										●				
SMITH, Pamela Colman *(1877/8-c.1950)*													●	
SMITH, Oliver *(b.1896)*													●	

	ARCHITECTURE	CERAMICS	FURNITURE	FANS	GARDENS	INTERIOR DESIGN	JEWELLERY	METALWORK	ORNAMENT	SCULPTURE	STAINED GLASS	TEXTILES	THEATRE	TRANSPORT
SMITH, Thomas *(worked third quarter of 18th century)*							●		●					
SMITHSON, Alison *(b.1928)*	●		●			●								
SMITHSON, Peter *(b.1923)*	●		●			●								
SNETZLER, L *(worked c.1757)*						●								
SOANE, Sir John *(1753-1837)*	●							●						
SOLIS, Virgil *(1514-1562)*, attributed to								●	●	●				
SOLON, Marc Louis *(1835-1913)*		●												
SONNABEND, Yolanda *(b.1935)*													●	
SORMANI *(Sormano, Sornanno)*, Leonardo *(d.p. 1589)*	●													
SORTE, Christoforo *(worked 1540-d.p.1600)*						●								
SOUTHERN, Richard *(b.1903)*													●	
SPIERS, Charlotte Horne *(worked c.1873-d.1914)*		●		●										
SPIERS, Frank E *(worked first quarter of 20th century)*								●				●		
SPIERS, Florence E P *(exhibited 1870)*			●											
SPINETTI, Domenico *(worked c.1720)*			●											
SPOONER, Charles *(1862-1938)*	●													
SPRIMONT, Nicholas *(1716-1771)*								●						
STABLER, Harold *(1872-1945)*								●						
STAG CABINET COMPANY LTD. Design Studio *(1951-1971)*			●											
STAMMERS, Harry J *(1902-1969)*											●			
STANNUS, Hugh Hutton *(1840-1908)*								●						
STANTON, Emily R *(exhibited 1870)*				●										
STANTON, William *(1639-1705)*, probably by										●				
STEFFAN, G J *(worked c.1750)*							●							
STELLETZKY, Dimitri Semjonovitsch *(b.1875)*													●	
STENNETT-WILLSON, Ronald *(b.1915)*		●												
STERN, Eric E *(worked 1934)*													●	
STERN, Ernest *(1876-1954)*													●	
STEVENS, Alfred *(1817-1875)*	●		●	●		●		●	●	●				●
STEVENSON, John James *(1831-1908)*	●													
STEWART, William Douglas *(b.1886-worked 1922)*													●	
STEYAERT, Louis *(worked 1915)*											●			
STIMMER, Christopher *(1549-c.1578)*											●			
STIMMER, Tobias *(1539-1584)*											●			
STIRLING, James *(b.1926)*	●													
STÖCKLIN, Peter *(worked 1616-d.1652)*											●			
STÖLZL, Gunda Stadler *(b.1897)*												●		
STONE, Alix *(b.1913)*		●										●	●	
STÖR, Hans Konrad *(d.1630)*											●			
STOTHARD, Thomas *(1755-1834)*			●					●	●	●	●			
STRACHAN, Douglas *(1875-1950)*											●			
STRAUB, Marianne *(b.1909)*												●		
STREET, George Edmund *(1824-1881)*	●		●			●								
STROHBACH, Hans *(1890-1949)*													●	
SUTHERLAND, Graham *(1903-1980)*											●			
SWASH, Caroline *(b.1941)*											●			
SWINDELLS, Albert *(1902-1950)*												●		
SYBOLD *(Syboltt)*, Abraham *(1592-1646)*											●			
SYKES, Charles *('Rilette')* *(1875-1950)*								●						
SYKES, Godfrey *(1824-1866)*	●					●		●		●				

T

| TAEUBER-ARP, Sophie *(1889-1943)* | | | | | | | | | | | | ● | | |

	ARCHITECTURE	CERAMICS	FURNITURE	FANS	GARDENS	INTERIOR DESIGN	JEWELLERY	METALWORK	ORNAMENT	SCULPTURE	STAINED GLASS	TEXTILES	THEATRE	TRANSPORT
TALBERT, Bruce James *(1838-1881)*											•	•		
TALMAN, John *(1677-1726)*			•			•								
TARSIA, Bartolomeo *(1711-1765)*						•								
TATTERSALL, Cecil F *(worked first quarter of 20th century)*												•		
TAUTE, Christian *(worked 18th century)*							•							
TAYLOR, Wendy *((b.1945)*										•				
TELBIN, Henry *(1840-1865)*													•	
TELBIN, William *(1815-1873)*													•	
TELBIN, William Lewis *(1846-1931)*													•	
THEED, William, I *(1764-1817)*, probably by								•						
THOMAS, James Harvard *(1854-1921)*										•				
THOMAS, John *(1813-1862)*		•												
THORNTHILL, Sir James *(1675-1734)*	•					•							•	•
THORNTHWAITE, J *(c.1740-p.1795)*										•				
TIEPOLO, Giovanni Battista *(1696-1770)*			•			•				•				
TIEPOLO, Giovanni Battista *(1696-1770)*, school of									•			•		
TIEZE, Franz *(1842-1932)*		•												
TILL, Reginald *(b.1895)*		•				•								•
TIMSON, Leonard Bailey *(worked c.1906-1936)*										•				
TISCHBEIN, Ludwig Philipp *(1743-1808)*													•	
TISDALL, Hans *(formerly known as Hans Aufseeser) (b.1910)*												•		
TOMBLING, J *(worked 1794-1817)*						•								
TOPOLSKI, Feliks *(b.1907)*													•	
TORAUD, F *(worked c.1810-c.1830)*											•			
TORO, Bernard *(1672-1731)*, possibly by									•					
TOWNROE, Reuben *(1835-1911)*						•				•				
TOWNSEND, Charles Harrison *(1852-1928)*												•		
TOWNSEND, Henry James *(1810-1890)*		•	•					•						
TOWNSEND, Thomas *(worked c.1815-c.1870)*														•
TOWNSEND, William George Paulson *(1868-1941)*												•		
TOWNSHEND, Caroline *(worked after 1927-d.1944)*											•			
TOYNBEE-CLARKE, George *(worked 1950)*													•	
TRAQUAIR, Phoebe Annie *(1851-1936)*								•				•		
TRAVERS, Martin *(worked 1918-1945)*											•			
TRIQUETI, Henri, Baron de *(1802-1874)*						•								
TRUBSHAW, James, I *(1746-1808)*, attributed to			•											
TRUMAN, Maria *(exhibited 1869)*				•										
TUCKER, William *(b.1935)*										•				
TURNER - *(worked ? first quarter of 20th century)*												•		
TURNER, Rev Charles Frederick Godbold *(worked 1895-1901)*	•		•											
TYE, Alan *(b.1933)*		•	•											
U														
UCHATIUS, Mitzi *(Marie)* von *(b.1882)*							•							
UNDERWOOD, *(George Claude)* Leon *(b.1890)*										•				
UPTON, John *(b.1933)*						•								
V														
VACHER, Sydney *(1854-1935)*	•		•									•		
VAGA, Perino del *(Piero Buonaccorsi) (1501-1547)*						•		•	•	•				
VAGA, Perino del *(Piero Buonaccorsi) (1501-1547)*, school of	•		•											
VALADIER, Giuseppe *(1762-1839)*								•						
VALLANCE, Aymer *(1862-1943)*												•		
VANBRUGH, Sir John *(1664-1726)*	•													

	ARCHITECTURE	CERAMICS	FURNITURE	FANS	GARDENS	INTERIOR DESIGN	JEWELLERY	METALWORK	ORNAMENT	SCULPTURE	STAINED GLASS	TEXTILES	THEATRE	TRANSPORT
VAN LEERSUM, Emmy *(b.1930)*							●							
VARDY, John *(worked 1730s-d.1765)*	●		●			●		●						
VARLEY, Fleetwood Charles *(worked c.1900)*								●						
VASARI, Giorgio *(1511-1574)*						●								
VASTERS, Reinhold *(d.1909)*							●	●						
VAUGHAN & SONS *(1806-1827)*												●		
VEAZEY, David Colin *(worked c.1896-c.1945), probably by*								●						
VEEVERS, Kathleen *(worked 1954)*												●		
VELDE, Willem van de, II *(1633-1707)in the style of*														●
VERMONT, Melanie *(1897-1972)*												●		
VERONESE, Paolo *(1528-1588), school of*						●								
VERRIO, Antonio *(1639-1707)*						●								
VERROCCHIO, Andrea del *(1435-1488)*										●				
VIGERS, Allan Francis *(1858-1921)*												●		
VIGERS, Frederick *(worked c.1884-post 1910)*												●		
VILE, William *(d.1767), possibly workshop of*			●											
VILETT, J. *(worked 18th century)*	●													
VINCIDOR, Tommaso *(Tommaso di Andrea) (c.1536 -?)*												●		
VISCHER, Hieronymus *(worked c.1580-c.1620)*											●			
VITTONE, *(Vitton, Vittoni), Bernardo Antonio (c.1705-1770), in the style of*	●													
VITTOZ, Eugene *(worked third quarter of 19th century)*			●					●	●					
VOUET, Simon *(1590-1649)*									●					
VOYSEY, Charles Francis Annesley *(1857-1941)*	●	●	●			●		●			●	●		
VRIES, Hans Vredeman de *(1572-p.1604)*									●					
VULLIAMY, Lewis *(1791-1871)*	●													
W														
W, G *(worked c.1877)*						●								
W, V *(worked early 20th century)*													●	
WAKHEVITCH, Georges *(b.1907)*													●	
WALLER, Pickford *(d.1930)*						●			●			●		
WALTERS, Molly *(worked second quarter of 20th century)*												●		
WALTON, Allan *(1892-1948)*						●						●		
WALTON, George *(1867-1933)*		●										●		
WARDLE, George Young *(worked c.1860-d.1910)*											●	●		
WARRE, Michael *(b.1922)*													●	
WATERHOUSE, Alfred *(1830-1905)*	●													
WATERIDGE, John *(1884-p.1952)*		●						●						
WATKINS, David *(b.1940)*							●							
WATSON, John Dawson *(1832-1892)*						●								
WATSON, Musgrave Lewthwaite *(1804-1847)*										●				
WATT, Linnie *(exhibited 1870-1908)*						●								
WATTIER, Émile *(exhibited 1869)*				●										
WEBB, Sir Aston *(1849-1930)*	●													
WEBB, Christopher *(1886-1966)*						●								
WEBB, John *(1611-1674)*						●								
WEBB, Philip Speakman *(1831-1915)*	●	●	●					●		●	●	●		
WEBB, Roger *(b.1949)*			●											
WEECH, Sigmund von *(worked c.1929-c.1930), studio of*												●		
WEIGHT, Michael *(worked 1928-1938)*													●	
WELCH, Robert *(b.1929)*								●						
WEST, Benjamin *(1730-1820)*											●			
WESTMACOTT, Richard, II *(1799-1872)*										●				

	ARCHITECTURE	CERAMICS	FURNITURE	FANS	GARDENS	INTERIOR DESIGN	JEWELLERY	METALWORK	ORNAMENT	SCULPTURE	STAINED GLASS	TEXTILES	THEATRE	TRANSPORT
WESTWOOD, Florrie *(worked c.1917-c.1919)*												●		
WHALL, Christopher W *(1849-1924)*											●			
WHALL, Veronica M *(1887-p.1935)*											●			
WHEELER, George *(worked last quarter of 18th century)*	●		●							●				
WHITE, James *(worked c.1820-c.1830)*						●								
WHITE, Peter D *(worked second quarter of 20th century)*											●			
WICKSTEED, F *(worked c.1825-1860)*														●
WIDAL, M *(exhibited 1869)*				●										
WIGHTMAN, J *(worked first half of 19th century)*	●									●				
WIINBLAD, Bjoern *(b.1919)*		●												
WILCOCK, Arthur *(worked first quarter of 20th century)*												●		
WILD, James William *(1814-1892)*	●									●				
WILDERMANN, Hans Wilhelm *(1884-1954)*													●	
WILHELM, C *(pseudonym of William John Charles Pitcher) (1858-1925)*													●	
WILKINSON, Arthur J Ltd *(c.1820-c.1880)*		●												
WILKINSON, George *(1814-1890)*	●													
WILKINSON, Norman *(of Four Oaks) (1882-1934)*													●	
WILLEMENT, Thomas *(1786-1871)*											●			
WILLIAMS, Chris *(worked 1976)*						●								
WILLIAMS, Lawrence P *(worked 1934)*													●	
WILLIGER, Karen *(worked 1950)*												●		
WILSON, George *(worked 1901-1902)*												●		
WILSON, Henry *(1864-1934)*			●			●	●	●		●	●			
WILSON, Robert *(worked 1760-1790)*								●	●					
WILTON, Joseph *(1722-1803)*			●			●				●				
WIMMER, Edvard Josef *(b.1882)*, attributed to						●								
WISCHAK, Maximilian *(worked c.1530-1552)*											●			
WISE, Henry *(1653-1738)*, attributed to					●									
WIT, Jacob de *(1695-1754)*								●		●				
WIT, Jacob de *(1695-1754)*, attributed to						●								
WITHERS, Edward *(worked c.1775-c.1795)*		●												
WOLFE, Arthur Theobald *(1870-1944)*								●				●		
WOLMARK, Alfred Aaran *(1877-1961)*														●
WOOD, Francis Derwent *(1871-1926)*	●		●					●		●				
WOOD, John *(1801-1870)*										●				
WOODS, John C *(worked second half of 19th century)*			●											
WOOLLAND BROTHERS *(1899-1918)*												●		
WOOLLEY, Reginald *(worked 1951)*													●	
WORTH AND PAQUIN, House of *(c.1865-1956)*												●	●	
WREN, Sir Christopher *(1632-1723)* or assistants	●													
WRIGHT, Austin *(b.1911)*										●				
WRIGHT, Edward *(b.1912)*						●				●				
WRIGHT, Frank Lloyd *(1867/68-1959)*, studio of						●								
WYATT, Benjamin Dean *(1775-1850)*	●													
WYATT, James, I *(1746-1813)*						●								
WYATT, James, II *(1808-1893)*										●				
WYATT, John Drayton *(worked second quarter of 19th century)*	●													
WYATT, Sir Matthew Digby *(1820-1877)*	●	●												
WYATT, Philip *(d.1836)*	●													
WYATVILLE, *(originally Wyatt)* Sir Jeffry *(1766-1840)*	●		●			●								

	ARCHITECTURE	CERAMICS	FURNITURE	FANS	GARDENS	INTERIOR DESIGN	JEWELLERY	METALWORK	ORNAMENT	SCULPTURE	STAINED GLASS	TEXTILES	THEATRE	TRANSPORT
Y														
YENN, John *(worked 1769-d.1821)*			●			●		●						
Z														
ZADKINE, Ossip *(1890-1867)*										●				
ZAMORRA, José *(worked first quarter of 20th century)*												●		
ZEFFIRELLI, Franco *(b.1923)*													●	
ZINKEISEN, Anna Katrina *(1901-1976)*												●		
ZINKEISEN, Doris Clare *(b.c.1898)*												●	●	
ZUCCARO, Federico *(c.1540-1609)*					●	●								
ZUCCHI, Jacopo *(c.1541-1596)*						●								
ZWIRN, Matthias *(worked 1640-1678)*											●			

Designers' names in a quarter century date sequence

In this index designers are listed in alphabetical order in the first quarter century in which they are known to have worked. Full dates are not given but if they are known to have worked to a considerable extent in later quarters their names are preceded by an asterisk. Precise dates, so far as they are known, are found easily in the list of names in uninterrupted alphabetical order.

15th Century: second quarter

Name	ARCHITECTURE	CERAMICS	FURNITURE	FANS	GARDENS	INTERIOR DESIGN	JEWELLERY	METALWORK	ORNAMENT	SCULPTURE	STAINED GLASS	TEXTILES	THEATRE	TRANSPORT
*FRANCESCO DI SIMONE *(Francesco di Simone Ferrucci)*										●				
*VERROCCHIO, Andrea del										●				

15th Century: third quarter

Name	ARCHITECTURE	CERAMICS	FURNITURE	FANS	GARDENS	INTERIOR DESIGN	JEWELLERY	METALWORK	ORNAMENT	SCULPTURE	STAINED GLASS	TEXTILES	THEATRE	TRANSPORT
E S, Master, *of 1466, attributed to*											●			

15th Century: last quarter

Name	ARCHITECTURE	CERAMICS	FURNITURE	FANS	GARDENS	INTERIOR DESIGN	JEWELLERY	METALWORK	ORNAMENT	SCULPTURE	STAINED GLASS	TEXTILES	THEATRE	TRANSPORT
*ALKMAAR, *Master of*											●			

16th Century: first quarter

Name	ARCHITECTURE	CERAMICS	FURNITURE	FANS	GARDENS	INTERIOR DESIGN	JEWELLERY	METALWORK	ORNAMENT	SCULPTURE	STAINED GLASS	TEXTILES	THEATRE	TRANSPORT
*BALDUNG, Hans										●				
(?) BAMBAIA *(Agostino Busti)*										●				
*BROSAMER, Hans								●						
*CALDARA, Polidoro (Polidoro da Caravaggio)	●													
*FUNK, Hans											●			
*GIULIO ROMANO (Giulio Pippi)							●	●	●			●		
*HEEMSKERCK, Maerten van *(also called Maarten van Veen)*										●				
*M, A									●					
MANUEL, Niklaus *(known as Deutsch)*										●				
MATURINO, B C								●	●					
NICOLETTO *(Rosex)* DA MODENA								●						
*PERUZZI, Baldassare										●				
*PERUZZI, Baldassare, school of														●
*PORDENONE *(Giovanni Antonio de Lodesanis* or *de Sachis)*									●					
*SANSOVINO, Andrea *(Andrea Contucci)*										●				
VAGA, Perino del *(Piero Buonaccorsi)*						●		●	●	●				
VAGA, Perino del *(Piero Buonaccorsi),* school of	●		●											
VISCHER, Hieronymus										●				

16th Century: second quarter

Name	ARCHITECTURE	CERAMICS	FURNITURE	FANS	GARDENS	INTERIOR DESIGN	JEWELLERY	METALWORK	ORNAMENT	SCULPTURE	STAINED GLASS	TEXTILES	THEATRE	TRANSPORT
*ANDROUET DUCERCEAU, Jacques			●			●								
*BEDOLI, Girolamo, *(self styled Girolamo Mazzola)*								●						
*BOCK, Hans											●			
BOS, Cornelis, in the style of									●					
COECKE *(Coeke Van Aelst),* Pieter												●		
COXIE, Michiel, I									●					
*DELAUNE, Etienne							●							
*FLORIS, Cornelis, in the style of									●					
*FRANCO, Battista *(known as Semolei)*		●				●								
*JAMNITZER, Christoph								●						
*JAMNITZER, Wenzel, attributed to								●						
*LANG, Hieronymus											●			
*LEONI, Leone										●				
*LUZZI *(de Lucij, de Lutiis),* Luzio *(Lutio)* da Todi *(known as Luzio Romano)*						●			●					
NERONI, Bartolommeo *(known as Il Riccio)*													●	
*PALLADIO, Andrea	●													
PARMIGIANINO *(Girolamo Francesco Maria Mazzola, known as Il Parmigianino)*						●								
*SALVIATI, Francesco *(de' Rossi)*						●		●	●					
*SALVIATI, Giuseppe *(Giuseppe Porta)*						●								

	ARCHITECTURE	CERAMICS	FURNITURE	FANS	GARDENS	INTERIOR DESIGN	JEWELLERY	METALWORK	ORNAMENT	SCULPTURE	STAINED GLASS	TEXTILES	THEATRE	TRANSPORT
SOLIS, Virgil, attributed to							●	●	●					
ORMANI, *(Sormano, Sornanno)*, Leonardo	●													
VASARI, Giorgio						●								
VISCHAK, Maximilian											●			

6th Century: third quarter

	ARCHITECTURE	CERAMICS	FURNITURE	FANS	GARDENS	INTERIOR DESIGN	JEWELLERY	METALWORK	ORNAMENT	SCULPTURE	STAINED GLASS	TEXTILES	THEATRE	TRANSPORT
ALBERTI, Cherubino *(known as Il Borgheggiano)*								●	●					
AMMAN, Jost											●			
M M											●			
ERTOIA, *(Jacopo Zanguidi)*						●								
BOSCOLI, Andrea									●					
UONTALENTI, Bernardo *(known as Bernardo Buontalenti delle Girandole)*	●												●	●
CAMPI, Antonio									●					
(?) CATI, Pasquale						●								
DUCA, Giacomo del									●					
ERO, Lunardo												●		
GUERRA, Giovanni						●								
HORNICK, Erasmus, attributed to								●						
MONTANO, Giovanni Battista			●						●					
MUZIANO, Girolamo						●								
RSO, Filippo								●						
PORTA, Giacomo della	●													
ORTA, Guglielmo della *(known as Fra Guglielmo del Piombo)*									●					
AFFAELLINO DA REGGIO *(Raffaello Motta)*								●						
RINGLER, Ludwig											●			
STIMMER, Christopher											●			
STIMMER, Tobias											●			
ERONESE, Paolo, school of						●								
INCIDOR, Tommaso *(Tommaso di Andrea)*												●		
VRIES, Hans Vredeman de									●					
ZUCCARO, Federico					●	●								

6th Century: last quarter

	ARCHITECTURE	CERAMICS	FURNITURE	FANS	GARDENS	INTERIOR DESIGN	JEWELLERY	METALWORK	ORNAMENT	SCULPTURE	STAINED GLASS	TEXTILES	THEATRE	TRANSPORT
ULDI, Heinrich											●			
ARBINGENSIS, Peter											●			
ENNINGES, Anna												●		
H											●			
LIGOZZI, Jacopo								●						
LINDTMEYER, Daniel											●			
LULLS, Arnold							●							
MARCHETTI, Marco *(Marco Da Faenza)*									●					
MURER *(or Maurer)*, Christoph											●			
LEPP, Hans Jacob											●			
IEDT, Niklaus von											●			
ROVERE, Giovanni Battista della, *(known as Il Fiammenghino)*						●								
SAUR, Hans Rudolph											●			
UCCHI, Jacopo						●								

7th Century: first quarter

	ARCHITECTURE	CERAMICS	FURNITURE	FANS	GARDENS	INTERIOR DESIGN	JEWELLERY	METALWORK	ORNAMENT	SCULPTURE	STAINED GLASS	TEXTILES	THEATRE	TRANSPORT
BERNINI, Giovanni Lorenzo										●				
BERNINI, Giovanni Lorenzo school of														●
BORROMINI, Francesco	●													

	ARCHITECTURE	CERAMICS	FURNITURE	FANS	GARDENS	INTERIOR DESIGN	JEWELLERY	METALWORK	ORNAMENT	SCULPTURE	STAINED GLASS	TEXTILES	THEATRE	TRANSPORT
*(?) CINGANELLI, Michelangelo									●					
*CLEYN, Franz (or Francis)									●					
*CORTONA, Pietro da (Pietro Berretini)								●	●					
*FIASELLA, Domenico, (known as Il Sarzana)	●													
*FISCH, Hans Ulrich, in the style of											●			
G, M L											●			
G, T H											●			
*GRASSI, Orazio	●													
KUBLER, Werner											●			
*L, P V							●							
*LANG, Hans Casper, school of											●			
*MADERNO, Stefano										●				
R, H											●			
*STÖCKLIN, Peter											●			
*STÖR, Hans Konrad											●			
*SYBOLD (or Syboltt), Abraham											●			
*VOUET, Simon										●				

17th Century: second quarter

	ARCHITECTURE	CERAMICS	FURNITURE	FANS	GARDENS	INTERIOR DESIGN	JEWELLERY	METALWORK	ORNAMENT	SCULPTURE	STAINED GLASS	TEXTILES	THEATRE	TRANSPORT
*BELLA, Stefano della		●							●				●	
CAILLARD, Jacques, after						●								
*CANO, Alonso										●				
*CAUS, Isaac de, attributed to					●									
*CHARMETON (or Charmetton), Georges									●					
*CHAUVEAU, François			●						●					
*CHIAVISTELLI, Jacopo						●								
DOBENECKER, Johann									●					
*GALLI DA BIBIENA FAMILY, attributed to various members of	●					●							●	
*GISSEY, Henri													●	
*JORDAENS, Jacob												●		
(?) LAURENTIANI, Giacomo								●						
*MAROT, Jean								●						
*MITELLI, Agostino								●	●					
PARIGI, Alfonso, the younger													●	
*PERRAULT, Claude, attributed to	●													
*ROMANELLI, Giovanni Francesco						●								
*SORTE, Cristoforo						●								
*VELDE, Willem van der, II, in the style of														●
*WEBB, John						●								
WREN, Sir Christopher, or assistants	●													

17th Century: third quarter

	ARCHITECTURE	CERAMICS	FURNITURE	FANS	GARDENS	INTERIOR DESIGN	JEWELLERY	METALWORK	ORNAMENT	SCULPTURE	STAINED GLASS	TEXTILES	THEATRE	TRANSPORT
*ANDROUET DUCERCEAU, Paul												●		
*BÉRAIN, Jean (Louis), I									●				●	
*BESOZZI, Giovanni Ambrogio			●						●					
*CALANDRUCCI, Giacinto						●								
*CIBBER, Caius Gabriel										●				
COUSTOU, Guillaume										●				
*FERRI, Ciro								●						
*GIARDINI, Giovanni, attributed to								●						
*GIORDANO, Luca										●				

	ARCHITECTURE	CERAMICS	FURNITURE	FANS	GARDENS	INTERIOR DESIGN	JEWELLERY	METALWORK	ORNAMENT	SCULPTURE	STAINED GLASS	TEXTILES	THEATRE	TRANSPORT
MOLA, Giovanni Battista	●									●				
*PIOLA, Domenico						●	●							
*PIERCE (Pearce), Edward										●				
*QUAINI, Luigi									●					
*QUELLINUS, Jan Erasmus	●					●								
*ROUSSEAU, Jacques						●								
*SANTI, Giovanni Giuseppe														●
*SCHEEMAKERS, Pieter, I										●				
*STANTON, William, probably by										●				
*VERRIO, Antonio						●								
ZWIRN, Matthias											●			

17th Century: last quarter

	ARCHITECTURE	CERAMICS	FURNITURE	FANS	GARDENS	INTERIOR DESIGN	JEWELLERY	METALWORK	ORNAMENT	SCULPTURE	STAINED GLASS	TEXTILES	THEATRE	TRANSPORT
*ALDROVANDINI, Tommaso														●
*ALMEIDA, Braz (Blazius) de						●								
*BOTT (Bodt), Johann von	●													
*DOMECHIN DE CHAVANNE, Pierre Salomon			●											
*EISLER, Johann Leonhard									●					
FOGGINI, Giovanni Battista	●							●		●				
*GALLI DA BIBIENA, Ferdinando														●
*HAWKSMOOR, Nicholas	●					●				●				
*MAROT, Daniel					●									
*MARUCELLI, Valerio, attributed to	●													
*MOUCHERON, Isaac de			●											
*MOUCHERON, Isaac de, in the style of						●								
(?) PALOMBO, Bartolomeo						●								
*PARODI, Domenico						●				●				
PERETTI, Luigi								●						
*PONSONELLI (Ponzanelli), Giacomo Antonio						●								
REGNIER, François								●	●					
*TORO, Bernard, possibly by									●					
*VANBRUGH, Sir John	●													
*WISE, Henry, attributed to					●									

18th Century: first quarter

	ARCHITECTURE	CERAMICS	FURNITURE	FANS	GARDENS	INTERIOR DESIGN	JEWELLERY	METALWORK	ORNAMENT	SCULPTURE	STAINED GLASS	TEXTILES	THEATRE	TRANSPORT
BABIN, François								●						
*BAURSCHEIT Jan Pieter van II?										●				
BÉRAIN, Jean, II									●					
*BERTOLI, Antonio Daniele														●
*BOUCHARDON, Edmé								●						
*CARLONE, Carlo						●								
CARWITHAM, Thomas									●					
*CASS, Christopher										●				
*CHAUFOURIER, Jean										●				
CHURCHILL, Robert										●				
*CLERMONT, Andien de, attributed to						●			●					
*CORNACCHINI, Agostino						●								
*GALILEI, Alessandro, attributed to	●													
*GARTHWAITE, Anna Maria												●		
*GIBBS, James	●		●			●			●	●				
*GRAVELOT, Hubert François (Hubert François Bourguignon d'Anville)								●						
*HECKEL, Augustin								●						

	ARCHITECTURE	CERAMICS	FURNITURE	FANS	GARDENS	INTERIOR DESIGN	JEWELLERY	METALWORK	ORNAMENT	SCULPTURE	STAINED GLASS	TEXTILES	THEATRE	TRANSPORT
*HEDLINGER, Johann Karl										●				
*JUVARRA, Filippo													●	
*KENT, William	●		●		●					●				
*KENT, William, after									●					
*LEMAN, (Lemon, Lemmon) James												●		
LONDON, George, attributed to					●									
*MEIER, Conrad											●			
*OPPENORD (Oppenort, Oppenordt, Oppenoordt), Gilles Marie										●				
POLETTI, Ferdinando	●									●				
*ROSSI, Angelo de									●					
*RUGGIERI, Ferdinando, attributed to	●													
*RYSBRACK, John Michael										●				
*SANTINI Family							●							
*SCHEEMAKERS, Pieter (Gaspar) II										●				
SPINETTI, Domenico				●										
TALMAN, John			●			●								
*TIEPOLO, Giovanni Battista			●			●				●				
*TIEPOLO, Giovanni Battista, studio of									●			●		
*VILETT, J	●													
*WIT, Jacob de									●	●				
*WIT, Jacob de, attributed to						●								

18th Century: second quarter

	ARCHITECTURE	CERAMICS	FURNITURE	FANS	GARDENS	INTERIOR DESIGN	JEWELLERY	METALWORK	ORNAMENT	SCULPTURE	STAINED GLASS	TEXTILES	THEATRE	TRANSPORT
*BERETI, F, attributed to								●						
*BOQUET, Louis René													●	
*BORRA, Giovanni Battista, attributed to	●													
*BOUCHER, François, possibly by									●					
*BOUCHER, François, after									●					
*CARR, John, of York						●								
*CHAMBERS, Sir William	●				●	●			●	●				
*CHEERE, Sir Henry						●				●				
*CHIPPENDALE, Thomas			●						●					
DRUMMOND, Samuel														●
*GALLIARI, Fabrizio													●	
*GIAQUINTO, Corrado						●			●					
GUADRO, Gaetano								●						
*GUARDI, Francesco													●	●
*GUGLIELMI, Gregorio						●								
HOPPENHAUPT, ? Johann Michel						●								
*JOLLI (Joli), Antonio													●	
*LINNELL, John			●			●								●
LIOR, P attributed to												●		
*LOCK, Matthias			●						●					
*MONDO, Domenico						●								
*MONDON, François-Thomas				●				●						
*MOORE, John Francis										●				
*MOSER, George Michael								●						
*PAINE, James I	●					●								
*PILLEMENT, Jean								●						
*PILLEMENT, Jean, school of												●		
*PIRANESI, Giovanni Battista			●											
*REHN, Jean Eric										●				

	ARCHITECTURE	CERAMICS	FURNITURE	FANS	GARDENS	INTERIOR DESIGN	JEWELLERY	METALWORK	ORNAMENT	SCULPTURE	STAINED GLASS	TEXTILES	THEATRE	TRANSPORT
ROUBILIAC, Louis François										●				
SAINT-AUBIN, Charles Germain de, school of												●		
SAINT-AUBIN, Gabriel Jacques de								●						
SANDBY, Thomas	●				●									
SPRIMONT, Nicholas								●						
STEFFAN, G J							●							
TARSIA, Bartolomeo						●								
AUTE, Christian						●								
VARDY, John	●		●			●		●						
VITTONE (Vitton, Vittoni), Bernardo Antonio, in the style of	●													
WILTON, Joseph			●			●				●				

8th Century: third quarter

	ARCHITECTURE	CERAMICS	FURNITURE	FANS	GARDENS	INTERIOR DESIGN	JEWELLERY	METALWORK	ORNAMENT	SCULPTURE	STAINED GLASS	TEXTILES	THEATRE	TRANSPORT
ADAM, Robert	●					●		●	●	●				
BACON, John, I										●				
EESOLA, P Giovanni						●								
BOUCHERON, Giovanni Battista								●						
ARBONI, Angelo														●
CRUNDEN, John	●					●			●					
DELAFOSSE, Jean Charles	●							●	●					
DUGOURC (Dugoure), Jean Démosthène						●								
EDWARDS, Edward										●				
FONTANA, Carlo						●				●				
GALLIARI, Gaspare														●
(?) GANDOLFI, Gaetano										●				
ANELLA, D						●								
GELDER, Peter Mathias van										●				
HERTZOG, Anna Margaretha												●		
HOLLAND, Henry						●								
HUET, Jean Baptiste								●						
KAUFFMANN, Maria Anna Angelica Catharina				●		●								
KEENE, Henry	●		●		●	●			●					
KILBURN, William												●		
LA RUE, Louis Félix de, attributed to														●
LAVALLÉE-POUSSIN, Etienne de, attributed to	●													
ESEURE –								●						
LOUIS, Victor	●					●								
LOUTHERBOURG, Philip James de									●	●			●	
MANOCCHI, Giuseppe								●	●	●				
MAZZONI, Gaetano										●				
MICHETTI, Niccoló														●
MOITTE, Jean-Guillaume			●											
MOITTE, Jean-Guillaume, attributed to								●						
MONGENOR –								●						
MOREAU Le Jeune, Jean Michel						●								
MORNAY –								●						
NOLLEKENS, Joseph										●				
NOLLI, A										●				
NOLLI, Carlo										●				
PAINE, James, II	●					●				●				
PETITOT, Ennemond Alexandre										●				

	ARCHITECTURE	CERAMICS	FURNITURE	FANS	GARDENS	INTERIOR DESIGN	JEWELLERY	METALWORK	ORNAMENT	SCULPTURE	STAINED GLASS	TEXTILES	THEATRE	TRANSPORT
PICAUT – attributed to		•												
RE, Vincenzo da										•				
RINGUET, J P, possibly by												•		
*ROSENBERG, Johann Georg													•	
*SAINT-AUBIN, Augustin de								•						
*SCHEEMAKERS, Thomas										•				
SEGONI, V			•											
*SHOUT, Robert										•				
SMITH, Thomas							•		•					
SNETZLER, L						•								
*THEED, William, I, possibly by								•						
*THORNTHWAITE, J										•				
*TISCHBEIN, Ludwig Philipp														•
*TRUBSHAW, James, I, attributed to			•											
VILE, William, possibly workshop of			•											
*WEST, Benjamin											•			
*WILSON, Robert								•	•					
*WYATT, James, I						•								

18th Century: last quarter

	ARCHITECTURE	CERAMICS	FURNITURE	FANS	GARDENS	INTERIOR DESIGN	JEWELLERY	METALWORK	ORNAMENT	SCULPTURE	STAINED GLASS	TEXTILES	THEATRE	TRANSPORT
*ALDRIDGE, James							•	•						
AMADEI, Amadio						•								
*BILLINGSLEY, William		•												
*BISON, Giuseppe Bernardino								•						
BOILEAU, Jean Jacques								•						
BOSCHI, Giuseppe								•						
CHARRON, William								•						
CHARPENTIER, Renat										•				
*COCKERELL, Samuel Pepys	•													
DEARE, John										•				
*FLAXMAN, John								•	•	•				
FOWLER, William										•	•			
*GANDY, Joseph Michael	•							•						
*GIANI (Gianni), Felice									•					
GREENWOOD, Thomas														•
GROGNARD –						•								
GUIDI, Mauro								•						
HAMILTON, William												•		
HAMPER, W										•				
*JOHNSON, John	•													
MASKALL, Nicholas	•									•				
MORTON, Richard, attributed to								•						
*NASH, John	•													
PANNINI, Francesco						•								
*PARDOE, Thomas		•												
PERGOLESI, Michelangelo, attributed to						•								
RICHMOND, G								•						
SACCHETTI, Lorenzo														•
SANDFORD, George G	•													
SCOTTI, Domenico								•		•				
*SCHUBERT, Johann David		•												

	ARCHITECTURE	CERAMICS	FURNITURE	FANS	GARDENS	INTERIOR DESIGN	JEWELLERY	METALWORK	ORNAMENT	SCULPTURE	STAINED GLASS	TEXTILES	THEATRE	TRANSPORT
SMITH, Francis, probably by	●													
SOANE, Sir John	●					●		●						
STOTHARD, Thomas			●					●	●	●	●			
THORNHILL, Sir James	●					●							●	●
TOMBLING, J						●								
VALADIER, Giuseppe								●						
WHEELER, George	●		●							●				
WITHERS, Edward		●												
WYATVILLE (originally Wyatt), Sir Jeffry	●		●			●								
YENN, John			●			●		●						

9th Century: first quarter

	ARCHITECTURE	CERAMICS	FURNITURE	FANS	GARDENS	INTERIOR DESIGN	JEWELLERY	METALWORK	ORNAMENT	SCULPTURE	STAINED GLASS	TEXTILES	THEATRE	TRANSPORT
AKBER, Mirza	●	●							●					
ATKINSON, William						●								
BACON, John, II										●				
BAILY, Edward Hodges, attributed to								●						
BARKER, Thomas, probably by														●
BASOLI DI CASTELGUELFO, Antonio														●
BELLI, Pietro								●						
BLORE, Edward and assistants	●		●			●								
BORSATO, Giuseppe, probably by														●
BUCKLER, John Chessel										●				
BURTON, Decimus	●													
CAPRONNIER, François		●												
CARRASSI (Carassi), Antoine														●
CLARK, George	●													
COCKERELL, Charles Robert	●					●		●		●	●			
COTTINGHAM, Lewis Nockalls			●			●								
CUTTS, John		●												
DALE, Mary Frances												●		
DANSEY, S.J									●			●		
DERBY CROWN PORCELAIN CO LTD		●												
DREWRY, W T			●							●				
EGINTON, William Raphael											●			
FIFIELD, William, I		●												
FISCHER, Christoph												●		
FISCHER, J H								●						
FRANCHI, Gregorio								●						
GANTZ, John										●				
GIBSON, John										●				
GILLOW & CO			●			●								
GOODRIDGE, Henry Edmund										●				
GOODWIN, Francis	●													
GOSSE, Nicholas Louis François						●								
GOUGH, A	●													
GRIEVE, Thomas													●	
H, H						●								
HAITÉ, John												●		
HARDY, C														●
HARPIN –													●	
HOREAU, Hector	●													

179

	ARCHITECTURE	CERAMICS	FURNITURE	FANS	GARDENS	INTERIOR DESIGN	JEWELLERY	METALWORK	ORNAMENT	SCULPTURE	STAINED GLASS	TEXTILES	THEATRE	TRANSPORT
*KAY, Joseph						●								
LEE, C W	●													
LIEBART, Philip							●							
*LOUDON, John Claudius	●													
MONGENOT, John		●												
PAPWORTH, John Buonarotti		●	●					●						
*PATON, Joseph Neil											●			
*PAXTON, Sir Joseph	●													
*PECHEUX, Bénoît								●						●
*PERRY & CO			●					●						
*PETIT, Jacob								●						
R, F														●
*RIGAUD, Stephen Francis								●		●				
*ROGERS, William Gibbs			●					●	●					
*ROGERS, William Harry			●					●	●					
RUNDELL, BRIDGE AND RUNDELL, Messrs								●						
*SAINT-ANGE, Louis												●		
*SCHNEBBELIE, Robert Blemmell	●													
*SCHNORR VON CAROLSFELD, Julius Veit Hans											●			
SHARPE, Sutton			●											
*SMIRKE, Sir Robert	●													
*SMIRKE, Sydney						●								
SMITH, James										●				
*TORAUD, F												●		
*TOWNSEND, Thomas														●
*TRIQUETI, Henri, Baron de						●								
*VAUGHAN & SONS												●		
*VULLIAMY, Lewis	●													
*WESTMACOTT, Richard, II										●				
*WHITE, James						●								
*WIGHTMAN, J	●									●				
*WILKINSON, Arthur J, Ltd		●												
*WILLEMENT, Thomas											●			
WOOD, John										●				
*WYATT, Benjamin Dean	●													
WYATT, Philip	●													

19th Century: second quarter

	ARCHITECTURE	CERAMICS	FURNITURE	FANS	GARDENS	INTERIOR DESIGN	JEWELLERY	METALWORK	ORNAMENT	SCULPTURE	STAINED GLASS	TEXTILES	THEATRE	TRANSPORT
ANDREWS, George Townsend	●													
*ARCHAMBAUT, A			●											
*AUSTIN, Jesse		●												
*BEAUMONT, (Charles) Edouard de				●										
*BEAUMONT, William													●	
*BELL, John		●						●						
*BELL, Joseph		●												
*BERTHELIN, Max						●								
*BILLINGS, Robert William									●	●				
*BLAND, Sarah, possibly by												●		
*BOOTH, Lorenzo, possibly by			●											
*BRANDON, David	●													
*BRIDGENS, Richard, probably by or after			●											

180

	ARCHITECTURE	CERAMICS	FURNITURE	FANS	GARDENS	INTERIOR DESIGN	JEWELLERY	METALWORK	ORNAMENT	SCULPTURE	STAINED GLASS	TEXTILES	THEATRE	TRANSPORT
BROWN, Ford Madox											●			
BROWNE, Hablot Knight		●						●						
*BUCKLER, George										●				
*BURY, Thomas Talbot			●											
*BUTTERFIELD, William	●		●			●		●				●		
C, A B										●				
*CAPRONNIER, Jean-Baptiste		●												
*CHRISTOFLE –							●							
CLERGET, Charles Ernest									●		●			
*COLE, Sir Henry ('Félix Summerly')		●						●		●				
COLLMAN, Leonard W	●		●			●		●	●					
*COOKE, Edward William					●									
*CORBOULD, Edward Henry														●
*CORNUAUD, J D												●		
CRABB, James			●			●								
*CRACE, John Gregory			●			●								
DANSEY, Helen												●		
*D'EGVILLE, James	●													
*DURHAM, Joseph										●				
*DYCE, William										●				
*FERGUSSON, James	●													
*FOSSEY, Félix				●										
*FOWKE, Captain Francis	●													
*FOYE, Mrs. Jones												●		
*GODWIN, Edward William	●	●	●		●			●			●	●	●	●
H, S										●				
*HAMON, Jean Louis				●										
*HEATON, BUTLER & BAYNE, Messrs								●						
*HOOK, James Clarke								●						
*HOWARD, Frank								●						
HULSE, James		●												
*HUTTON, Mary												●		
*JONES, John		●						●						
*JONES, Owen	●		●			●		●	●	●	●	●		
*KEEN, Richard Wynne ('Dykwynkyn')														●
*MACLISE, Daniel								●		●				
MALENFANT, Jean Eloi Ferdinand								●						
MELLIER & CO, Charles			●											
MILLWARD, John, of Olney												●		
*MOODY, Francis Wollaston						●								
*NOBLE, Matthew										●				
*OSTERWALD, Georg								●		●				
*PICOU, Henri Pierre				●										
*PLANAT, Emile ('Marcelin')													●	
PRICE, H.C	●													
PUGIN, Augustus Welby Northmore	●		●				●	●	●		●	●		
*REDGRAVE, Richard							●	●						●
RHODES, William	●													
RICHARDSON, Charles James	●					●		●						
*ROGERS, Frederick Horace			●					●	●					
*SCOTT, Sir George Gilbert	●													
*SCOTT, Major-General Henry Young Darracott	●													

	ARCHITECTURE	CERAMICS	FURNITURE	FANS	GARDENS	INTERIOR DESIGN	JEWELLERY	METALWORK	ORNAMENT	SCULPTURE	STAINED GLASS	TEXTILES	THEATRE	TRANSPORT
*SCOTT, William Bell						●					●			
*SHARP, Thomas								●						
*STEVENS, Alfred	●		●		●	●		●	●	●				●
*STREET, George Edmund	●		●			●								
*SYKES, Godfrey	●					●		●		●				
*TELBIN, William													●	
*THOMAS, John		●												
*TOWNSEND, Henry James		●	●					●						
WATSON, Musgrave Lewthwaite										●				
*WILD, James William	●										●			
*WILKINSON, George	●													
*WYATT, James, II											●			
WYATT, John Drayton	●													
*WYATT, Sir Matthew Digby	●	●												

19th Century: third quarter

	ARCHITECTURE	CERAMICS	FURNITURE	FANS	GARDENS	INTERIOR DESIGN	JEWELLERY	METALWORK	ORNAMENT	SCULPTURE	STAINED GLASS	TEXTILES	THEATRE	TRANSPORT
*ALEXANDRE, M				●										
ALLEN, C Bruce	●													
*ALMA-TADEMA, Sir Lawrence													●	
*ANDERSON, Percy													●	
ARCHER, Henry			●											
*ARMSTEAD, Henry Hugh								●						
AUSTEN, Matilda				●										
*BARTLETT –			●					●						
BARTON, S and J														●
*BENTLEY, John Francis	●		●		●	●					●			
BEVAN, Charles			●											
*BEVERLEY, William Roxby													●	
*BLOMFIELD, Sir Arthur William			●											
BLOUNT, Gilbert J	●		●					●						
*BODLEY, George Frederick							●	●						
*BOWLER, Henry Alexander			●											
BRAUTIGAN, Ch and J														●
BROADLEY, Frances						●								
BROOKS, Maria						●								
*BURGES, William	●	●	●				●	●	●	●	●			
*BURNE-JONES, Sir Edward Coley		●	●				●	●	●		●	●		
CALAMATTA, Joséphine (née Rochette)						●								
CANEY, Robert													●	
*CARAN D'ACHE (pseudonym of Emanuel Poiré)												●		
*CHAMBERLAIN, John Henry						●								
CHARLES, Richard			●											
CHARLTON, Thomas, & Co			●					●						
*CHASEMORE, Archibald													●	
CLARKE, G														●
COCKERELL, Samuel Pepys	●													
*COKE, Alfred Sacheverell												●		
COLFAX, Louisa				●										
*COMPTON, Lord Alwyne, Bishop of Ely								●						
COOMBS, Henrietta				●										
*COOPER, J C														●

	ARCHITECTURE	CERAMICS	FURNITURE	FANS	GARDENS	INTERIOR DESIGN	JEWELLERY	METALWORK	ORNAMENT	SCULPTURE	STAINED GLASS	TEXTILES	THEATRE	TRANSPORT
COTTINGHAM, N J			•			•								
*CRACE, John Dibblee			•			•	•	•			•			
*CRANE, Walter						•						•	•	
*DAY, Lewis Foreman		•	•	•		•					•	•		
*DEARLE, John Henry												•		
*DE MORGAN, William Frend		•								•				
*DENNISON, S														•
DICKINSON, Henry D	•													
EDLER, Eduard								•						
EVANS, Emily				•										
FIELD, Jessie				•										
FOSTER, Amelia A				•										
*FOX, George Edward			•			•		•			•			
FRY, P A				•										
G, A														•
*GAMBLE, James	•					•				•				
*GEORGE, Sir Ernest	•													
GILFOY, J														•
*GORDON, George													•	
GREENLEES, Georgiana M				•										
GROSE, Anne				•										
H, L A												•		
HAITÉ, George												•		
*HANN, Walter													•	
HARBUTT, William	•													
*HARDGRAVE, Charles						•					•			
*HARFORD, William													•	
*HART & SON								•						
HATCH, C														•
HATCH, W														•
HENRY, T (or ? J)				•										
*HOLIDAY, Henry George Alexander											•			
*IMAGE, Selwyn											•	•		
*JACK, George	•		•			•		•		•				
JAMES, Susan				•										
*JECKYLL, Thomas	•	•				•								
JEFFERSON, Robert						•								
*KINGMAN, George												•		
LAWSON, John												•		
LEBAN, H						•								
*LEIGHTON, Frederic, Baron Leighton of Stretton						•								
LENOIR, Clodimer								•						
*LEPEC, Charles			•						•					
LIDDELL, John	•													
LIEVESLEY, S K														•
LOCKE, Alice				•										
LOOSCHEN, L														•
McGEE, Mary A				•										
MANT, Major Charles	•													
*MARSHALL, Peter Paul											•			
MAZEROLLE, Alexis Joseph				•										
*MILLER, William					•									

	ARCHITECTURE	CERAMICS	FURNITURE	FANS	GARDENS	INTERIOR DESIGN	JEWELLERY	METALWORK	ORNAMENT	SCULPTURE	STAINED GLASS	TEXTILES	THEATRE	TRANSPORT
MINNS, Fanny M				●										
*MOORE, Albert Joseph						●								
MONGARINI, V							●							
*MONTALBA, Ellen				●										
MONTALBA, Henrietta				●										
*MONTALBA, Hilda				●										
*MOREAU, Gustave													●	
*MORGAN, Alfred						●								
*MORRIS, William						●					●	●		
MÜLLER, Robert A				●										
*NESFIELD, William Eden	●							●						
*NEWALL, Josephine Mary (née Moody)												●		
PASCATTI, A				●										
PFÄNDER, Caroline				●										
*POWELL, John Hardman and assistants, probably by											●			
*POYNTER, Sir Edward John						●		●			●			
PUGIN, Edward Welby			●					●						
*PURKISS, Alice B				●										
*RANDALL, William Frederick								●						
REYNOLDS, W P		●												
*RICHMOND, Sir William Blake						●					●			
*ROBINSON, Gerrard			●											
RODGER, Eliza				●										
ROUVENAT, M Léon, firm of							●							
*RYAN, Thomas Edward														●
*SCOTT, George Gilbert	●													
*SEDDON, John Pollard	●	●	●			●				●	●	●		
SHARP, W			●											
*SHAW, Richard Norman	●		●											
*SHIELDS, Frederic James						●					●			
SLINGER, Martha Maude				●										
*SLOCOMBE, Charles Philip			●											
SMITH, Edward	●													
SOLON, Marc Louis		●												
SPIERS, Florence E P				●										
*SPOONER, Charles	●													
*STANNUS, Hugh Hutton								●						
STANTON, Emily R				●										
*STEVENSON, John James	●													
*TALBERT, Bruce James											●	●		
TELBIN, Henry													●	
*TELBIN, William Lewis													●	
*TIEZE, Franz		●												
*TOWNROE, Reuben						●					●			
*TOWNSEND, Charles Harrison												●		
*TRAQUAIR, Phoebe Annie								●				●		
TRUMAN, Maria				●										
VITTOZ, Eugene			●					●		●				
*WARDLE, George Young											●	●		
*WATERHOUSE, Alfred	●													
*WATSON, John Dawson						●								
*WATT, Linnie						●								

	ARCHITECTURE	CERAMICS	FURNITURE	FANS	GARDENS	INTERIOR DESIGN	JEWELLERY	METALWORK	ORNAMENT	SCULPTURE	STAINED GLASS	TEXTILES	THEATRE	TRANSPORT
WATTIER, Émile				●										
*WEBB, Sir Aston	●													
*WEBB, Philip Speakman	●	●	●			●		●			●	●		
*WHALL, Christopher W											●			
*WICKSTEED, F														●
WIDAL, M				●										
WOODS, John C			●											
*WORTH AND PAQUIN, House of												●	●	

19th Century: last quarter

	ARCHITECTURE	CERAMICS	FURNITURE	FANS	GARDENS	INTERIOR DESIGN	JEWELLERY	METALWORK	ORNAMENT	SCULPTURE	STAINED GLASS	TEXTILES	THEATRE	TRANSPORT
*AMES, Victor							●							
ANDERSON, Emily												●		
*ASHBEE, Charles Robert	●						●	●		●				
*BAKST, Léon Nikolaievitch (Lev Samoilovitch Rosenberg)		●										●		
*BELL, Robert Anning		●									●			
*BENSON, William Arthur Smith	●							●						
BESCHE, Lucien												●		
BIGIARELLI, A												●		
BÖÖCKE, R L												●		
*BOSWELL, John Edward								●						
BROADFOOT –														
*BROWN, J W											●			
BURLISON AND GRYLLS, Messrs											●			
*BUTTERFIELD, Lindsay Phillip												●		
*C, A												●		
*CAMERON, Arthur, possibly by								●						
CHARLTON ALLEN & CO		●	●											
*COCKERELL, Douglas Bennett												●		
*COMBA, Pierre														●
*COMELLI, Attilio												●		
*COMPER, Sir (John) Ninian											●			
*CONDER, Charles				●								●		
CRAGE, Basil												●		
CRAVEN, Hawes												●		
*CREES, Margaret												●		
CRIVELLI, D						●								
*EDEL, Alfredo												●		
*EDEN, Frederick Charles											●			
FERGUSON, J Knox						●								
*FISHER, Alexander, attributed to						●								
*FORBES-ROBERTSON, Eric ('John Le Celt' 'Kelt')												●		
*FORMILLI, Cesare Titus Giuseppe			●											
FREDERICS, Arthur												●		
G, F												●		
*GASKIN, Arthur Joseph							●							
*GASKIN, Georgina Evelyn Cave (née France)							●							
*GELDART, Ernest M			●									●		
*GLOAG, Isobel Lilian											●			
GRAY (Grivois), Henri (pseudonym of Boulanger)													●	
*HAITÉ, George Charles		●	●								●	●		
*HALL, Stafford													●	

185

	ARCHITECTURE	CERAMICS	FURNITURE	FANS	GARDENS	INTERIOR DESIGN	JEWELLERY	METALWORK	ORNAMENT	SCULPTURE	STAINED GLASS	TEXTILES	THEATRE	TRANSPORT
HAMILTON, G Q												●		
*HARKER, Joseph Cunningham													●	
*HAWARD, Sidney												●		
HAWKINS, L Leila Waterhouse		●												
HAYES, Michael												●		
HICKS, William Searle						●								
*HODGES, W E										●				
*HOFFMANN, Josef		●	●				●	●	●			●		
HOOPER, George Norgate														●
*HORNE, Herbert Percy	●		●						●		●			
HOUGHTON, J W													●	
*HUNTER, Edmund Arthur												●		
JAMES, Charlotte J	●													
*JOHNSON, Ernest Borough	●													
KEMPE, John						●								
KENNERLEY, G R, after												●		
*KING, Jessie Marion (Mrs E A Taylor)		●										●		
*KLIMT, Gustav						●								
*KNOX, Archibald							●	●						
*KOROVIN, (Korovine), Konstantin Alexeivich													●	
*LALIQUE, René							●							
LAVIGERIE, J Clédat de													●	
LEE & SONS LTD, Arthur H												●		
LEE, Ernest Claude	●													
*LEVASSEUR, E			●											
LYONS, A, attributed to												●		
*MACKINTOSH, Charles Rennie						●						●		
*MACKMURDO, Arthur Heygate						●								
*MACKMURDO, Arthur Heygate, after												●		
*MACQUOID, Percy													●	
*MAILLOL, Aristide Joseph Bonaventure										●				
MARRE, Jules													●	
*MAWSON, Sidney G												●		
MINON –													●	
*MOIRA, Gerald (Edward)										●				●
*MORRIS, Mary (May)												●		
*MORTON, Gavin, possibly by												●		
*ORLIK, Emil													●	
*P, A L													●	
*PARLBY, George Measures										●				
*PARR, James		●												
*POWELL, James and Sons, firm of			●							●	●			
*POWELL, James Crofts							●		●		●			
*REID, James Eadie											●			
RICARDO, Halsey Ralph		●												
*RICKETTS, Charles de Sousy													●	
*RIGBY, John Scarratt												●		
*RISCH, Mathias												●		
*ROBINSON, Frederick Cayley													●	
ROBINSON, George Thomas			●						●					
ROWE, Samuel, after											●			
RUSSELL, J Howell													●	

	ARCHITECTURE	CERAMICS	FURNITURE	FANS	GARDENS	INTERIOR DESIGN	JEWELLERY	METALWORK	ORNAMENT	SCULPTURE	STAINED GLASS	TEXTILES	THEATRE	TRANSPORT
SILAS, L						●								
SILVER, Arthur						●						●		
*SIME, Sidney H													●	
*SPIERS, Charlotte Horne		●			●									
STELLETZKY, Dimitri Semjonovitsch													●	
*THOMAS, James Harvard										●				
*TOWNSEND, William George Paulson												●		
*TURNER, Rev. Charles Frederick Godbold	●		●											
*VACHER, Sydney	●		●									●		
*VALLANCE, Aymer												●		
*VASTERS, Reinhold							●	●						
*VEAZEY, David Colin, probably by								●						
*VIGERS, Allan Francis												●		
*VIGERS, Frederick												●		
*VOYSEY, Charles Francis Annesley	●	●	●			●		●			●	●		
W, G						●								
*WALLER, Pickford						●			●			●		
*WALTON, George		●										●		
*WILHELM, C (pseudonym of William John Charles Pitcher)													●	
*WILSON, Henry			●				●	●	●		●	●		
*WOOLLAND BROTHERS												●		
*WRIGHT, Frank Lloyd, studio of						●								

20th Century: first quarter

	ARCHITECTURE	CERAMICS	FURNITURE	FANS	GARDENS	INTERIOR DESIGN	JEWELLERY	METALWORK	ORNAMENT	SCULPTURE	STAINED GLASS	TEXTILES	THEATRE	TRANSPORT
*ADLER, Jankel												●		
*ALABASTER, Annie							●	●						
*ALEXANDER, John						●								
*ANDREÜ, Mariano														●
*ANREP, Boris		●				●						●		
*ARMFIELD, Maxwell												●		
ARTHUR, Messrs						●								
*ARMSTRONG, John						●						●		
*ATKINSON, Lawrence										●				
*AVADIS, Marcus												●		
*BALFOUR, Ronald Egerton														●
BAN, Jules O de													●	●
*BART (Barthe) Victor Sergeevich													●	
BATEMAN, C E										●				
*BEDFORD, Richard Perry			●							●				
*BELL, Vanessa												●		
*BENOIS, Alexandre Nikolaevich													●	
*BENOIS, Nadia													●	
*BILBIE, Joseph Percy											●			
*BILBIE, Olive (née Harrison)											●			
*BILIBIN, Ivan Jakovlevich													●	
BISHOP, Vyvian													●	
*BOMBERG, David Garshen													●	
BOSDET, H T											●			
*BOSSANYI, Ervin											●			
*BOUCHENE, Dimitri													●	
*BRADSHAW, Lawrence						●		●		●				

187

	ARCHITECTURE	CERAMICS	FURNITURE	FANS	GARDENS	INTERIOR DESIGN	JEWELLERY	METALWORK	ORNAMENT	SCULPTURE	STAINED GLASS	TEXTILES	THEATRE	TRANSPORT
*BRAQUE, Georges													●	
*BREUER, Marcel			●											
*BRODZKY, Horace													●	
*CHAMPNEYS, Walpole						●								
CHARBONNIER, Frances				●										
*CHARDON, Ferdinand Eugène Léon							●							
*CHERMAYEFF, Serge						●								
CLARKE, Somers			●											
*CRAIG, (Edward Henry) Gordon													●	
CROW (? pseudonym)													●	
*CSAKY, Joseph										●				
*DARCY BRADDELL, Dorothy						●								
DAVIS, Mary				●										
*DELANY, Edward													●	
DEMPSEY, C W		●												
*DERAIN, André													●	
*DERRICK, Thomas											●		●	
*DOBSON, Frank										●	●			
*DOBOUJINSKY, Mstislav Valerjanovich													●	
DORAN, Joseph M												●		
*DORN, Marion V												●		
*DUFY, Raoul												●		
*EDNIE, John						●								
EDWARDS, Albert												●		
EMDEN, Henry													●	
*ERRIDGE, A F									●					
*ERTÉ (pseudonym of Romain de Tirtoff)												●	●	
ESPLIN, Mabel									●					
*ETCHELLS, Frederick												●		
*EXTER, Alexandra													●	
FAULKNER, Charles Joseph										●				
*FEDOROVITCH, Sophie													●	
FIELD, Ruth				●										
*FORSETH, Einar			●							●	●			
FRASER, Claud Lovat												●	●	
*FRY, Roger Eliot			●									●		
GAUDIER-BRZESKA, Henri										●	●			
*GILL, (Arthur) Eric Rowton										●				
GLASBY, William											●			
*GONTCHAROVA, Natalie Sergeevna									●				●	
*GONZALEZ, Julio										●				
*GOODAY, Rita (née Andrews)												●		
*GRANT, Duncan James Corrower						●						●		
*GRAY, Eileen	●		●									●		
GUY, Lucien												●		
*HAMMOND, Aubrey Lindsay													●	
*HANDLEY-SEYMOUR LTD, House of												●		
*HAYBROOK, Rudolf A						●								
*HAYES, Albert Edward												●		
*HEASMAN, Ernest		●						●			●			
HEMBROW, Victor													●	
*HILLERBRAND, Josef												●		

188

	ARCHITECTURE	CERAMICS	FURNITURE	FANS	GARDENS	INTERIOR DESIGN	JEWELLERY	METALWORK	ORNAMENT	SCULPTURE	STAINED GLASS	TEXTILES	THEATRE	TRANSPORT
*HOGAN, James Humphries		•												
*HUNTER, Alec B												•		
*IRVING, Laurence Henry Forster													•	
*JORDAN, J E												•		
*KAUFFER, Edward McKnight												•	•	
*KLUTSIS, Gustav			•											
*KNOWLES, John Alder											•			
KNOX, Archibald, style of												•		
*KOKOSCHKA, Oskar													•	
KRISTIAN, Roald												•		
*L, F						•								
*LARIONOV, Mikhail Fyodorovich													•	
*LAURENS, Henri										•				
*LEACH, Bernard Howell		•												
LÉGER, Fernand												•		
*LEPAPE, Georges												•	•	
*LEWIS, Percy Wyndham			•											
*LOEWY, Raymond			•			•								
*LOWINSKY, Thomas Esmond												•		
*McCLEERY, Robert Charles												•		
*MACLEISH, Minnie												•		
*MANN, Cathleen (Marchioness of Queensbury)													•	
*MARINOT, Maurice		•						•						
MARKS, William								•						
MATEAR, Huon A	•													
MÉWES & DAVIS, Messrs			•		•	•		•						
MILLAR, Cecil												•		
MODIGLIANI, Amedeo										•				
*MOORE, Charles E											•			
*MOORE, Henry Spencer										•		•		
*MORRISON, R Boyd												•		
*MOSTYN, Elfrida						•								
*MURRAY, George						•								
*NAPPER, Harry												•		
*NASH, John Northcote						•								
*NASH, Paul												•	•	
*NICHOLSON, Sir William Newzam Prior													•	
*NIEDECKEN, George M, attributed to						•								
*NIELSEN, Kay													•	
OAKLEY, Violet						•								
OMEGA WORKSHOPS LTD												•		
*PAINE, Charles												•		
*PHILPOT, Glyn Warren													•	
*POGEDAIEFF, George Anatol'evich													•	
*POLUNIN, Elizabeth (née Hart)													•	
*POSNER, A F												•		
*PRITCHARD, Jack			•											
*QUENNELL, Charles Henry Bourne												•		
*RAMSDEN, Omar								•						
*RHOADES, Geoffrey Hamilton													•	
ROBERTSON, Nora Murray				•										
*ROERICH, Nicolas Konstantinovich													•	

	ARCHITECTURE	CERAMICS	FURNITURE	FANS	GARDENS	INTERIOR DESIGN	JEWELLERY	METALWORK	ORNAMENT	SCULPTURE	STAINED GLASS	TEXTILES	THEATRE	TRANSPORT
*RUSSELL, Sir (Sydney) Gordon		●	●					●						
*RUTHERSTON, Albert Daniel			●	●									●	
*SAMPSON, Helen												●		
SCHNEIDER, H								●						
SCHMIDT, T								●						
*SCHWABE, Randolph													●	
*SÉGALLA, Irène													●	
*SHELVING, Paul (pseudonym of Frederic William Severne North)													●	
*SHERINGHAM, George				●								●	●	
*SILVER, (Reginald) Rex								●						
SIMPSON, Ronald D												●		
*SMITH, Pamela Colman													●	
*SMITH, Oliver													●	
SPIERS, Frank E								●				●		
*STABLER, Harold								●						
*STERN, Ernest													●	
STEWART, William Douglas													●	
STEYAERT, Louis												●		
*STÖLZL, Gunda Stadler												●		
*STRACHAN, Douglas											●			
*STROHBACH, Hans													●	
*SYKES, Charles ('Rilette')								●						
*TAEUBER-ARP, Sophie												●		
TATTERSALL, Cecil F												●		
*TILL, Reginald		●				●								●
*TIMSON, Leonard Bailey											●			
*TRAVERS, Martin											●			
TURNER –												●		
UCHATIUS, Mitzi (Marie) von								●						
*UNDERWOOD, (George Claude) Leon										●				
VARLEY, Fleetwood Charles								●						
W, V													●	
*WATERIDGE, John		●						●						
*WALTON, Allan						●						●		
*WEBB, Christopher						●								
WESTWOOD, Florrie												●		
*WHALL, Veronica M											●			
WILCOCK, Arthur												●		
*WILDERMANN, Hans Wilhelm													●	
*WILKINSON, Norman (of Four Oaks)													●	
WILSON, George												●		
*WIMMER, Edvard Josef, attributed to						●								
*WOLFE, Arthur Theobald								●				●		
*WOLMARK, Alfred Aaran													●	
WOOD, Francis Derwent	●		●					●		●				
*ZADKINE, Ossip										●				
ZAMORRA, José											●			
*ZINKEISEN, Anna Katrina												●		
*ZINKEISEN, Doris Clare												●	●	

20th Century: second quarter

	ARCHITECTURE	CERAMICS	FURNITURE	FANS	GARDENS	INTERIOR DESIGN	JEWELLERY	METALWORK	ORNAMENT	SCULPTURE	STAINED GLASS	TEXTILES	THEATRE	TRANSPORT
ABBS, George Cooper										●				

	ARCHITECTURE	CERAMICS	FURNITURE	FANS	GARDENS	INTERIOR DESIGN	JEWELLERY	METALWORK	ORNAMENT	SCULPTURE	STAINED GLASS	TEXTILES	THEATRE	TRANSPORT
ADAMS, Robert										●				
ANDREENKO, Michel													●	
ANDREWS, Dorothy												●		
ANGUS, Peggy		●												
ARMITAGE, Kenneth										●				
AYRTON (Ayrton Gould), Michael													●	
BARDER, Daphne Rosalind												●		
BEATON, Cecil Walter Hardy													●	
BICAT, André												●		
BOSWELL, James						●								
BOYD, Arthur													●	
BUCKNELL, John											●			
BUGGÉ, Margarita											●			
BULL, H J												●		
BURRA, Edward													●	
BUTLER, Reginald Cotterel										●				
CALTHROP, Gladys E													●	
CALTHROP, Peggy													●	
CARRICK, Edward (pseudonym of Edward Anthony Craig)													●	
CASS, Charles Melville							●							
CHADWICK, Lynn										●				
CHAPELAIN-MIDY, Roger													●	
CHAPPELL, William													●	
CLARKE, Hilary A								●						
CLOUGH, Prunella												●		
COLQUHOUN, Robert													●	
CONSAGRA, Pietro										●				
COOPER, Susie (Mrs Susan Vera Barker)		●												
CROOKE, Frederick													●	
CRUDDAS, Audrey													●	
CUMMINS, Catherine													●	
DANDY, Leslie G			●			●								
DAVEY, Leon (George)													●	
DAVIES, Frank												●		
DAY, Lucienne												●		
DICKIN, Nevil												●		
DRAPER, Frank						●								
EAMES, Charles, after			●											
EASTON, Hugh Ray											●			
EDWARDS, Carl											●			
ELLIS, Michael T													●	
EMETT, Rowland						●								
FANSHAWE, Elizabeth (pseudonym of Elizabeth Waller and Pat Fanshawe)													●	
FEJÉR, George	●	●				●		●						
FÉRAT, M													●	
FINN, Jean												●		
FIRTH & SONS LTD, T F												●		
FOURMAINTRAUX, Pierre											●			
FREEDMAN, Barnett													●	
FULLARD, George										●				
FURSE, Roger													●	
GAMES, Abram										●				

	ARCHITECTURE	CERAMICS	FURNITURE	FANS	GARDENS	INTERIOR DESIGN	JEWELLERY	METALWORK	ORNAMENT	SCULPTURE	STAINED GLASS	TEXTILES	THEATRE	TRANSPORT
*GEDDES, Wilhelmina Margaret											●			
*GEORGIADIS, Nicholas													●	
GIBSON, Frank R												●		
*GILLIE, Ann												●		
*GOFFIN, Peter													●	
*GOODDEN, Robert Yorke		●	●					●	●					
GOTTSTEIN-IVO, Gerda ('Gerdago')													●	
*GROAG, Jacqueline												●		
GRYLLS, Harry											●			
H, T													●	
HAINES, Wilfrid Stanley												●		
HAMILTON, Douglas											●			
*HARTNELL, Norman												●		
*HAVEL, Miroslav		●												
*HAVINDEN, Ashley Eldrid												●		
HAYNES, William Henry & Co							●							
*HEAL, J Christopher			●											
*HEPWORTH, Barbara												●		
HESELTINE, Barbara													●	
HEYTHUM, Antonin													●	
HILLER, Eric													●	
*HOFLEHNER, Rudolph										●				
HOGAN, Edmond H											●			
HOLLAND, Anthony													●	
*HURRY, Leslie													●	
*JUHL, Finn			●											
K, T												●		
*KESSELL, Mary												●		
*KING, Lawrence	●		●							●				
LAKE, Richard													●	
*LANCASTER, Osbert													●	
LANE, E												●		
*LASDUN, Sir Denys	●													
*LINDBERG, Stig		●												
*LISSIM, Simon (Semen Mikhailovich)		●	●				●	●					●	
*LLOYD, Yvonne													●	
*LUXTON, John		●												
McGRATH, Raymond B			●			●								●
*McWILLIAM, Frederick Edward										●				
MAHNKE, Adolf													●	
MAHONEY, Cyril													●	
*MAYNARD, Alister			●									●		
*MEADOWS, Bernard										●				
*MESSEL, Oliver Hilary Sambourne												●	●	
MILNE, Drew H			●											
*MINTON, (Francis) John													●	
*MOISEIWITSCH, Tanya													●	
MOLLO, Eugene													●	
*MONNINGTON, Sir (Walter) Thomas						●								
*MOORE, C Rupert											●			
MOROSOFF, Vera												●		
*'MOTLEY' (pseudonym of Audrey Sophia Harris, Margaret F. Harris, Elizabeth Montgomery)													●	

	ARCHITECTURE	CERAMICS	FURNITURE	FANS	GARDENS	INTERIOR DESIGN	JEWELLERY	METALWORK	ORNAMENT	SCULPTURE	STAINED GLASS	TEXTILES	THEATRE	TRANSPORT
NOGUCHI, Isamu													●	
NORRIS, Herbert													●	
'ODILON' (pseudonym of Elizabeth Boedecker, Mrs Fritz Müshsam)													●	
PARKS, John Gower													●	
PEMBERTON, Reece													●	
*PIPER, John										●	●		●	
*PLUMMER, Caroline Scott													●	
POMODORO, Arnaldo							●			●				
RAMSDELL, Roger													●	
RAVILIOUS, Eric William		●				●								
*REID, John			●											
*REID, Sylvia			●											
*RELLING, Ingmar			●											
*RICHARDS, Ceri Giraldus													●	
RINKA, Max													●	
RISS, Egon			●											
ROBINSON, Simpson													●	
*ROBINSON, (Thomas) Osborne													●	
ROSE, Yootha													●	
*RUSSELL, Richard Drew			●					●						
*RUSSELL, William Henry (Curly)			●											
*RUSSELL, William Henry, possibly by						●								
*SAINTHILL, Loudon													●	
*SCARFE, Laurence	●	●				●								
*SCHOUVALOFF, Paul ('Sheriff')													●	
*SELWOOD, Cordelia												●		
SENSANI, Gino													●	
*SHARAFF, Irene													●	
*SHEPPARD, Guy													●	
*SLUTZKY, Naum J							●							
*SOUTHERN, Richard													●	
*STAMMERS, Harry J											●			
*STENNETT-WILLSON, Ronald		●												
STERN, Eric E													●	
*STONE, Alix		●										●	●	
*STRAUB, Marianne												●		
*SUTHERLAND, Graham												●		
SWINDELLS, Albert												●		
*TISDALL, Hans (formerly known as Hans Aufseeser)												●		
*TOPOLSKI, Feliks													●	
TOWNSHEND, Caroline											●			
*VERMONT, Melanie												●		
*WAKHEVITCH, Georges													●	
WALTERS, Molly												●		
WARRE, Michael													●	
WEECH, Sigmund von, studio of												●		
WEIGHT, Michael													●	
WHITE, Peter D											●			
*WIINBLAD, Bjoern		●												
WILLIAMS, Lawrence P													●	
*WRIGHT, Austin										●				
*WRIGHT, Edward						●				●				

193

	ARCHITECTURE	CERAMICS	FURNITURE	FANS	GARDENS	INTERIOR DESIGN	JEWELLERY	METALWORK	ORNAMENT	SCULPTURE	STAINED GLASS	TEXTILES	THEATRE	TRANSPORT
*ZEFFIRELLI, Franco													●	

20th Century: third quarter and onwards

	ARCHITECTURE	CERAMICS	FURNITURE	FANS	GARDENS	INTERIOR DESIGN	JEWELLERY	METALWORK	ORNAMENT	SCULPTURE	STAINED GLASS	TEXTILES	THEATRE	TRANSPORT
*ADRON, Ralph			●			●								
AGOMBAR, Elizabeth													●	
*AGUILAR, Sergi							●							
*ALBECK, Pat												●		
*ANNALS, Michael													●	
*APPLETON, Ian										●				
ARAM, Zeev & Associates						●								
ARCHIGRAM ARCHITECTS	●													
ARMITAGE, Edward Liddell											●			
*BAKER, Martin							●							
*BANNENBERG, Jon						●								
*BARNES, Brian						●								
*BATES, John												●		
*BENNEY, (Adrian) Gerald (Sallis)								●						
*BLAHNIK, Manolo												●		
*BOSHIER, Derek										●				
*BOUVIER, Alain			●											
*BOWYER, Carolyn, probably by												●		
*BUNDY, Stephen														●
*BUNT, Camilla						●								
*BURY, Claus							●							
*CAMPBELL, Sarah												●		
*CHAPMAN, Howard			●					●						
*CLATWORTHY, Robert										●				
*CLENDINNING, Max			●			●								
*COATES, Nigel	●													
COCHRANE, J D		●												
*COHEN, Harold												●		
*COLLIER, Susan												●		
*CONNER, T			●											
*CONRAN ASSOCIATES			●			●								
*COOK, Peter	●													
CROSSLEY CARPET DESIGN STUDIO												●		
*CROWLEY, Graham						●								
*DAY, Allan Edward Robert						●								
*DÉGAN, Joël							●							
*DESIGNERS GUILD												●		
*DEVLIN, Stuart								●						
*DIBBETS, Jan										●				
*DODD, Robert W												●		
*DUTTON, Ronald										●				
*DYSTHE, Sven Ivan			●											
*EVANS, Peter						●								
FARRAH, Abd'elkader													●	
*FASSETT, Kaffe												●		
*FINLAY, Ian Hamilton										●				
*FISHER, Alfred Robin											●			
*FLÖCKINGER, Gerda							●							
*FOX, Angela		●												

	ARCHITECTURE	CERAMICS	FURNITURE	FANS	GARDENS	INTERIOR DESIGN	JEWELLERY	METALWORK	ORNAMENT	SCULPTURE	STAINED GLASS	TEXTILES	THEATRE	TRANSPORT
FRINK, Elizabeth										●				
FRISBY, John			●											
G-PLAN DESIGN STUDIO			●											
GIBB, Bill												●		
GLADSTONE, Gerald										●				
GNOLI, Domenico													●	
GODDARD, Lily												●		
GRAHAM, Robert										●				
GRAHAM, Sheila													●	
GRANGE, Kenneth			●											
GUILD, Tricia												●		
HALL, Nigel										●				
HARDING, Gillian		●												
HERITAGE, Robert			●											
HERON, Susanna							●							
HOLSCHER, Knud			●											
HONEY, Christopher			●											
HUGH MACKAY & CO LTD., Design Studio												●		
JACKSON, Mike							●							
JEFFERIES, Paul											●			
JUNGER, Herman							●							
KARNAGEL, Wolf		●												
KAY, Barry														●
KAYE, Margaret												●		
KENNY, Sean														●
KÜNZLI, Otto							●							
LAYTON, Susan			●											
LEE, Lawrence											●			
LEWIS, Roger			●											
LONG, Brian			●		●									
LORENZEN, Rudiger							●							
LOUNSBACH, Eric												●		
McGOWAN, Peter												●		
McNISH, Althea												●		
MAKEPEACE, John			●											
MINKIN, Robert		●												
MORRIS, Roger C							●							
MUIR, Jean												●		
MUNRO, Ian												●		
NAYLOR, Martin										●				
NEAGU, Paul										●				
OMAN, Julia Trevelyan													●	
PAOLOZZI, Eduardo										●				
PHILLIPS, Tom												●		
PLUNKETT, William			●											
POMODORO, Gio									●	●				
PRIZEMAN, John B	●		●			●								
QUANT, Mary												●		
RICE, Peter														●
RAMSHAW, Wendy							●							
REEVES, Sheila												●		
ROBERTS, Martin						●								

	ARCHITECTURE	CERAMICS	FURNITURE	FANS	GARDENS	INTERIOR DESIGN	JEWELLERY	METALWORK	ORNAMENT	SCULPTURE	STAINED GLASS	TEXTILES	THEATRE	TRANSPORT
*ROSENFELT, Peter			●											
ROWELL, Kenneth													●	
RUSSELL –												●		
SCHREITER, Johannes											●			
*SCHURER, Arnold			●											
*SCOTT, Fred			●											
*SMITHSON, Alison	●		●			●								
*SMITHSON, Peter	●		●			●								
*SONNABEND, Yolanda													●	
STAG CABINET COMPANY LTD, *Design Studio*			●											
*STIRLING, James	●													
*SWASH, Caroline											●			
*TAYLOR, Wendy										●				
TOYNBEE-CLARKE, George													●	
*TUCKER, William										●				
*TYE, Alan		●	●											
*UPTON, John						●								
*VAN LEERSUM, Emmy							●							
VEEVERS, Kathleen												●		
*WILLIAMS, Chris						●								
*WATKINS, David							●							
*WEBB, Roger			●											
*WELCH, Robert								●						
WILLIGER, Karen												●		
WOOLLEY, Reginald													●	